Natalie,

Enjoy!

BEAUTY AT HOME
AERIN LAUDER

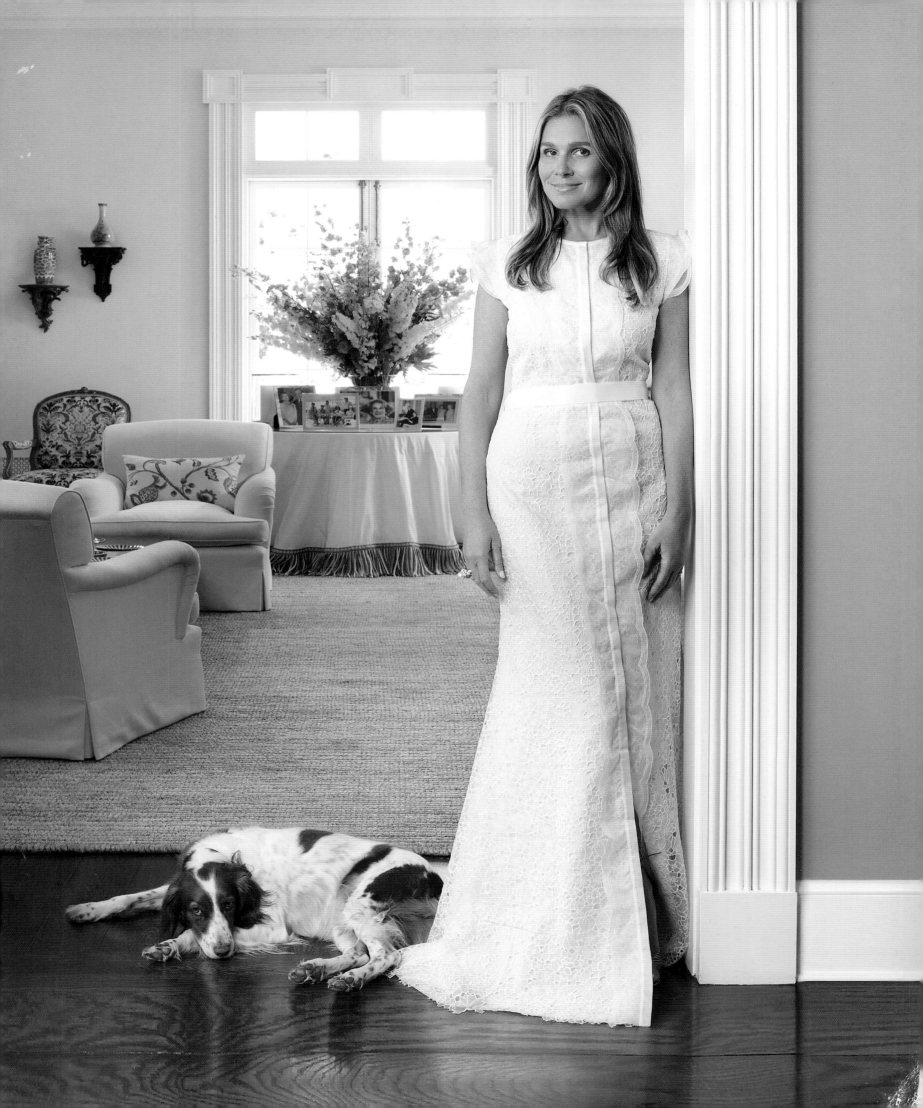

BEAUTY AT HOME
AERIN LAUDER

WRITTEN WITH CHRISTINE PITTEL
PHOTOGRAPHS BY SIMON UPTON

POTTER STYLE
NEW YORK

Published in the United States by Potter Style, an imprint of the Crown Publishing Group,

a division of Random House, Inc., New York.

www.crownpublishing.com

www.clarksonpotter.com

POTTER STYLE with colophon is a registered trademark of Random House, Inc.

Library of Congress Cataloging-in-Publication Data
Lauder, Aerin
 Beauty at home/Aerin Lauder.—First Edition.
 pages cm
 1. Lauder, Aerin—Homes and haunts—New York (State) 2. Lauder, Estée—Homes and haunts—New York (State)
 3. Interior decoration—New York (State)—Themes, motives. I. Title.
 NK2004.3.L39A4 2013
 747—dc23 2012050518

ISBN 978-0-770-43361-1
eISBN 978-0-770-43362-8

Printed in Hong Kong

Book design by LLOYD&CO, Doug Lloyd & Sara Huang
Jacket design by Doug Lloyd
Jacket photography by Simon Upton; framed author photograph: Skrebneski Photograph © 1996

10 9 8 7 6 5 4 3 2 1

First Edition

To my parents, whom I love so much. They encouraged me to follow my dreams and inspired me to be the person I am today. And to Jane, my sister and best friend.

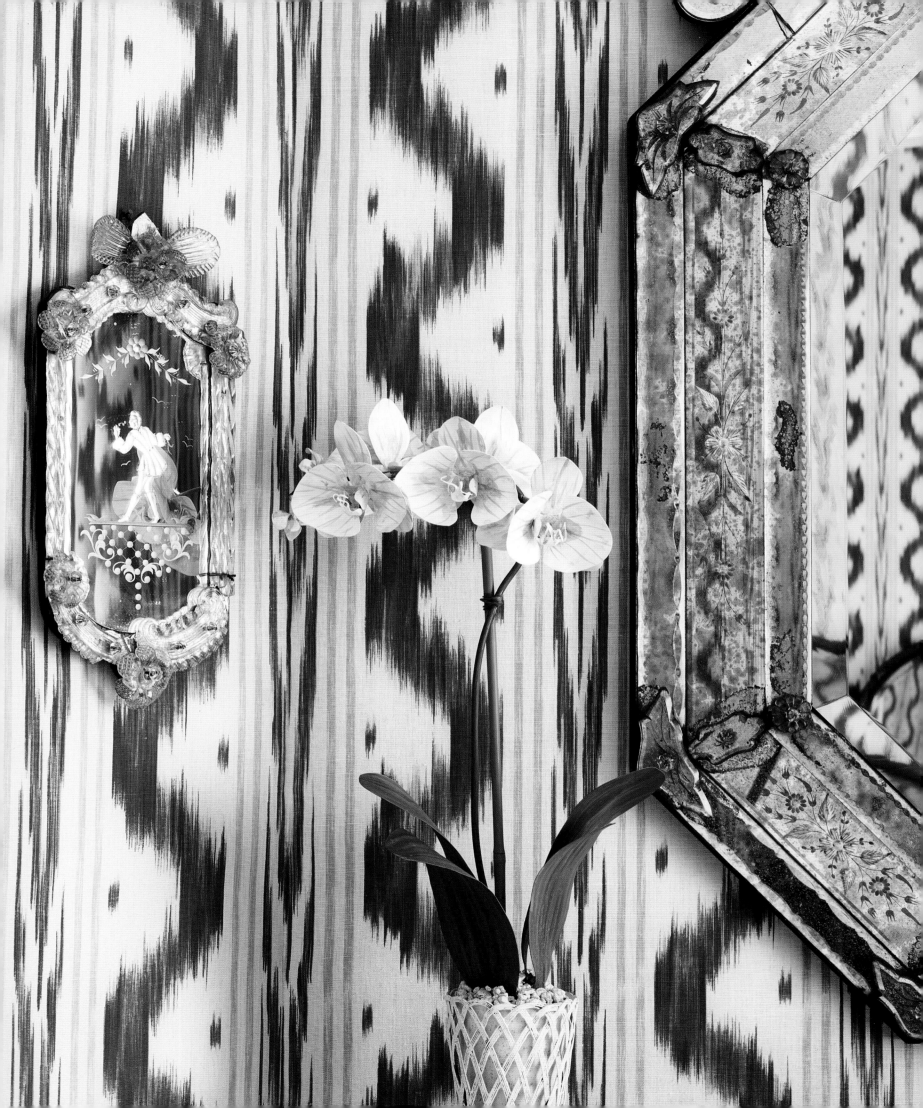

CONTENTS

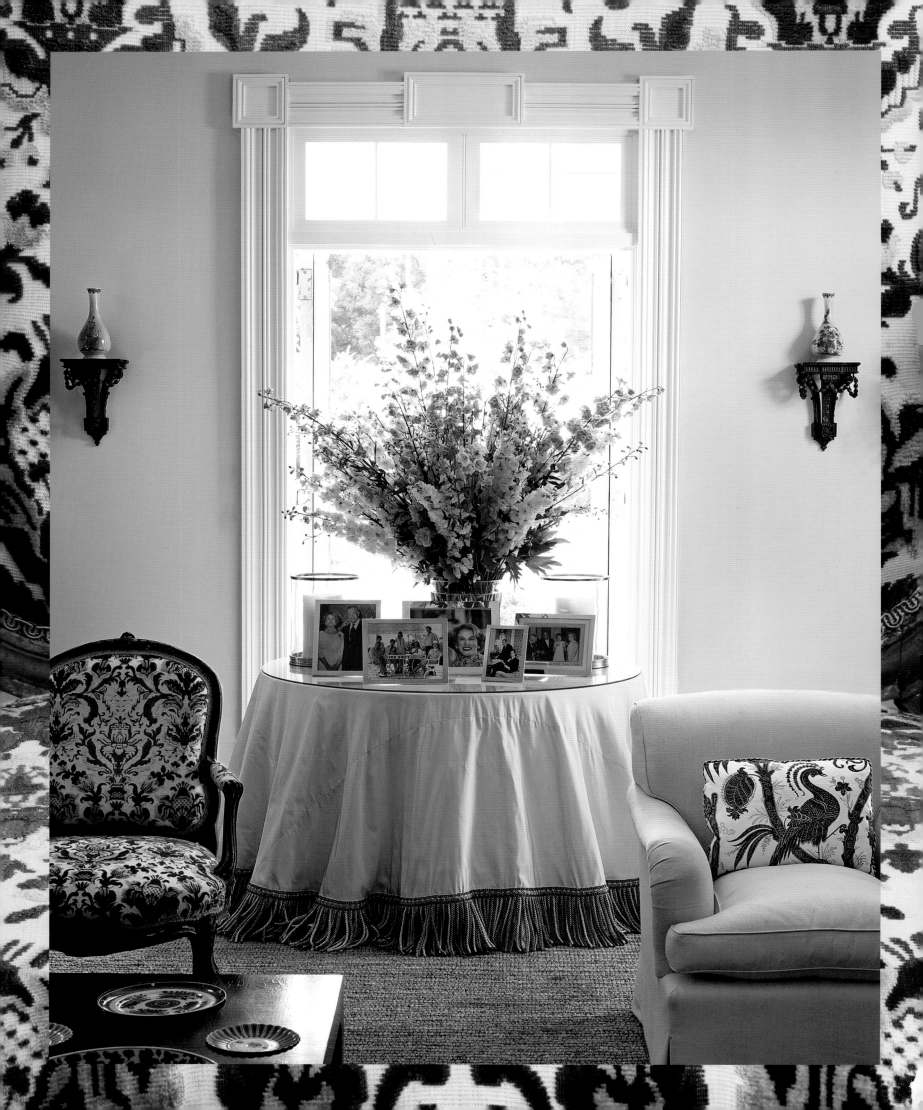

LEGACY

I loved watching my grandmother, Estée Lauder, put on her makeup. She did it so expertly— patting on moisturizer, foundation, a little blush on the cheeks to give them a glow, then a dusting of powder. She could put lipstick on without even looking into the mirror. Estée took the time to make herself beautiful because she knew that how you look affects how you feel about yourself. As she said, "Beauty is the best incentive to self-respect."

A lipstick was never just a lipstick to her. In a fundamental sense, makeup was about confidence. She wanted to improve people's lives. I grew up around all her products, but I didn't realize how special they were. Then one day, when I was probably in fifth or sixth grade, I went to school with all my new lip glosses. Everyone wanted to try them on and I thought, Oooh . . . this is something people really want.

Estée was a brilliant businesswoman. She was the first to understand that what she was selling was not only cosmetics but a lifestyle. Her ad campaigns were shot by one photographer, Victor Skrebneski, in striking black and white and featured one particular model in elegant, antiques-filled rooms. Often, you didn't even see the product. Yet you wanted to be that woman and live that life.

Estée will also go down in cosmetics history as the originator of the "gift with purchase"—a concept that initially made her competitors scoff at her for giving away the store. Of course, she proved them all wrong, because her customers appreciated those free samples and came back to buy the product once they had tried it.

I knew her as a grandmother, not an entrepreneur—although we never called her Grandma, always Estée. I started out at the company in summer jobs. Even when I graduated from college and came to work full-time, I never got to sit beside her in a meeting and observe her in action. But I've heard stories from people at the company who have been here a long time—some were even hired by her. Estée would go into a department store and stand by the cosmetics counter. She would touch the customers as she demonstrated her products, putting a bit of cream in her palm and then deftly rubbing it into their skin.

She built an empire on that touch. Hers is the quintessential American success story—a daughter of Hungarian immigrants starts out mixing face creams in her kitchen in Corona, Queens, builds a multibillion-dollar business, and becomes the friend and confidante of princesses and presidents. But I had no idea how famous she was when I stood beside her in her bedroom, with its handpainted Chinese paper on the walls, plush carpet, and fresh flowers—always fresh flowers—on her dressing table. I was fascinated with that table. There was one drawer devoted to lipsticks, another for eye shadows, another for eye pencils. This was my first lesson in organization as a way of life. And then there was that enticing array of lotions and potions and perfume bottles. She had "a nose," as perfumers say, and created one bestselling fragrance after another, beginning in 1953 with Youth Dew.

Estée's success with perfumes is another example of her vision as a saleswoman. Back then, American women did not normally buy perfume for themselves. It was considered indulgent. They would wait for a husband or a friend to give it as a gift

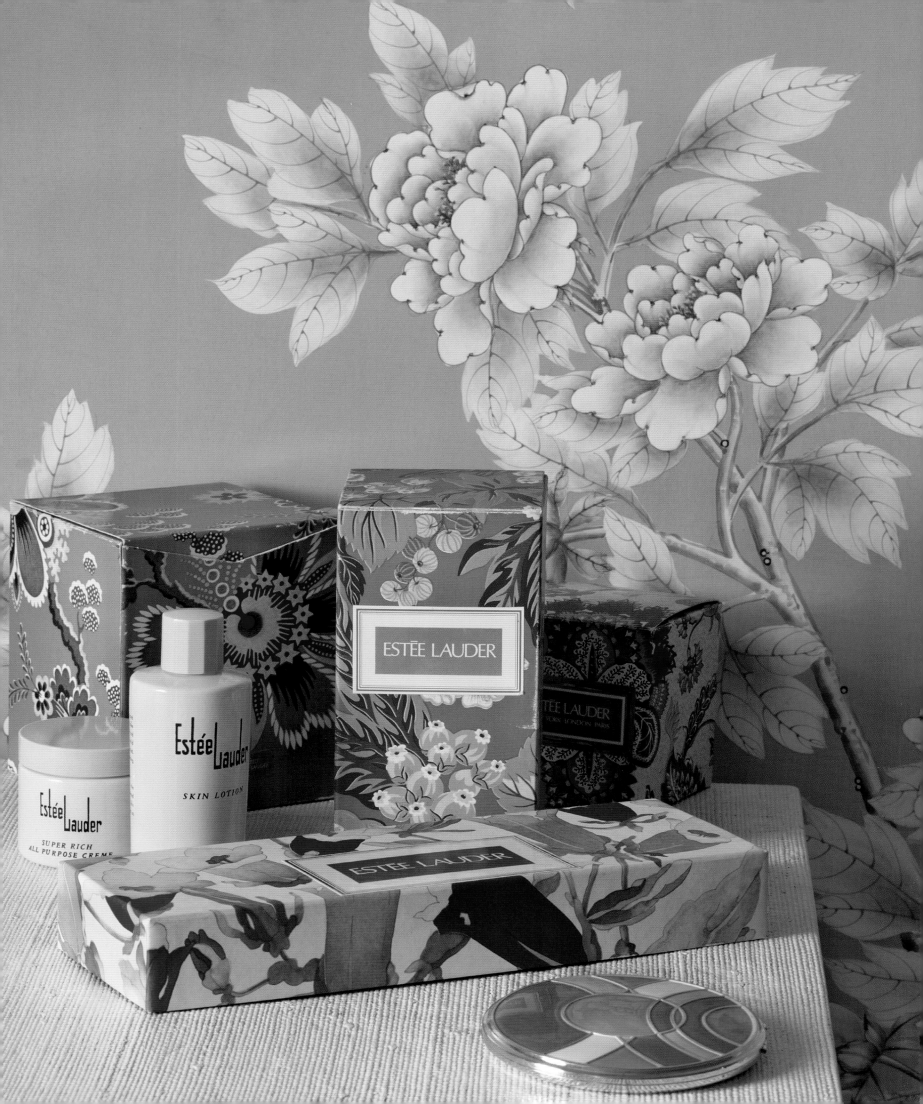

for a special occasion. Estée thought that was ridiculous. To get around it, she decided not to call her creation a perfume. Instead, she blended the scent into a bath oil. Nothing too indulgent about that—everyone was entitled to take a bath. And then the fragrance seeped into your skin and, unlike other perfumes on the market, lasted for hours. Actually, it was a technological breakthrough. She and her chemists had figured out how to do a type of time-release perfume. It's lovely when a scent stays in your hair and your clothes . . . it becomes your signature.

When Estée was working on a new perfume—and this seemed to be constantly—there were dozens of lab samples around. She was like an alchemist, mixing and pouring all these little bottles of essential oils into one another. She would hold one out to me for a sniff and ask me what I thought. She was genuinely curious, interested in everyone's comments, but she always made the final decision on her own. She was supremely confident in her own judgment.

That's one crucial thing I've learned from her. Try not to second-guess yourself. If you do, you'll make yourself crazy. Instead, follow your dream. Take a risk . . . like I did, when I decided to start my own business.

Now I'm the one surrounded by little bottles, trying to find just the right scent. I'm testing lipsticks and blushes and eye shadows, composing my own palettes. And it makes me feel closer to my grandmother than ever before, as if she's looking over my shoulder and whispering words of encouragement.

It feels somehow natural and right to be doing this. Beauty is my heritage and my passion. For as long as I can remember, I've been completely enthralled by it. But the modern woman wants more than just a blusher and a compact. My goal is to expand on the whole concept of beauty and make it a real part of the way we live.

But what does it mean, to live beautifully? For me, it's about dinner at home with a great group of friends on Saturday night. It's about a bike ride in the country with my boys, or a quiet walk along the beach picking up seashells.

We're all moving in so many different directions at once, managing a home, a family, and a career. Frankly, I don't know how we all do it, and I wouldn't presume to tell you how to try. This is not going to be one of those books with elaborate recipes for dinner-party dishes and daunting instructions for do-it-yourself projects that no one in her right mind would even attempt. (Actually, I kind of like reading about those . . . but realistically, who has the time?) Instead, think of this as a conversation with a friend. I want to share a few stories from my life, which revolves around friends, family, work, and home—everything that we all love.

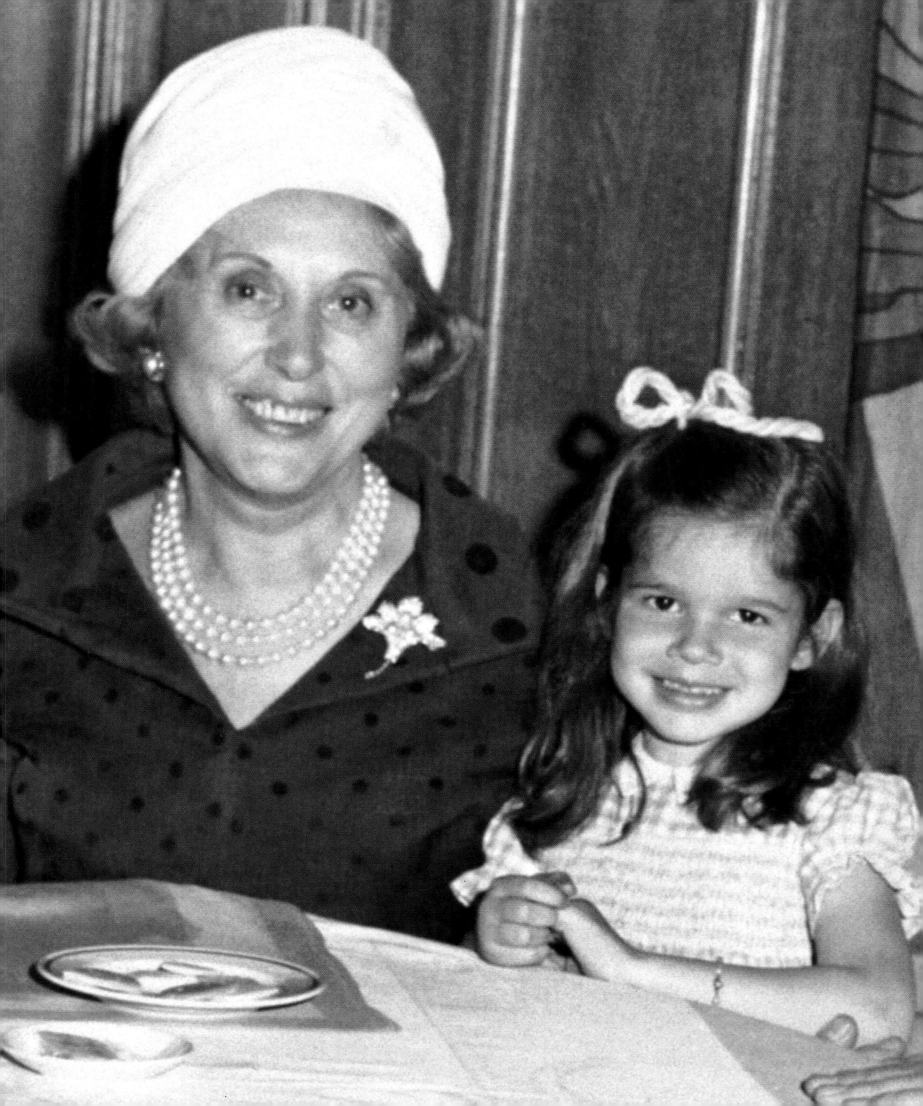

Estée used to take me
for tea at the Palm Court
in the Plaza Hotel, where
I would have a Napoleon
and a chocolate éclair.
I always admired her sense
of style. She gave me the
bracelet I'm wearing,
which I still have today.

My style is more easy and effortless. At home, that often means a man's shirt, pants, and bare feet. It's all about being comfortable in your own environment.

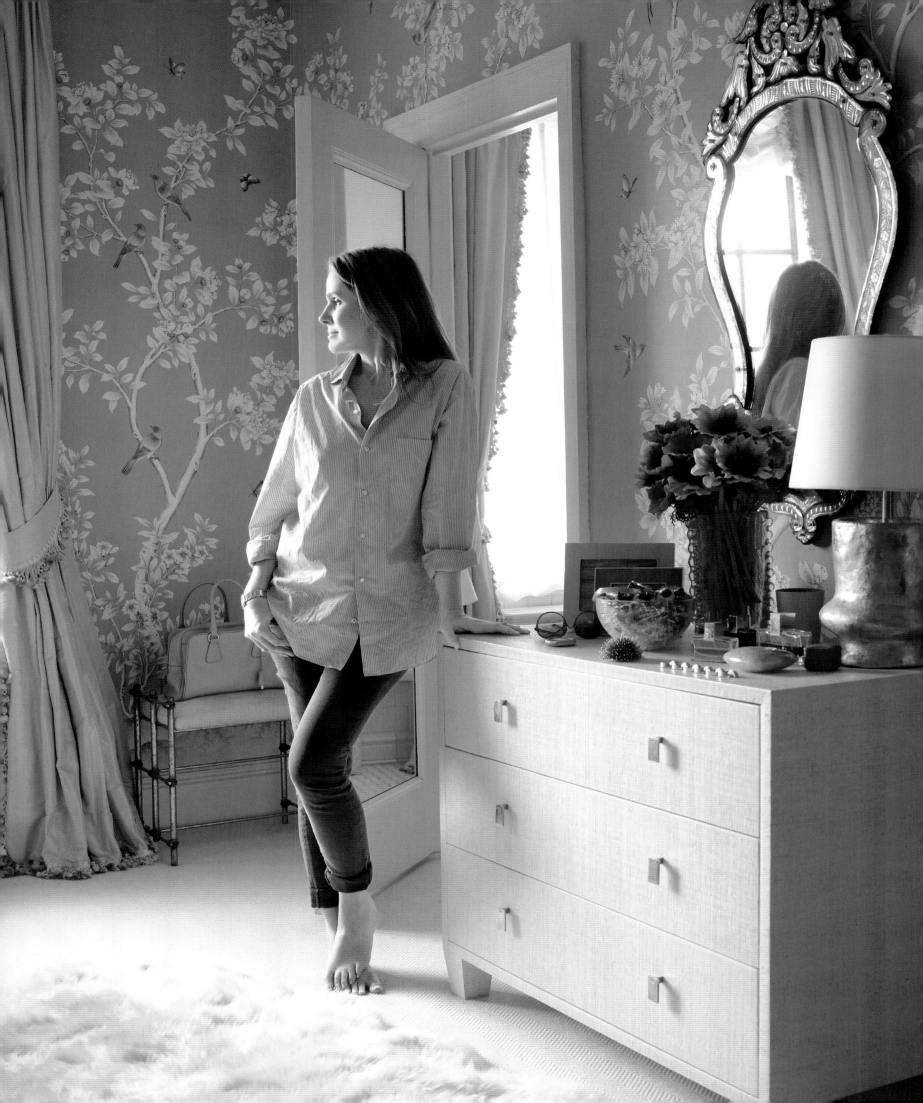

GROWING UP

One of my earliest memories is of my dad carrying me in his arms and walking me around our New York apartment. I must have woken up crying, or perhaps I couldn't sleep, and he came in and picked me up. Sometimes all a child needs is the sound of a parent's voice. My dad, Ronald Lauder, loved to talk about art, so that's how he comforted me: "Look at those two shapes," he said, pointing to a painting by Paul Klee. "See how they form a triangle? But look, it's also a bird."

My dad received his first work of art—an antique pistol and sword—when he was twelve. That was it. He learned everything he could about medieval arms and armor and then moved on to drawings and paintings and the decorative arts. His interests span centuries—the Middle Ages, the French Impressionists, Art Nouveau, Art Deco, and especially Vienna at the beginning of the twentieth century, when the city was home to Egon Schiele, Gustav Klimt, Josef Hoffmann, Otto Wagner, Oskar Kokoschka, Koloman Moser, and Adolf Loos.

These names are as familiar to me as old friends. That's because on many Saturday mornings, my dad would tell my mom that he was taking me to the park, and then we would head instead to Serge Sabarsky's gallery, where he and my father would spend hours discussing these artists. They would hand me a pack of crayons and some paper, and I would happily draw and listen as they talked. Serge was a great mentor to my father, and eventually they combined their collections and created a new museum of German and Austrian art in Manhattan—the Neue Galerie. Back then, however, that was still just a dream. After a few hours, my dad and I would walk home through the park, so technically we had gone to the park—just not in quite the way my mother anticipated.

My father speaks with such passion about art, and even if you don't particularly like the artist, listening to him may change your mind. All the art in my living room was chosen by my parents. They both have an amazing eye.

He and my mother, Jo, are a good match, because she has her own equally strong sensibility. She also shares his commitment to art. My mother was the one who took me to children's classes at the Metropolitan Museum of Art, starting when I was five. I think she still has some of my masterpieces tucked away.

As far as my sister, Jane, and I were concerned, the focal point of our apartment was the dollhouse in the blue-and-white bedroom we shared. We used to spend

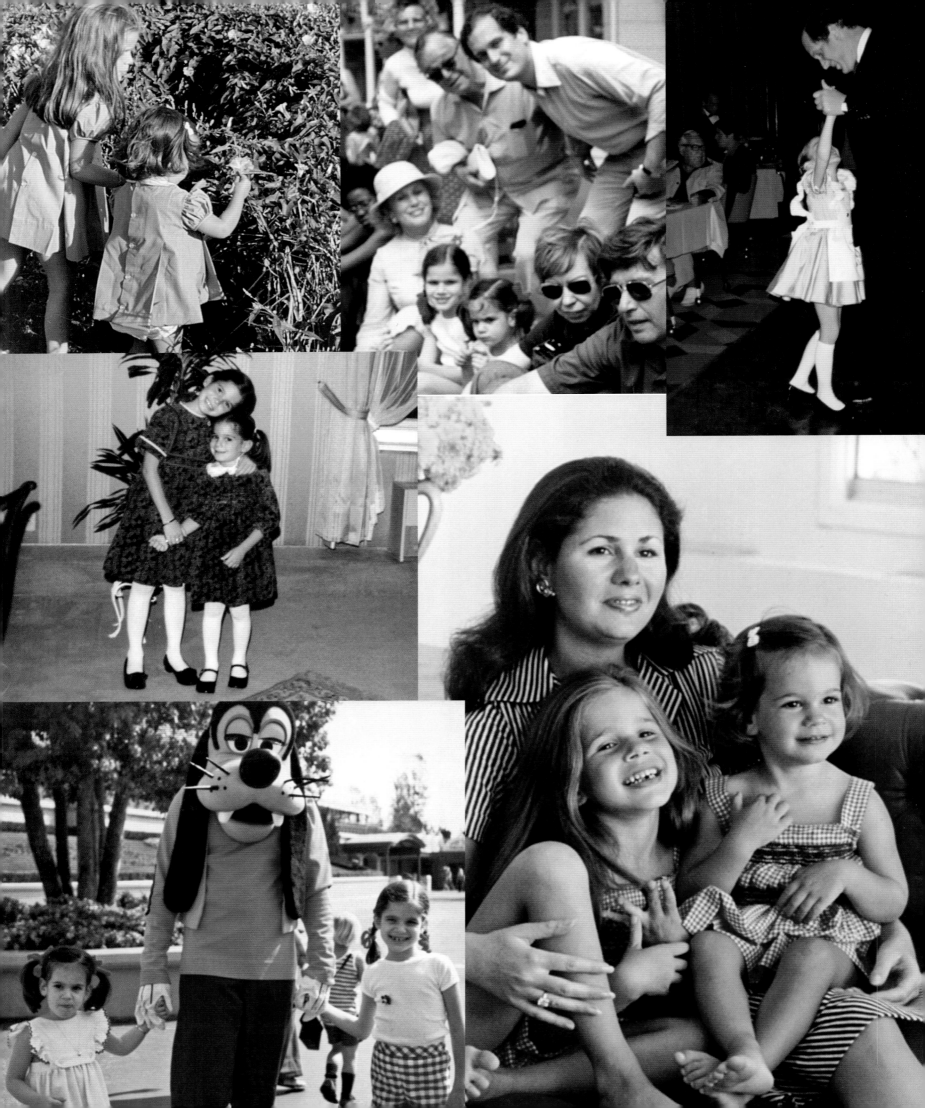

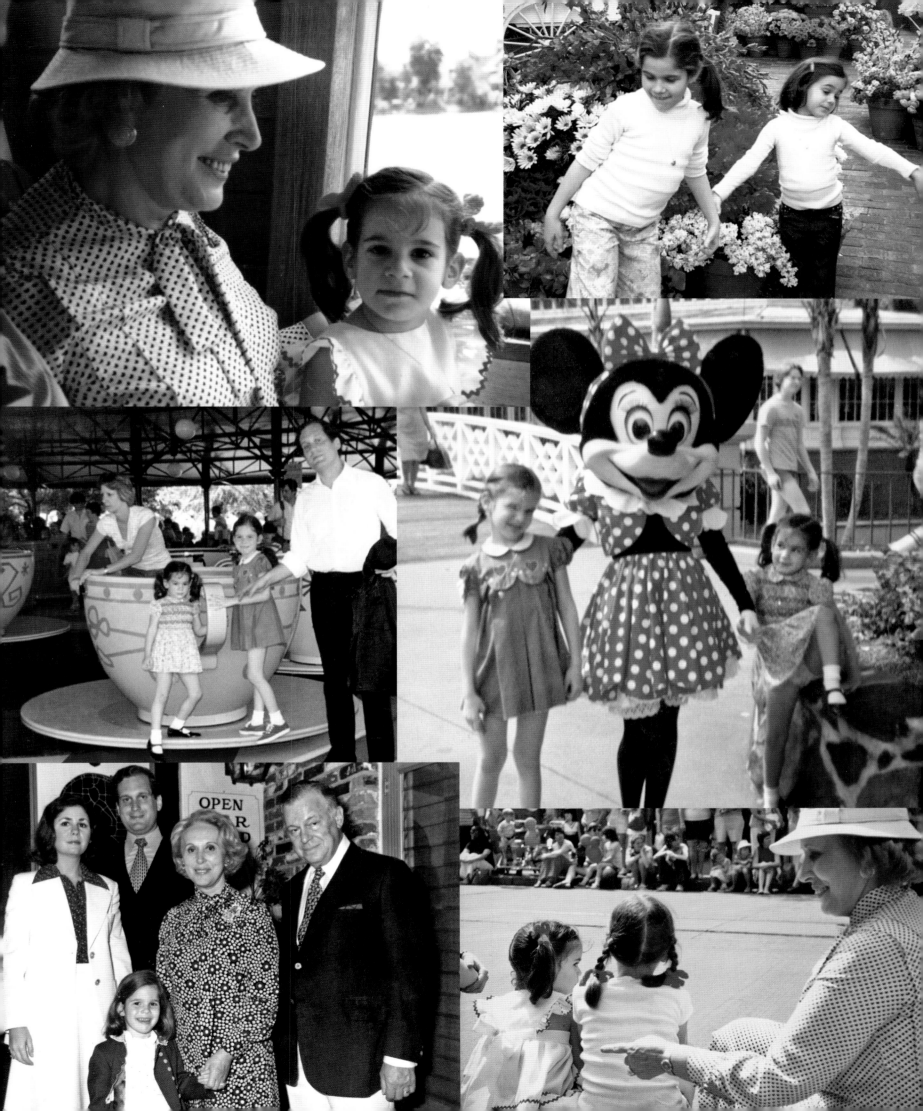

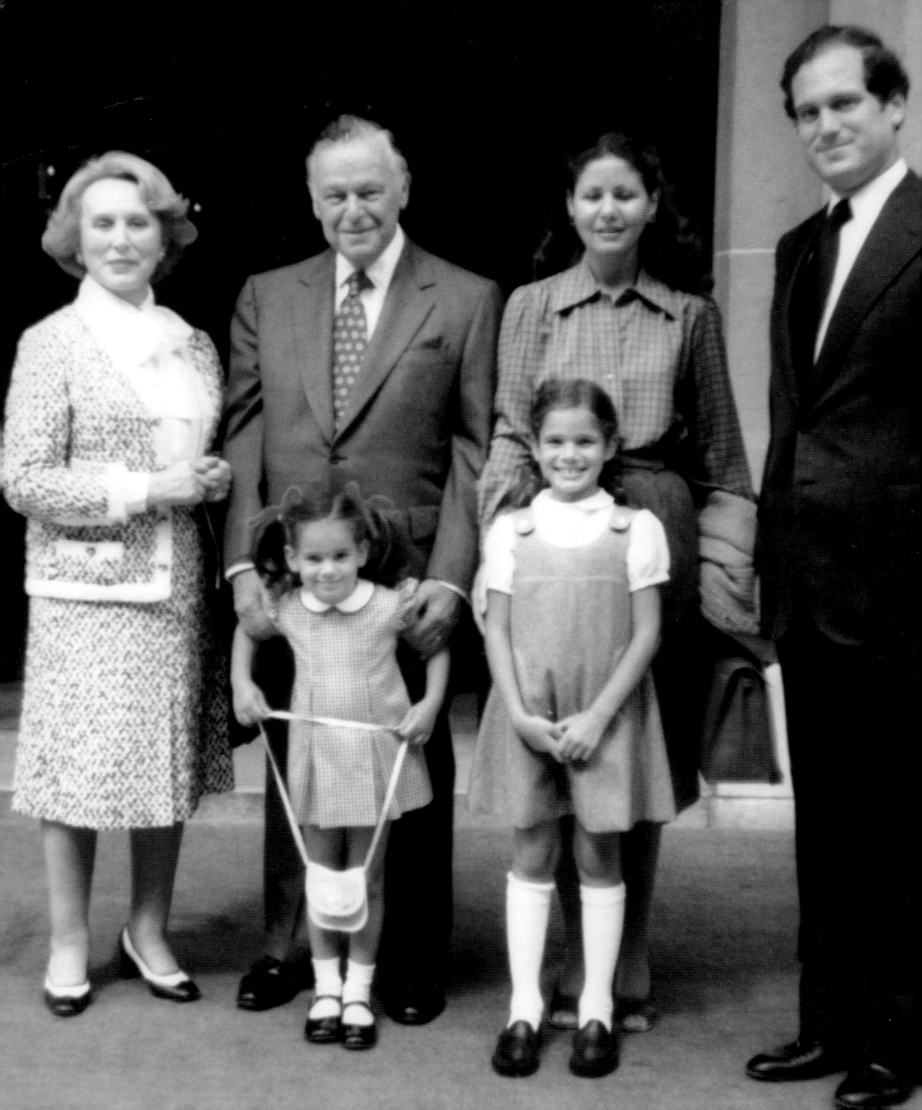

hours rearranging the furniture. This may be one reason why I still love moving furniture around, or freshening a room with a new color of paint or a different piece of art. Sometimes on a weekend, for a treat, Estée would pick Jane and me up and the three of us would walk over to a shop that carried everything you could ever want for a dollhouse. Have you ever taken a close look at miniature furniture? It's endlessly fascinating—tiny books and candlesticks and meticulously carved Chippendale chairs. . . . We both got to choose one or two or three things to buy—a process that could take hours. Then there was the fun of coming home and incorporating the new additions into the dollhouse. I used to take a grain of puffed-wheat cereal and put it on a tiny plate, pretending it was a croissant. In the country in spring, I would make a beeline for the pussy willows. One of those soft, furry gray catkins could make a very convincing hamster.

When I was in the sixth grade, we moved to Seventy-First and Park, and for the first time Jane and I each had our own room. I told my mother that I wanted to keep the same fabric Jane and I had in our last apartment—white with little blue flowers. I always have been and will be a creature of habit. My husband, Eric, is the opposite. When we go out to a restaurant, he'll order the special of the day. And then he says, "Let me guess. You're going to have the roast chicken." I like consistency, and I love roast chicken.

That's why it was very hard for me when my parents announced that we would be moving to Washington, DC, just as I was about to start high school at Chapin, a traditional all-girls school. My father had agreed to take on a new challenge, developing policy for Europe and NATO as a Deputy Assistant Secretary of Defense at the Pentagon. But I couldn't have cared less about that. I was hysterically crying at the thought of leaving all my friends and going to a new school in a new city.

This was where my mother was at her best. She understood exactly how both Jane and I felt and she was determined to transform the whole experience into something positive. She told us that we could decorate our rooms any way we wanted. I had always dreamed of having a four-poster bed with a canopy and bed curtains—every little girl's fantasy. My mother bought them for both of us, with all the trimmings. She found a beautiful townhouse in Georgetown, with a garden, and furnished it with fine American antiques so it felt very cozy and traditional. And best of all, we were allowed to have a dog—a miniature poodle named Yankee Doodle Dandy (we called her Doodle).

Once we got there and eased into life in DC, I had to admit it was not so bad. In New York, my parents went out almost every night, or at least that's how it seemed

to me. In Washington, their social calendar wasn't quite so packed and they could stay home with us. It was one of our closest times as a family.

Then, after two years, we were uprooted again. In 1986, President Ronald Reagan named my dad US ambassador to Austria. I went to Vienna kicking and screaming, but that year in Europe made me who I am. It opened my eyes to the fact that not everything is centered on New York. Vienna was a very traditional place, with picture-postcard views of horse-drawn carriages, violinists playing in coffeehouses, and people wearing lederhosen and dirndls.

Everything was different. Hot dogs were sausages. Pizza was much thinner. I became a connoisseur of potato salad and pretzel rolls. I realize now that it was my mother who held us all together and kept everyone calm. The embassy was beautiful, with expansive lawns, a tennis court, and a pool. But our house did not become our home until my mother made it into one. She created the comfort. She arranged all our things and made it feel familiar. On Thanksgiving, she invited all the US Marines stationed in the city for dinner. And every weekend, we traveled.

I remember a cocktail party on São Schlumberger's terrace in Paris with the Eiffel Tower looming right above. Berlin. London. Cap Ferrat. Venice. Rome. My father must have dragged us to every museum on the Continent. We went skiing in Kitzbühel. We wandered through palaces and heard great music in concert halls and ate in the finest restaurants and cafés. There were wonderful dinners in people's homes. The way Europeans lived and entertained was so unlike anything I'd seen before. There was always a sense of elegance to the table, set with beautiful china and silver and linens. The presentation was exquisite. The food was delicious. All that was familiar to me, from New York and Washington. The difference was more intangible: it was in the atmosphere. The house could be big and grand, and yet if you looked closely, the paint would never be perfect. The fabric on the sofa might be faded and worn. Suddenly, I understood the beauty of age.

When we all returned to New York and I went to Chapin for my senior year, I had a much broader perspective. Seeing more of the world had also given me a new appreciation for America. All of that moving had instilled in me the importance of home. I felt more connected to my family and our personal history. I had a clearer sense of what I wanted to do. I've always been very visual—fine art and photography had made their mark on me. But I also wanted to learn how to express myself in different ways. I applied early to the University of Pennsylvania, where I studied at the Annenberg School for Communication. That's where I met my husband, Eric Zinterhofer. It was the beginning of a whole new life.

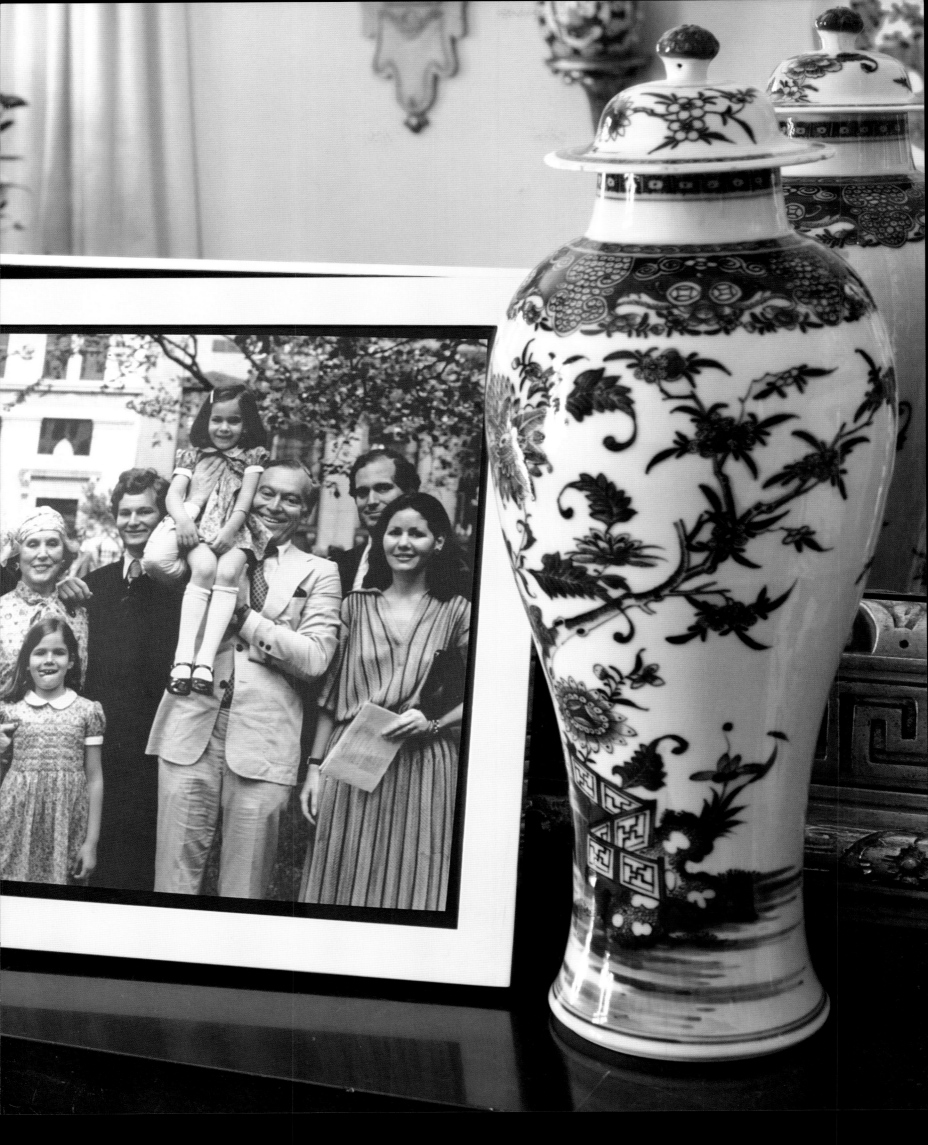

I remember our living room on East Seventieth Street, all white walls and dark wood floors and tall, European-style windows. It felt like Paris, with a glorious view of Central Park and the Frick Collection. I shared a blue-and-white bedroom with my sister, Jane. I've always lived with that color palette. The same blue-and-white flowered pattern on the wallpaper, the headboards, the curtains—everything matched. It was Estée's favorite combination, and it's clearly embedded in me as well.

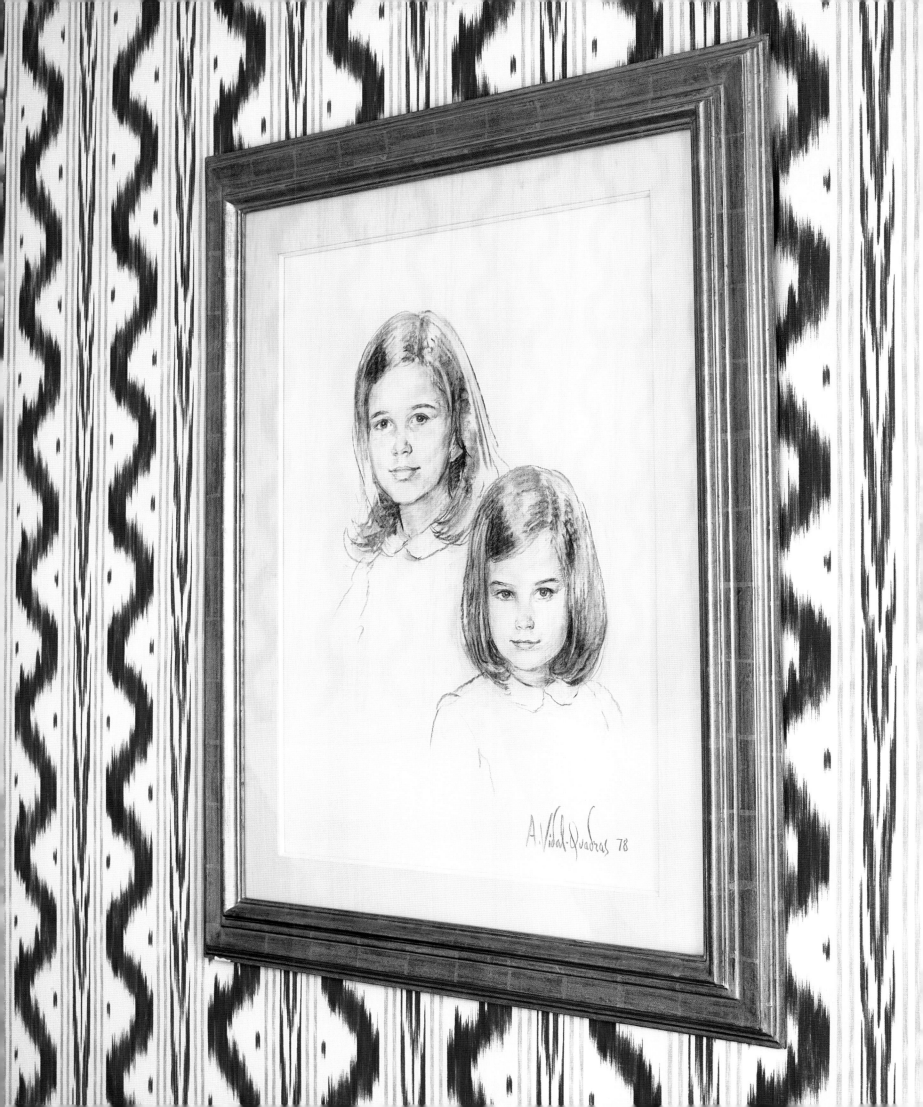

CITY LIFE

The first time I saw the apartment we live in now, sunlight was streaming through the windows. They were tall, old-fashioned casements, the kind that always make me feel as if I've stepped back in time. I thought, I could be happy here. If I had to pick the one element that's most important to me in choosing a space, there isn't any question: it has to be light. Light can animate even the smallest room as it moves across the walls over the course of a day. And then you get that lovely play of shadows. Light brings warmth and life.

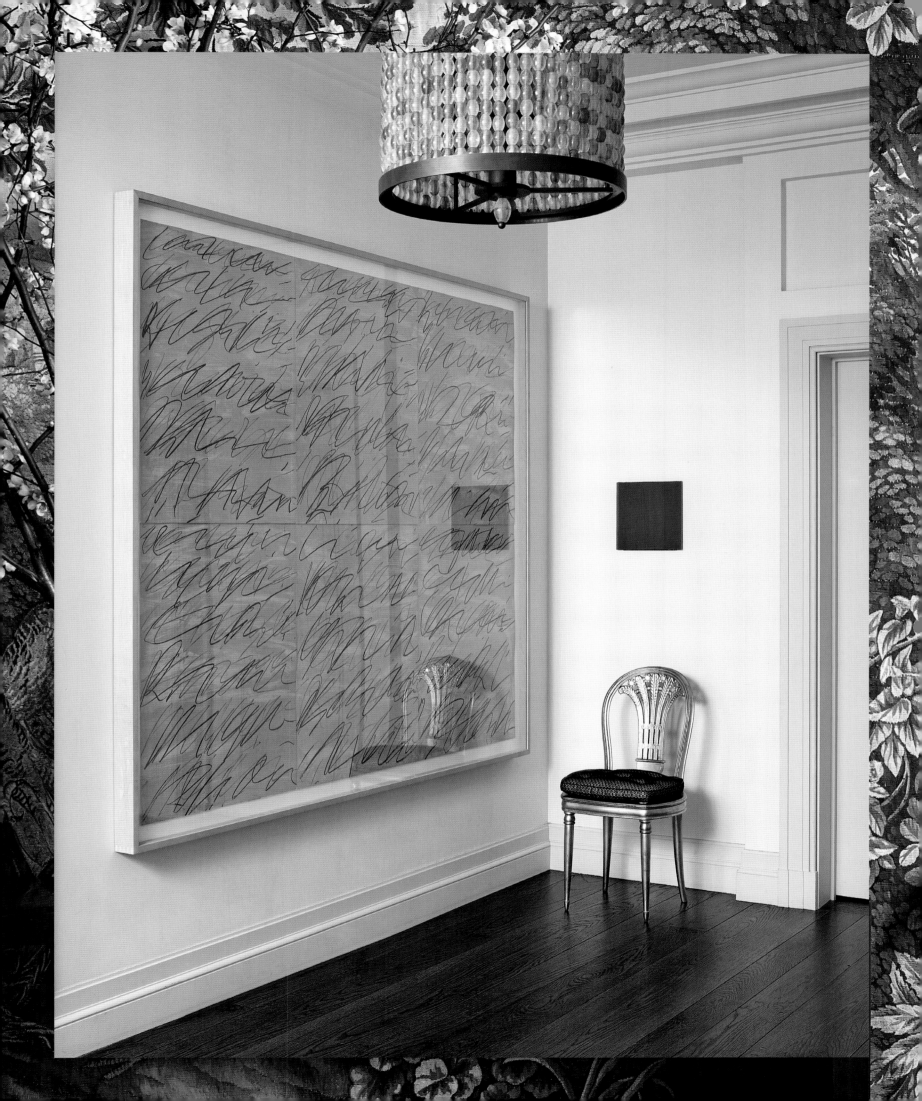

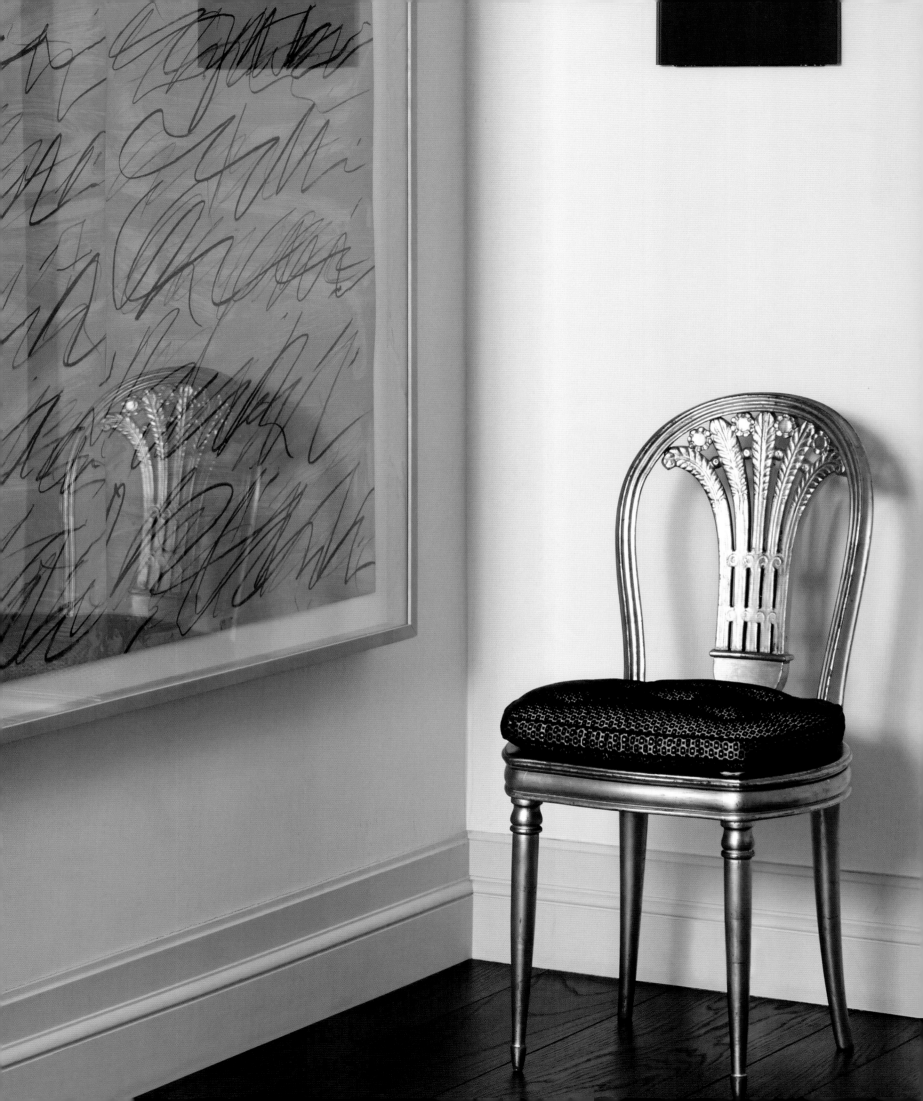

If I'm going to do something traditional, there usually will be something contemporary right next to it. I like the energy that comes from that contrast. I have a great respect for tradition, but I'm always tempted to tweak it, to give it a little edge.

ENTRANCE HALL

Since the first thing a guest sees is the entrance hall, I wanted to make it special. Walk through your front door. Where do your eyes go first? That's where you should create a focal point. I hung a large abstract painting on a wall painted ivory white. Simple and powerful. The space feels clean, clear, and roomy. There's hardly any furniture—just a long dark wood table that looks simultaneously ancient and modern, and three whimsical gilded chairs. And then one big gesture—an entire wall is covered with a Beauvais tapestry from the first half of the eighteenth century, found on a trip to Paris. I saw it in the window of an antiques shop and thought there was something beautiful and magical about it. The lush, peaceful forest scene is woven in every shade of tawny brown and leaf green.

It's not something you would expect. My grandmother loved Renaissance art and furniture and had a tapestry hanging in her New York living room, but I had never seen anyone else use one. In our apartment, we pulled it back so it draped the doorway. Just beyond it, in the hallway to the kitchen, are large, blown-up photographs of my sons, Will and Jack, in pop-art colors like lime and lavender. That's my personality, in a nutshell. I'm attracted to the classic beauty of the tapestry but I have to add something fresh and unexpected to take away any hint of formality.

Jacques Grange, the French designer who worked with me on the apartment, has a similar sensibility. He decorated our first apartment when Eric and I got married, and he and I have been friends ever since. I love his aesthetic—cool, understated, and refined. He has a classic command of structure and proportion mixed with a Bohemian charm. We have a great time shopping together for furniture and fabrics. New York designer Victoria Borus also helped with several rooms, including the kitchen and bedrooms. Both designers brought their own vision to the project. We were collaborators. It's fun to bounce ideas back and forth.

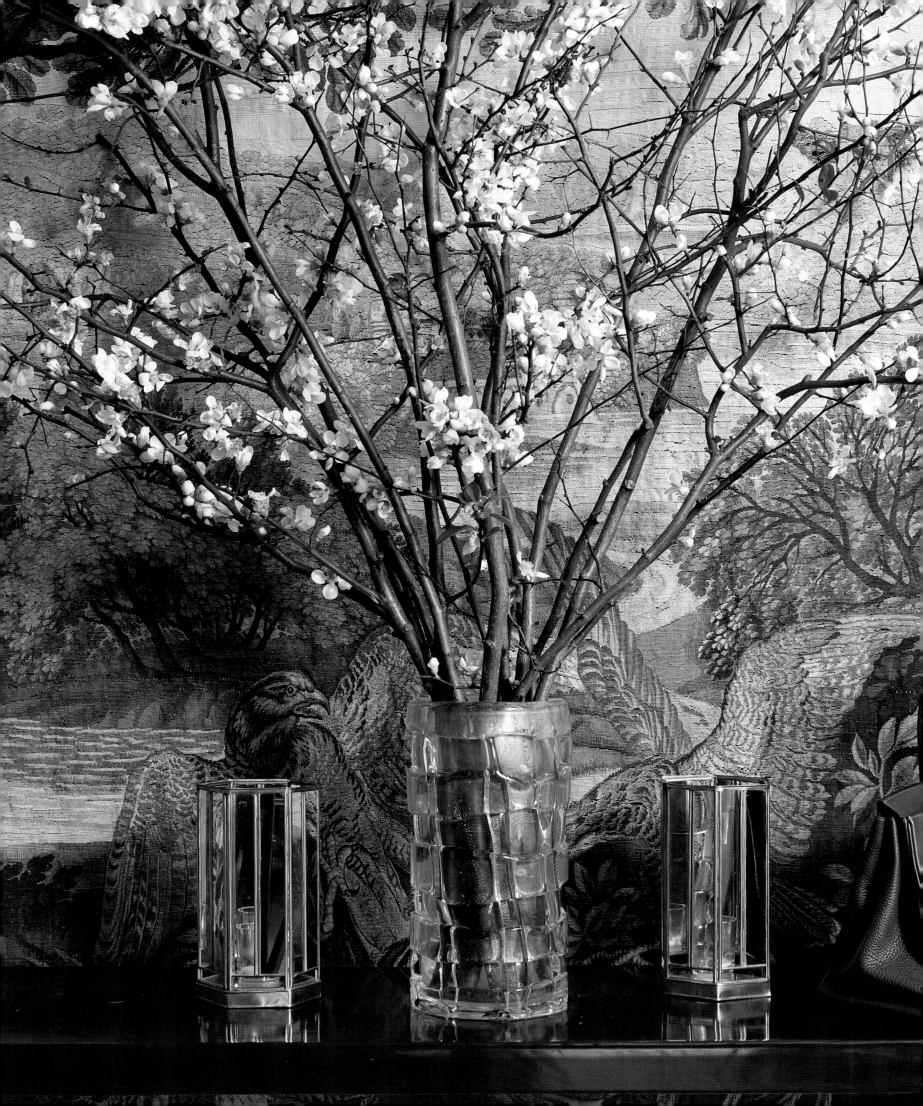

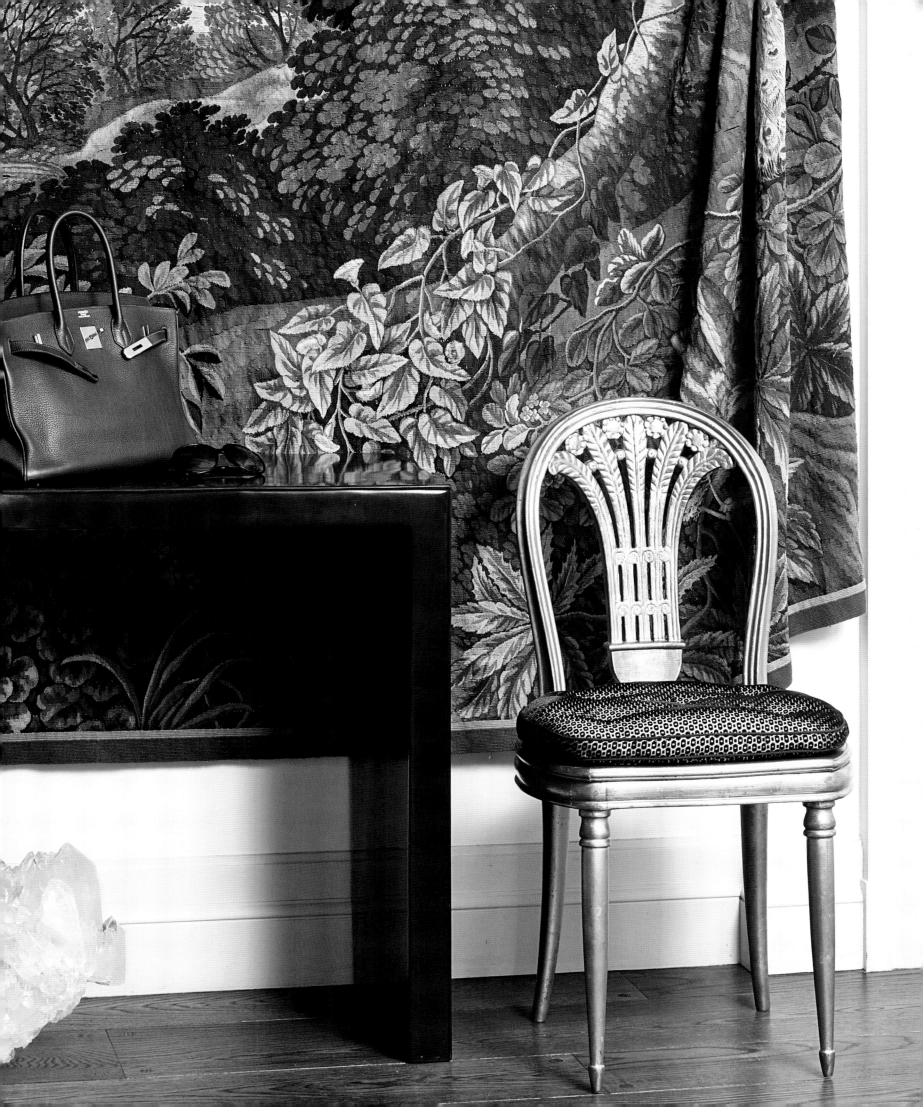

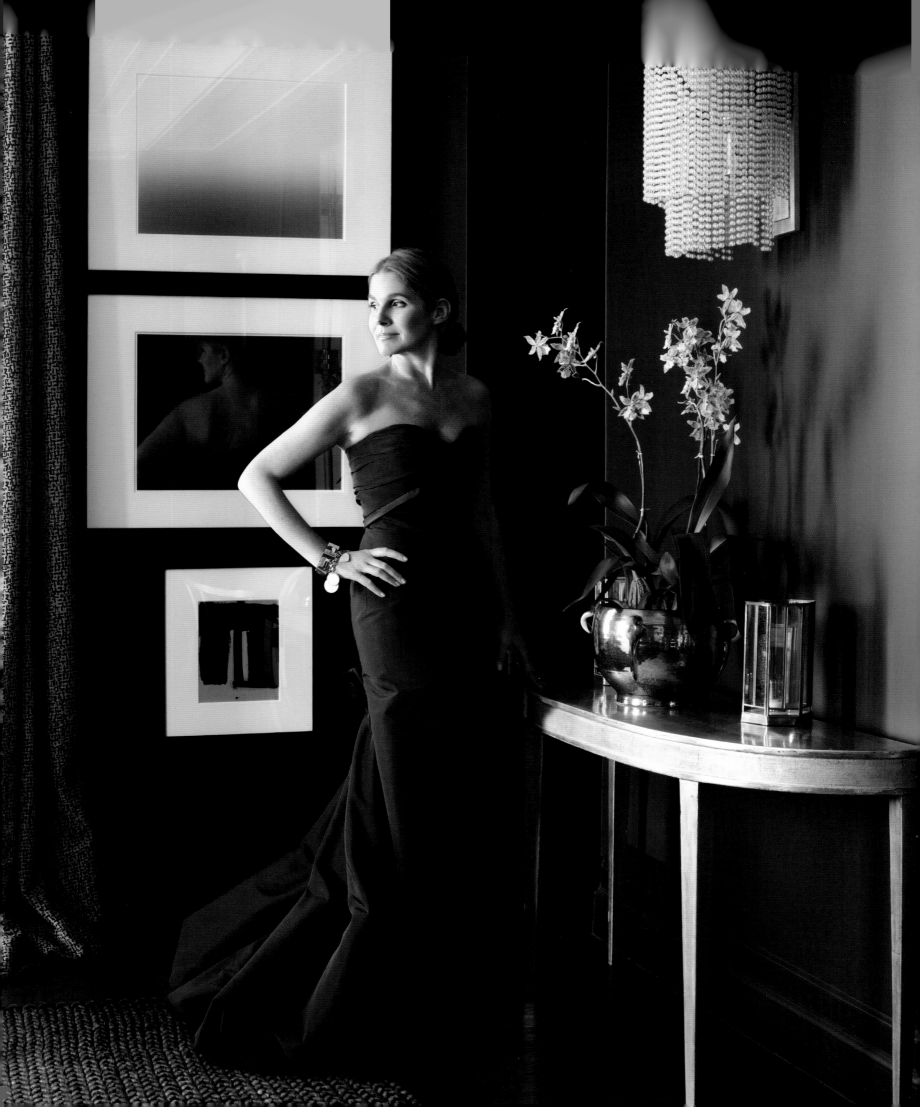

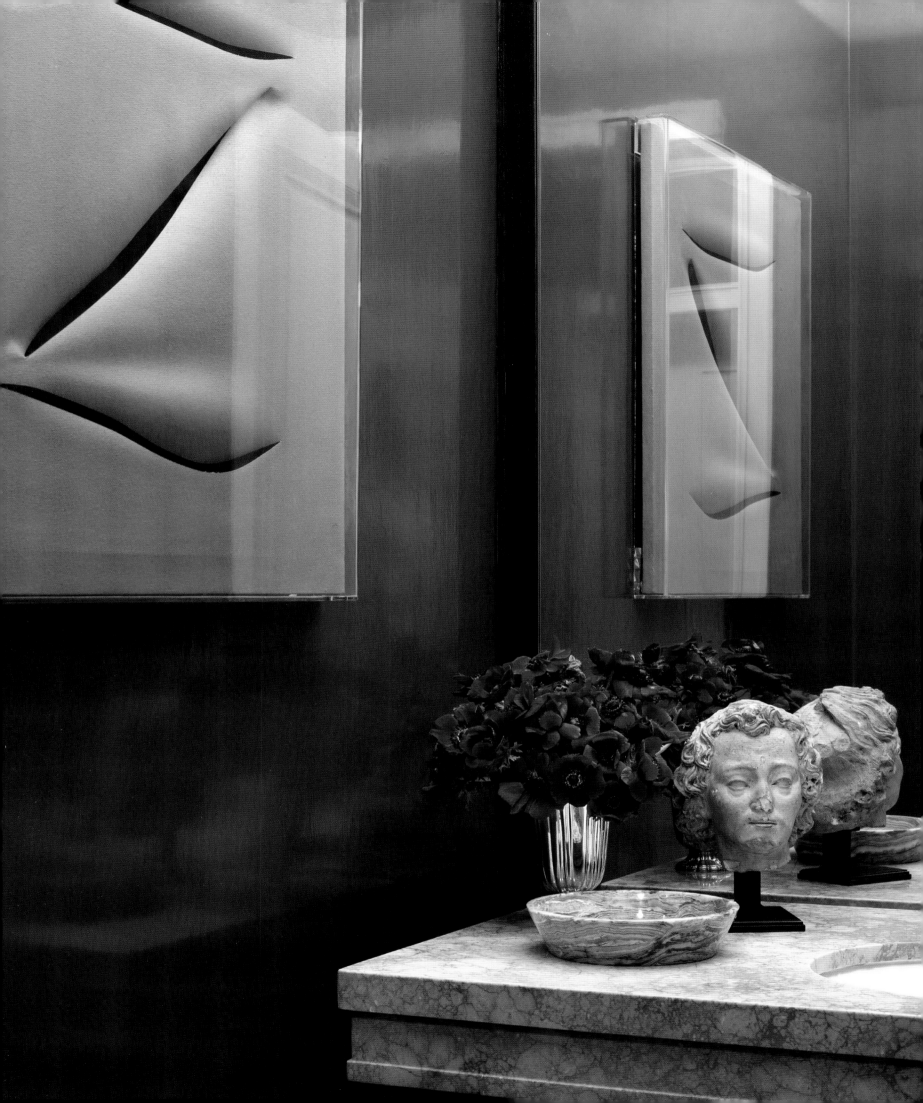

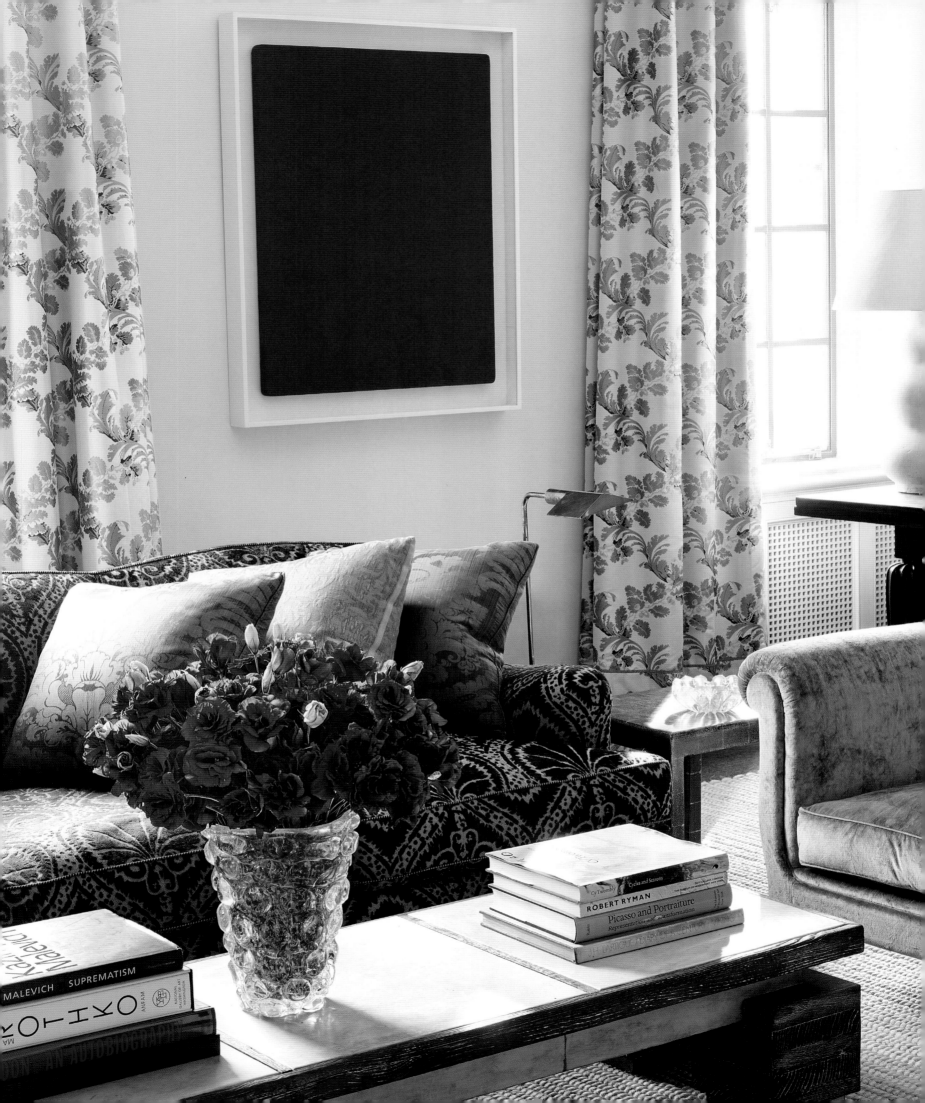

LIVING ROOM

From the entry, you see straight into the living room. It's the light from those windows that draws you in, and I wanted the room itself to be light and airy. The warm cream on the walls acts as a neutral backdrop for more intriguing shades of brown and green. There's a mocha velvet on one sofa and a chartreuse damask on another. The curtains, which bring in olive and pistachio, are actually from my previous apartment. They were too short for these windows but I couldn't bear to get rid of them. I love the fabric. It's old and French and who knows if I could ever find it again? Luckily I had one more curtain than I needed, and Jacques just cut it up and added another foot to the bottom of each panel.

That kind of nonchalance is utterly charming to me. Jacques's rooms are profoundly comfortable and effortlessly chic—two qualities that you don't necessarily find in the same place. He steered me toward French furniture from the 1920s to the 1950s, made by designers like Jean-Michel Frank, Armand-Albert Rateau, Jean Royère, and Alberto Giacometti. I've lived with these pieces for years now, and they still feel current to me. The leopard-patterned fabric on the two chairs by the fireplace may be getting a little frayed, but that doesn't bother me. It just makes the room feel more relaxed.

I'm drawn to warm colors, like brown and gold. And then the chartreuse on the sofa in the corner comes as a surprise. It's the equivalent of adding a twist of lemon to a drink. It sparks up the palette. Paintings by Ed Ruscha and Mark Rothko hang above it. I'm a big fan of contemporary art. I grew up with it on the walls, and I can't imagine living without it. The colors are strong and bold—the mesmerizing blue of the Yves Klein and the emerald-green Lucio Fontana bring energy to the space.

I don't believe in matching art to the furniture. I never pull a color from a painting and then find a fabric in that same color. To me, art is a thing apart. It has its own reality.

Actually, I don't pay much attention to matching at all. Most people would not automatically put those curtains, patterned in leafy green, behind a brown sofa. It's a clash of pattern, not to mention color. But the combination works for me because the patterns are equally strong, and both have a lot of character.

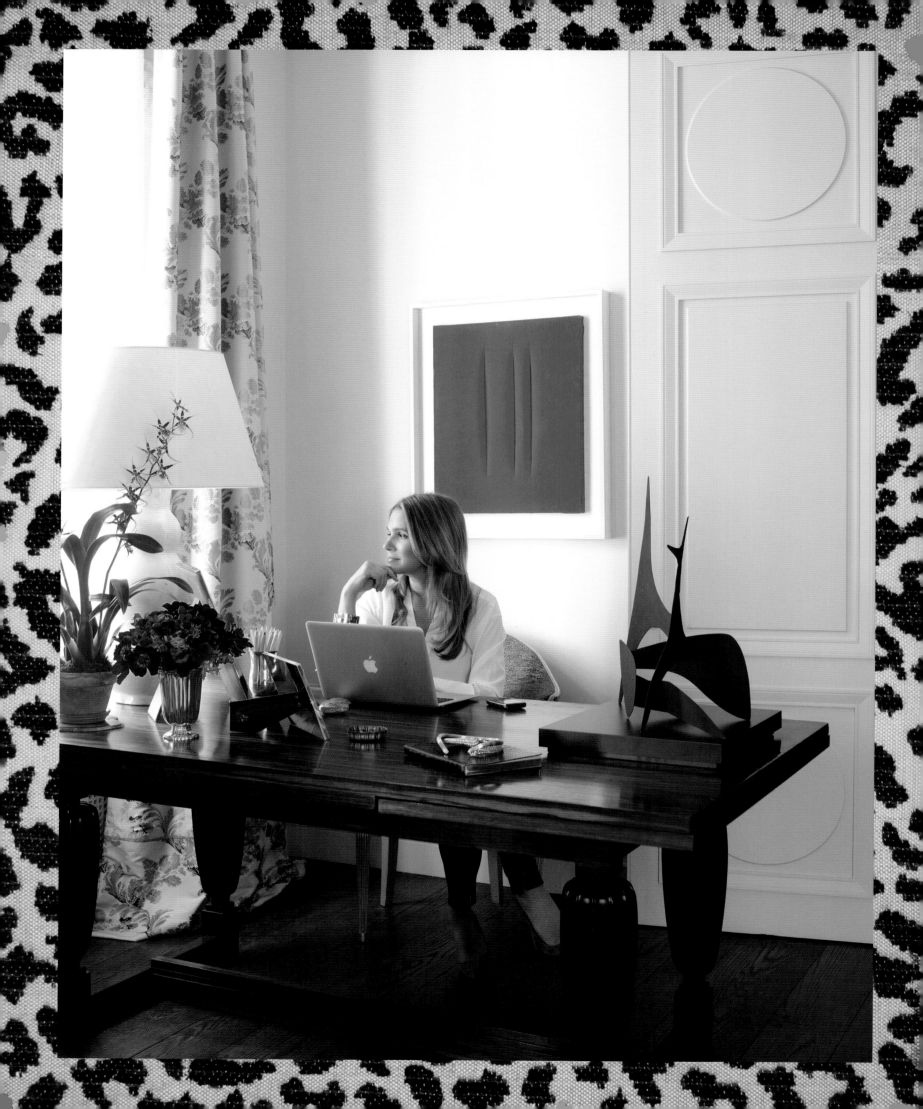

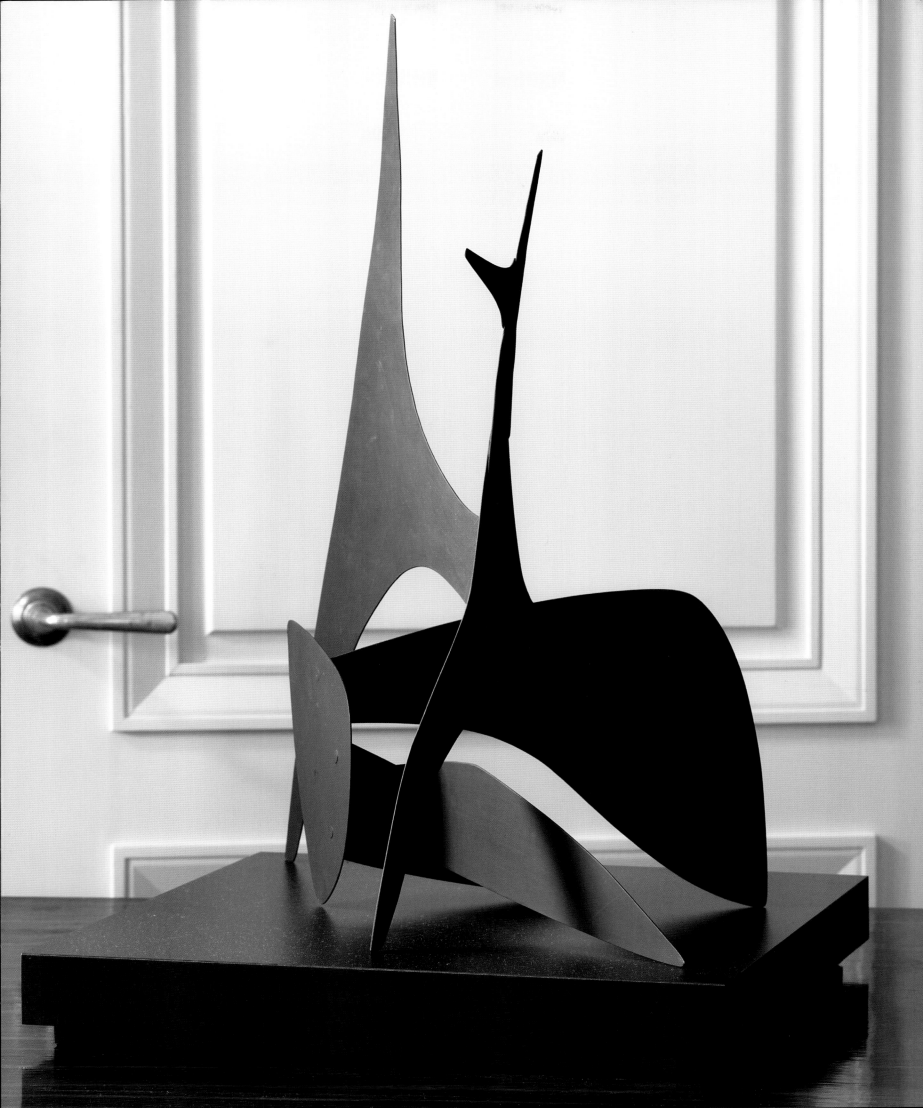

When I come into the room on a Saturday afternoon, I'll often find our dogs, Biscuit and Disco, asleep on the velvet sofa. I don't shoo them off. Furniture is meant to be used. Nothing here is off-limits to the dogs or the boys. Usually, the living room is the best room in a house—the largest, with the nicest views. Don't let it sit empty. Use it.

Putting your desk in the living room gives you yet another reason to come in. I like working here by the window, enjoying the light and the space.

Try to think in multipurpose terms when you're planning a room. If you like to play games with your kids or cards with your friends, add a small table and four chairs. We put a cabinet that doubles as a bar in our living room. People can walk over and serve themselves. It animates the room.

I don't like carpets. I had a serious carpet in the living room. Once. With two muddy boys and two even muddier dogs bounding in after a wet morning in the park, the carpet had to go. I'm back to sisal.

You see sisal everywhere in Europe, where all the old country houses seem to have it on the floors. Sisal acts as a neutral backdrop that will work with any décor, giving even the most luxurious room a kind of ease. There's a warmth to it, and a nice texture that feels great on bare feet. And as it gets worn, it gets even better.

Here again, contrast is the key. Fine antiques stand out even more on top of humble sisal. And in a city apartment, it's a very practical choice. If you get a stain on it, you can just flip it over and it's like a new rug. I can't imagine anything else in here, especially since these rooms get so much traffic.

I keep wishing that we had a mudroom like we do in the country. Right now, sneakers and backpacks and sports equipment all get piled up under the tapestry in the front hall. But even if we had a mudroom, I'd still stick with my sisal.

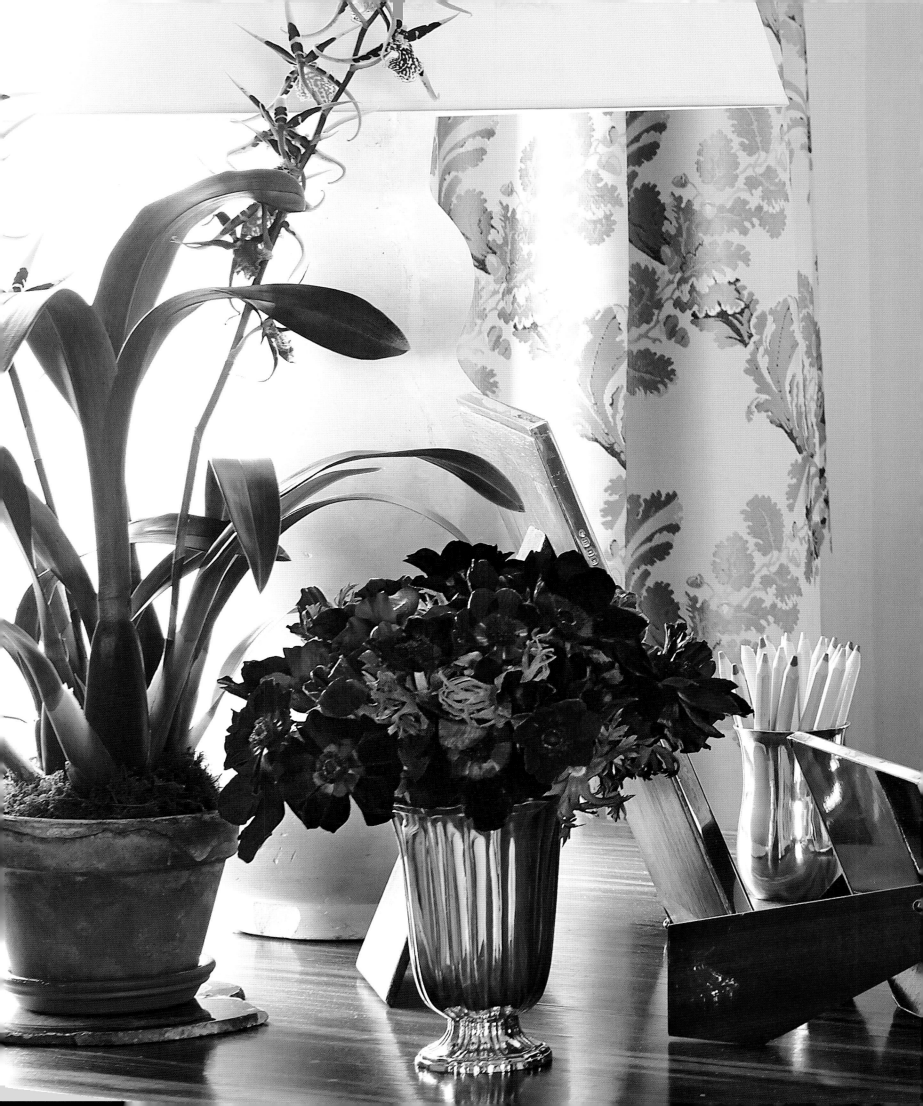

My grandmother loved to embellish things. Every sofa had a fringe, every table was a nesting spot for one of her beloved porcelain birds. But I'm more like my mother, who prefers a clean, contemporary look: I don't like clutter. The mantel in my living room is bare.

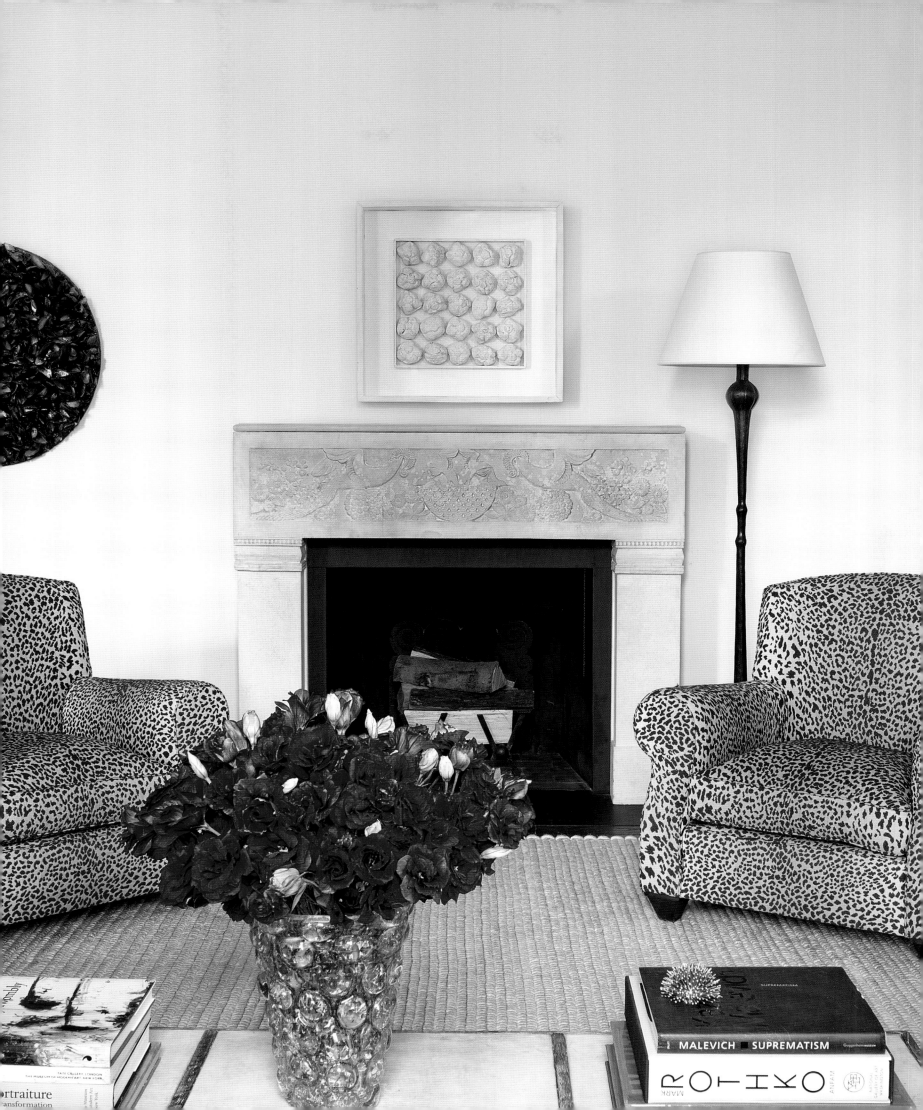

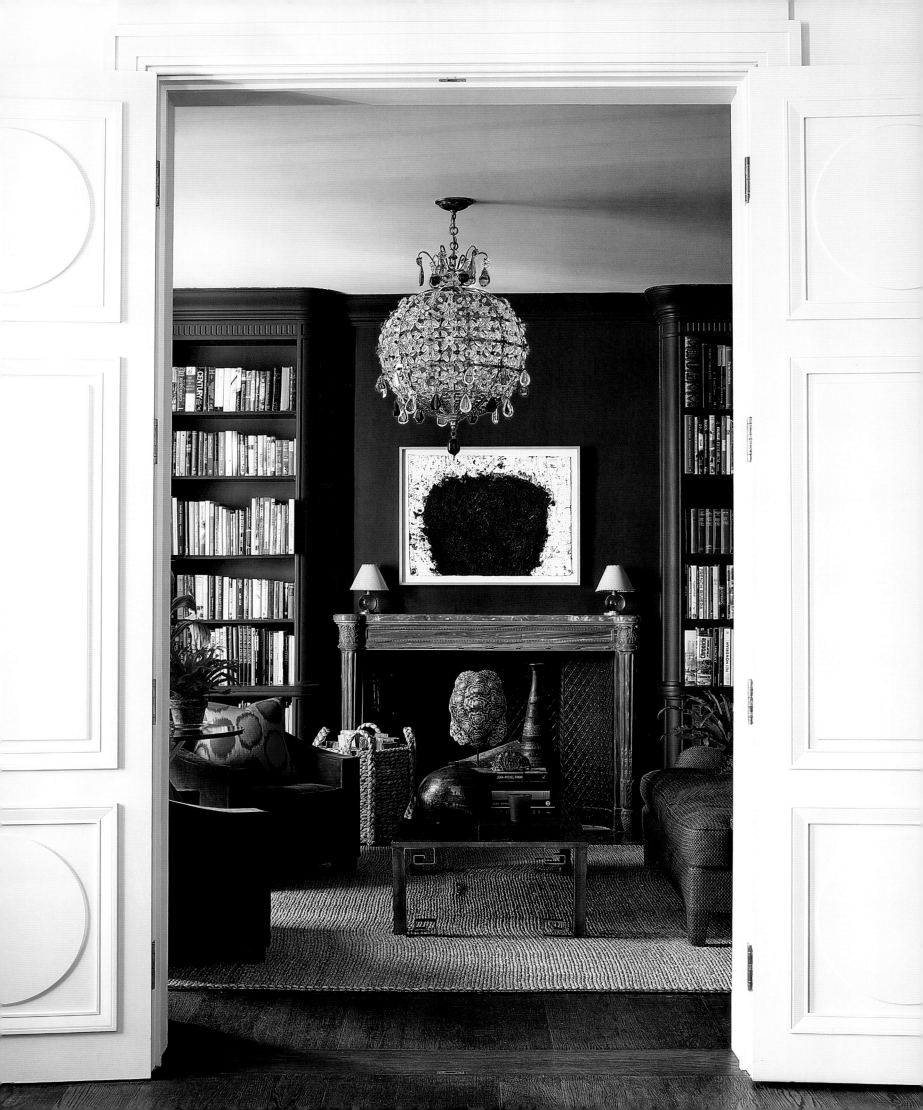

LIBRARY

The living room is open to the library on one side and the dining room on the other, so the three rooms work as one unit. The doorways form an enfilade and the space seems to expand, because your eye naturally goes to the farthest point. It's a very gracious layout, the kind you'd see in a Parisian apartment (with no space wasted on connecting hallways).

Recently I decided it was time to redo the library. Our family spends a lot of time in this room. We've got the Xbox on the TV for the boys. The lower shelves are filled with books they might want to read. I've even saved some of the books they've out-grown and put them here, because I can't bear to give them away. (That Lucite box with the sneaker in it is my version of the bronzed baby shoe.) With young boys con-stantly in that room during playdates, the sofa was looking a little ragged. Before, the walls had been a soft beige, but suddenly I had this brainstorm: Wouldn't it be interesting to go darker? Every house needs a dark, cozy room.

Jacques came back to help, and we called Donald Kaufman and Taffy Dahl, who specialize in mixing just the right paint color. Each of their own miraculous paints is made up of eight to twelve pigments, rather than the typical two or three, which means the color seems to change over the course of the day. Something as simple as pale gray could look more blue at one point and then, at another time, more green. I love that ambiguity.

Donald and Taffy came up with this mysterious Prussian-blue slate color and we put it everywhere—on the walls, the bookcases, the moldings. And then, because this is the way decorating works—you change one thing and it affects another—I realized we now had to repaint the dining room as well. I envisioned a light-filled living room, flanked by two dark rooms. A deep color would make the dining room more dramatic. Imagine opening the doors to a candlelit table, glittering against dark walls. . . .

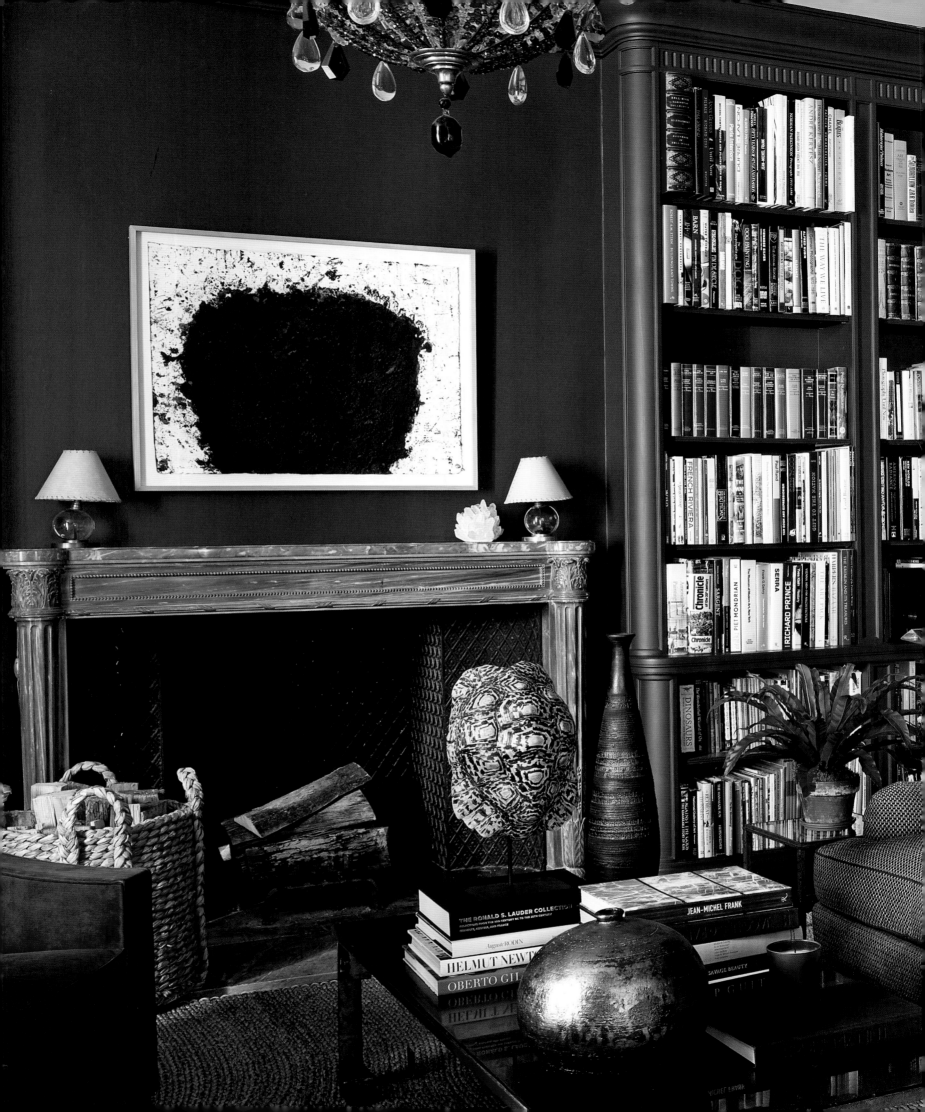

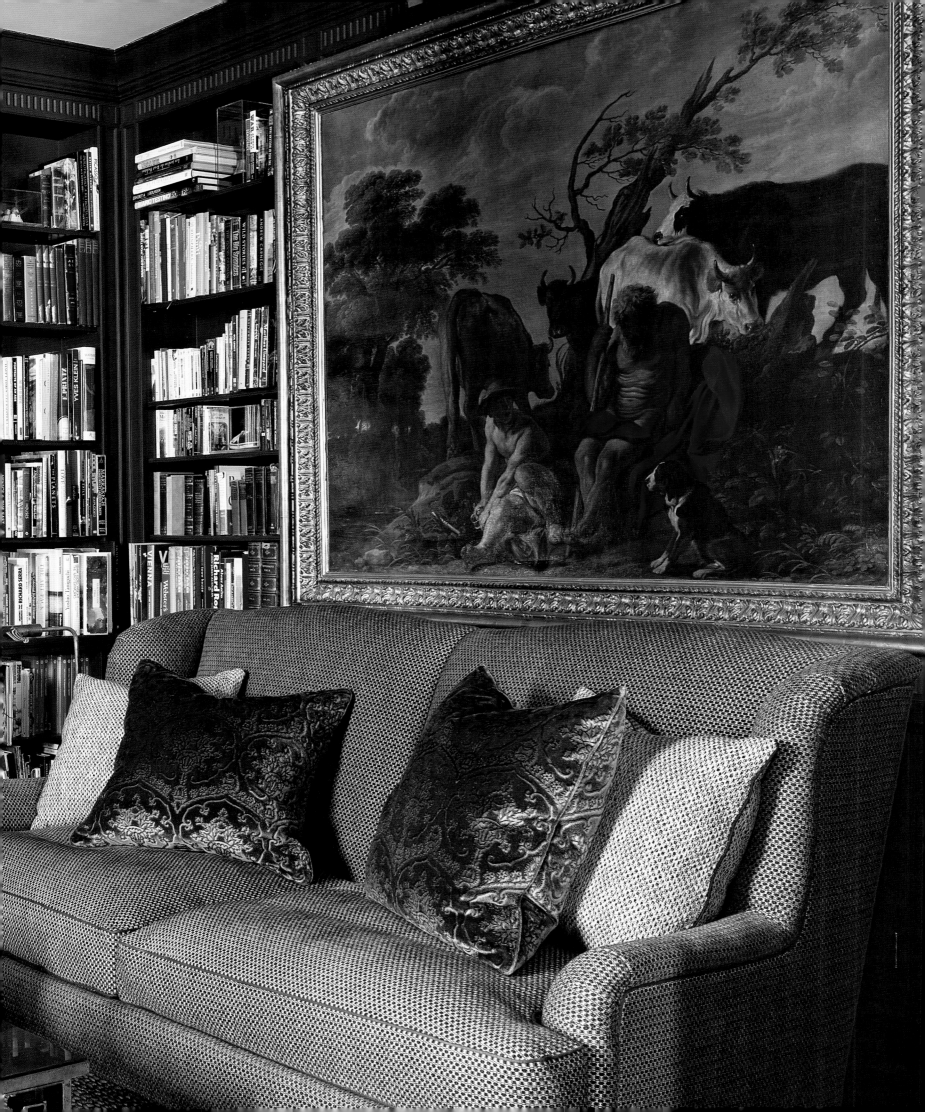

I like bringing different
textures into a room—
rock crystal, tortoiseshell,
and crushed velvet pillows
unexpectedly paired with
a more masculine sofa covered
in wool. I saw that chandelier
in the window of an antiques
shop in Paris and immediately
fell in love. I liked the shape
and the colors, especially those
dangling bits of amethyst.

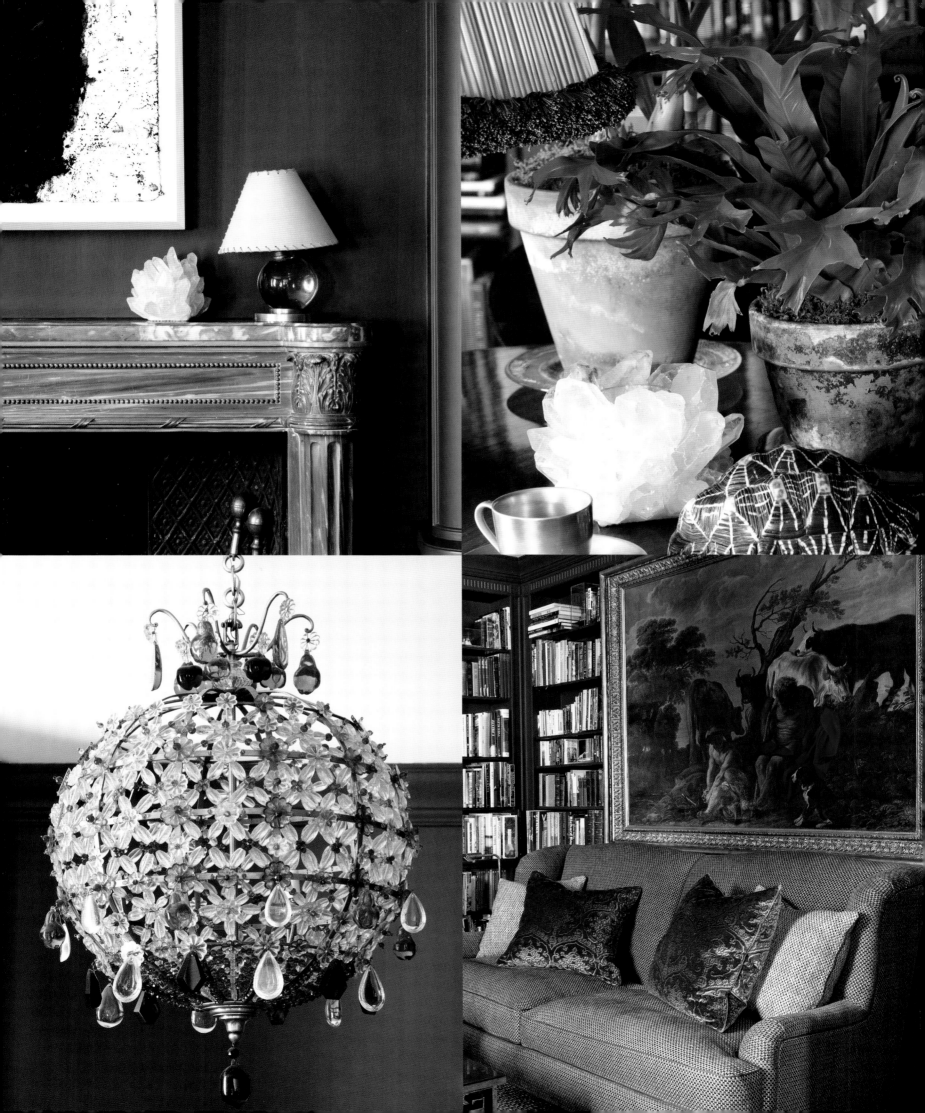

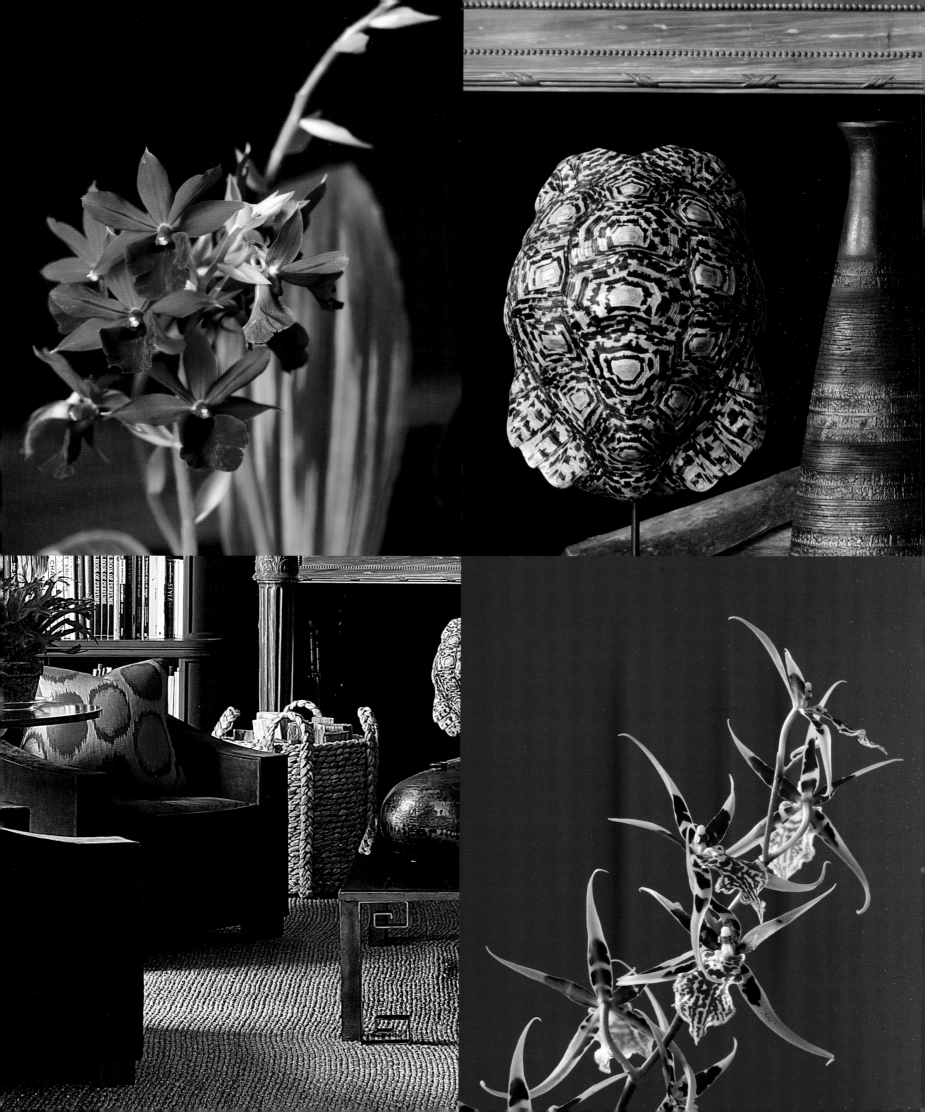

FLOWERS

Fresh flowers are one of my basic pleasures. A little plant from the corner deli to a beautiful orchid, and everything in between . . . It's nice to have that bit of life in a room. I always feel so guilty when flowers die. By now, I've figured out which flowers last the longest—flowering branches are a good bet.

That's another reason why I love orchids. They last a long time. With their sculptural shape and clean lines, they look very graphic. I'm entranced by all the pretty colors and patterns. Some are pure white and serene. Others are flamboyant. Some even look as if you've been nibbling on the petals. I love their names—Moonrise, Lady-Slipper, Japanese Wind, Ghost. To me, orchids are magical.

Plants also make a great hostess gift. I'll often send a beautiful flowering plant—anything from an azalea to a passionflower—to a friend the day after a party, as a thank-you. Sometimes I'll bring a pretty cachepot to the florist and have him plant an orchid inside, and then deliver it. I think sending something the day after is more thoughtful than arriving with a bunch of flowers on the night of the event. By the time you ring the doorbell, the hostess has no doubt already bought and arranged her own flowers. The last thing she needs to do, while greeting guests and putting the finishing touches on the dinner, is to scramble around looking for a vase for your bouquet.

DINNER AT HOME

The dining room is now a rich, almost black eggplant that feels very sophisticated and at the same time utterly cozy to me. The dark, velvety walls set off the sparkling crystal and gilded chairs and turn the room into a jewel box.

My dining table is round, because in my opinion a round table seems more inviting. Everybody is equal—there's no "head." And conversation is better. It's more casual.

In some ways I take after my mother, who understood the concept that less is more. But I do like a decorative dining table, and that is pure Estée. Her black-tie dinners in New York, Cap Ferrat, London, and Palm Beach were completely over the top, with unbelievably elaborate place settings—reproduction Fabergé eggs, candelabra three feet tall, and cut-crystal bowls for candies and nuts. The whole experience was decadent and enchanting.

I never go quite that far, but for a dinner party, I like to dress it up. My table might be covered with a zebra-patterned cloth and set with gold-rimmed plates and delicate gold-flecked Champagne glasses from Murano. On top of each white linen napkin will be a small gift—another gesture I've borrowed from Estée. She would often give women her latest compact or a bottle of perfume. Everyone loves a little present.

Estée was also a firm believer in place cards, with everyone's name written out in beautiful calligraphy. That might be a tradition worth reviving (although no need to bother with calligraphy). If you're having more than six people, place cards make sense. They eliminate that awkward moment when all the guests are waiting for you to tell them where to sit. This way, you can plan it out beforehand and make sure that you seat people together who might like each other.

When I entertain, I want my guests to feel as if they're in their own home. I'll put several decanters of wine on the table, so they're always within reach. I think people are more comfortable when they can help themselves. The main course might be an Indian curry, for example, with all the condiments in bowls. Everyone has to pass things along, and that can get the conversation going.

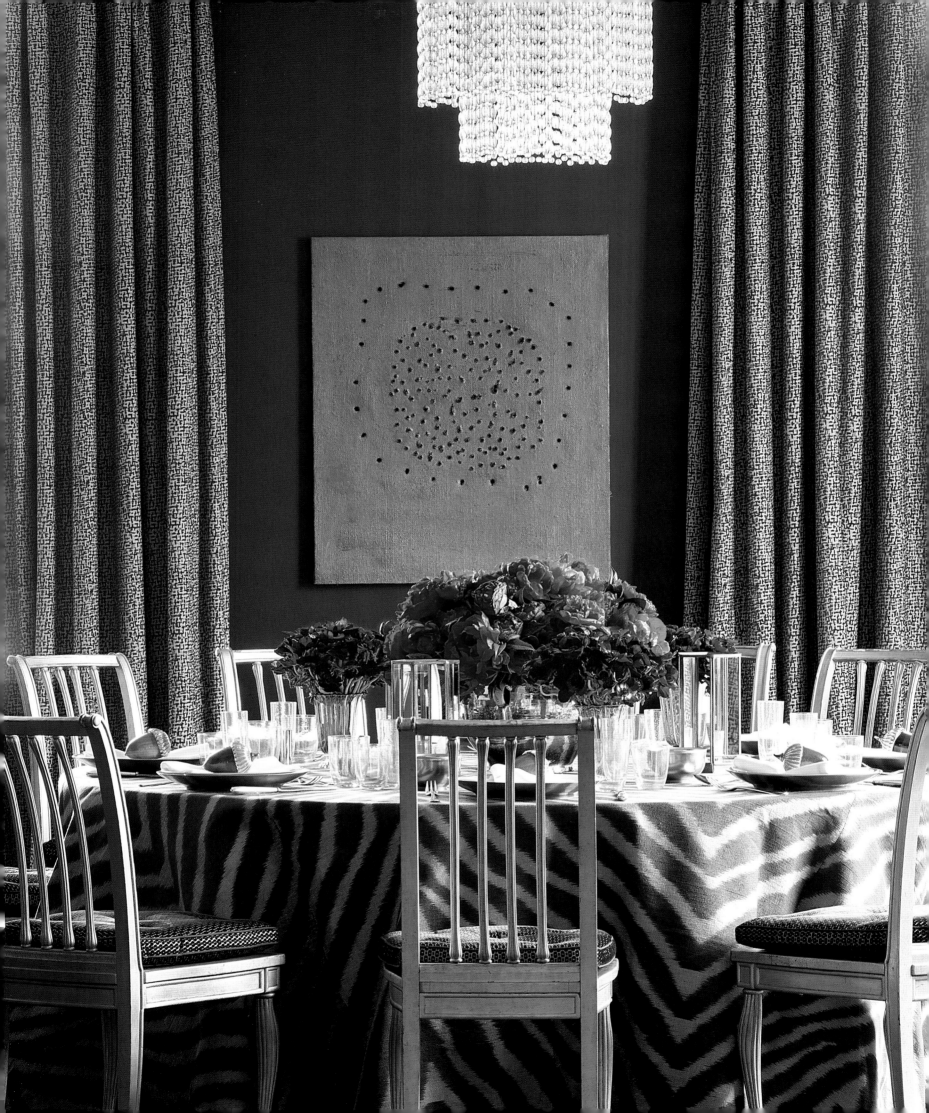

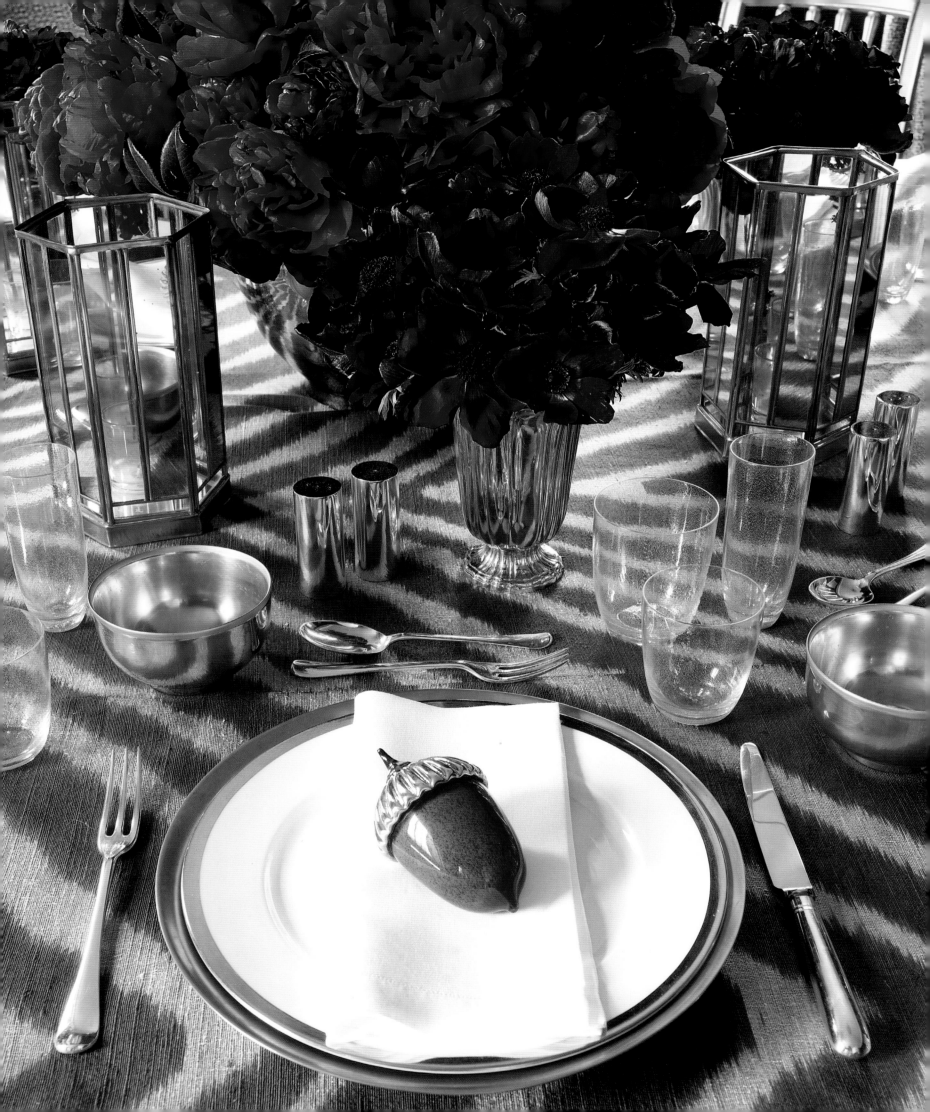

When I'm dressing a table, I like to stay with one or two colors, in flowers as well as everything else. Gold—on the vases, bowls, and plates as well as the hand-blown Murano glasses—acts like a neutral. Then a zebra-patterned linen tablecloth adds an exotic touch. Marble acorns are a little favor for each guest.

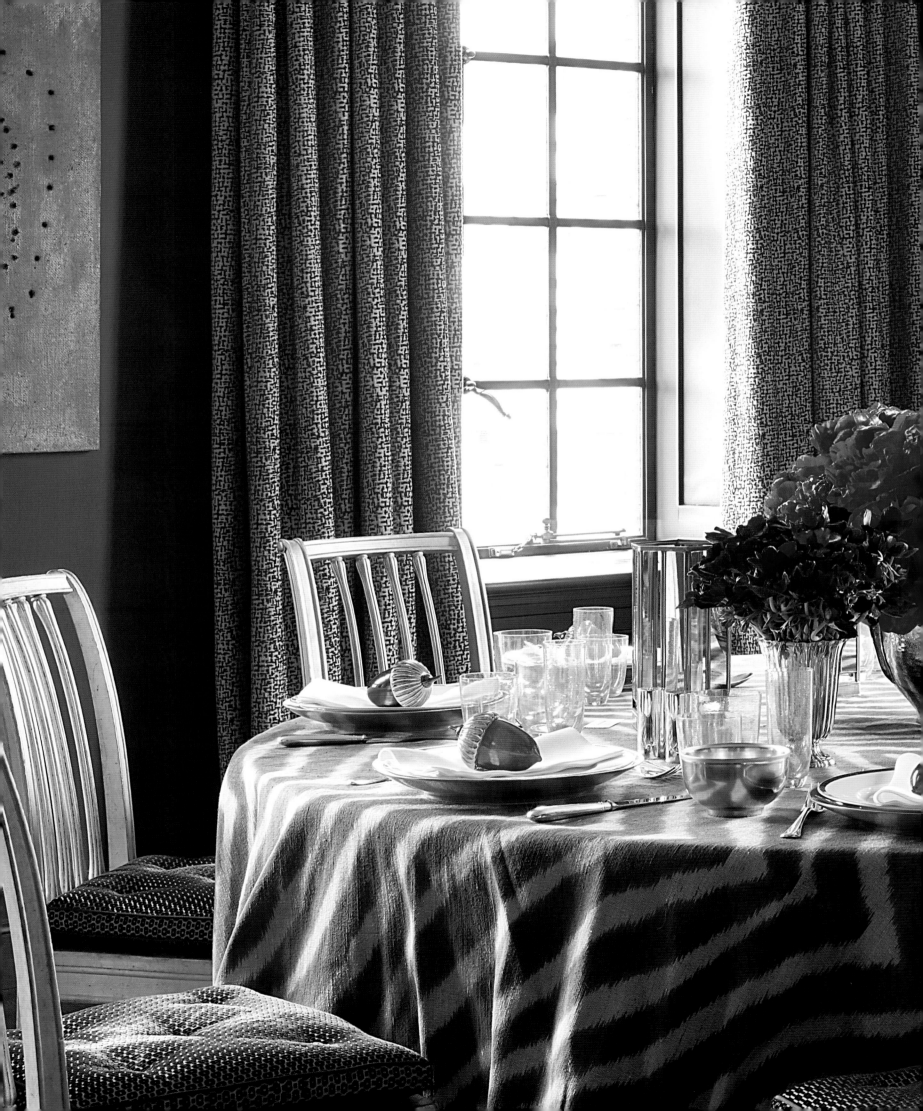

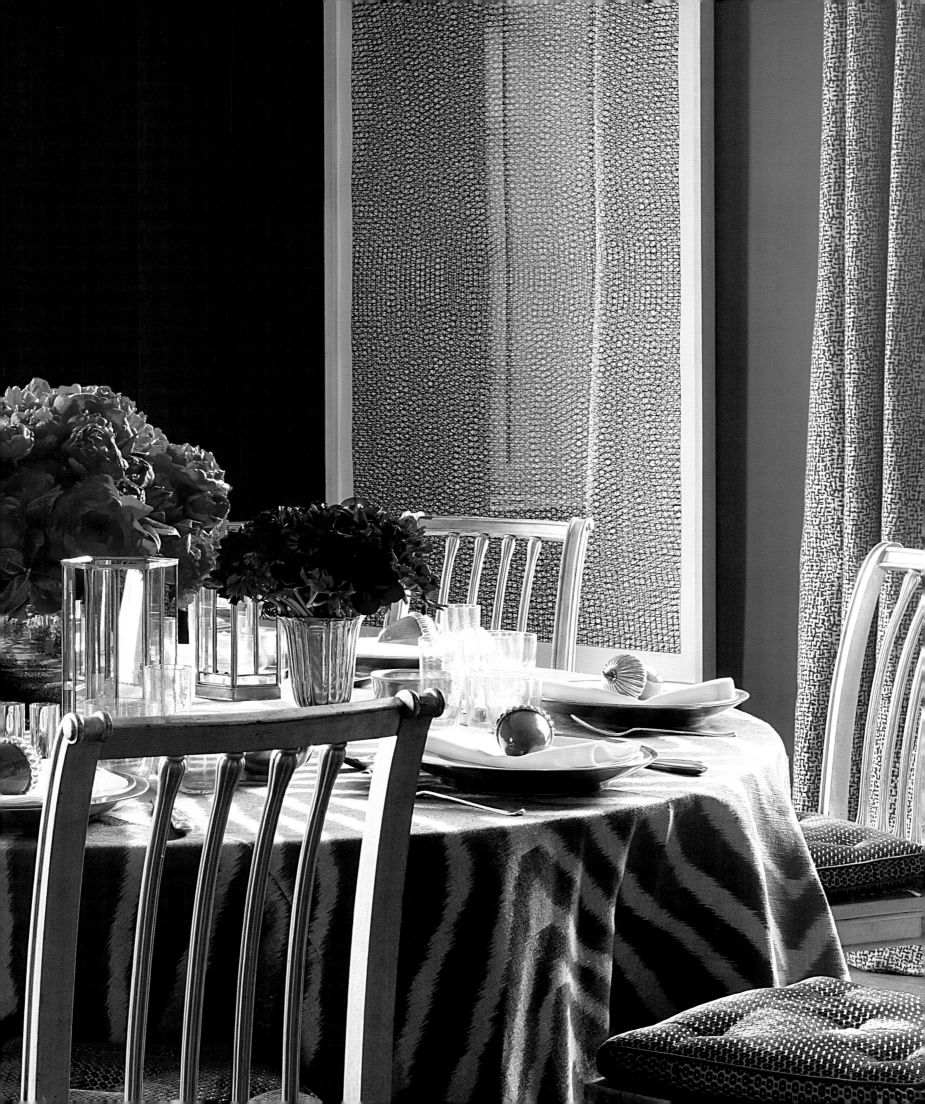

CELEBRATE

Sharing a meal is a great way to relax with friends. But some people simply freeze up at the thought of entertaining. Maybe we should just jettison that word. It can sound intimidating.

The whole trick is to make it easy. Sometimes I'll call people up on the spur of the moment and ask if they want to come over for a drink. If they can't get a babysitter, no problem. Just bring the kids. It's very cozy to sit by the fire with a glass of good wine. I'll put gourmet potato chips in a silver bowl. Who doesn't like potato chips? And Dean & Deluca makes an addictive spicy nut mix—and another one that's equally good, with sundried cherries. While you're shopping, you might as well pick up some good cheese, and make sure three out of the five are soft and runny and definitely *not* healthy. Those taste the best. You could even make a meal out of cheese and a green salad. And if people end up staying forever, you can always order in. Keep it effortless so you can enjoy your company. And then, for special occasions like a birthday or a party, I'll go all out. It's fun to order a personalized cake. This one is frosted to match one of my tablecloths.

My family liked to make a big deal out of holidays. I remember Christmas Eve dinners at my grandmother's townhouse, with Champagne, caviar, roast beef, and her favorite dessert—bûche de Noël. The table was always beautifully set. There would be a fire crackling, and piles of presents, and she would have the Salvation Army come over to sing carols with us. It was warm and generous, and I've tried to re-create that same feeling for my own children. I grew up in houses that were always full of friends and family, and that impulse to bring people together is part of my DNA.

MY STANDBYS

• Easy hors d'oeuvres—frozen pigs in a blanket.
• Macaroni and cheese—what could be more comforting?
• Dinner for two in front of the fire—buy beef stew, put it in a pretty
bowl, and serve it with a delicious red wine and rustic bread.
• Mexican food with margaritas and good tequila with fresh lime.
• And just for fun, set out a few small bowls filled with
Swedish Fish, M&M's, licorice—this is foolproof. Everyone goes
right to the candy.

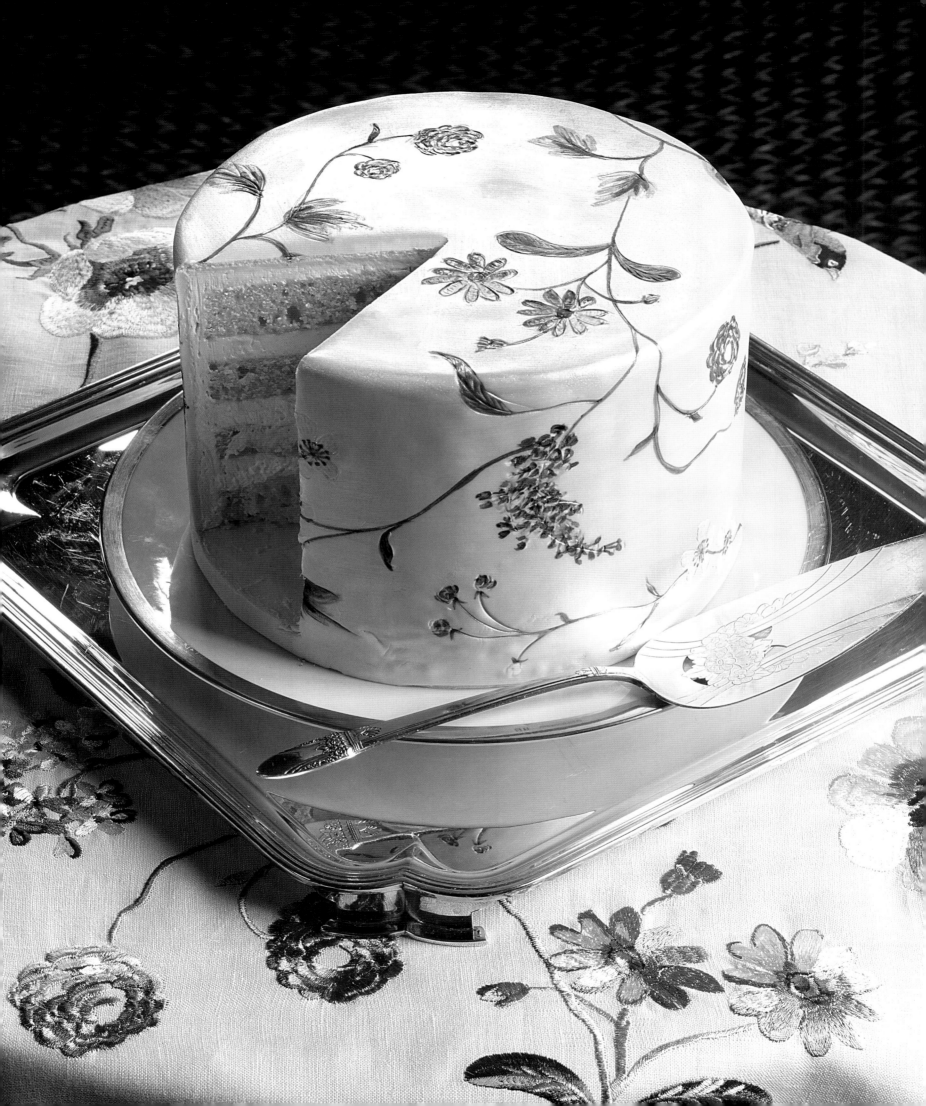

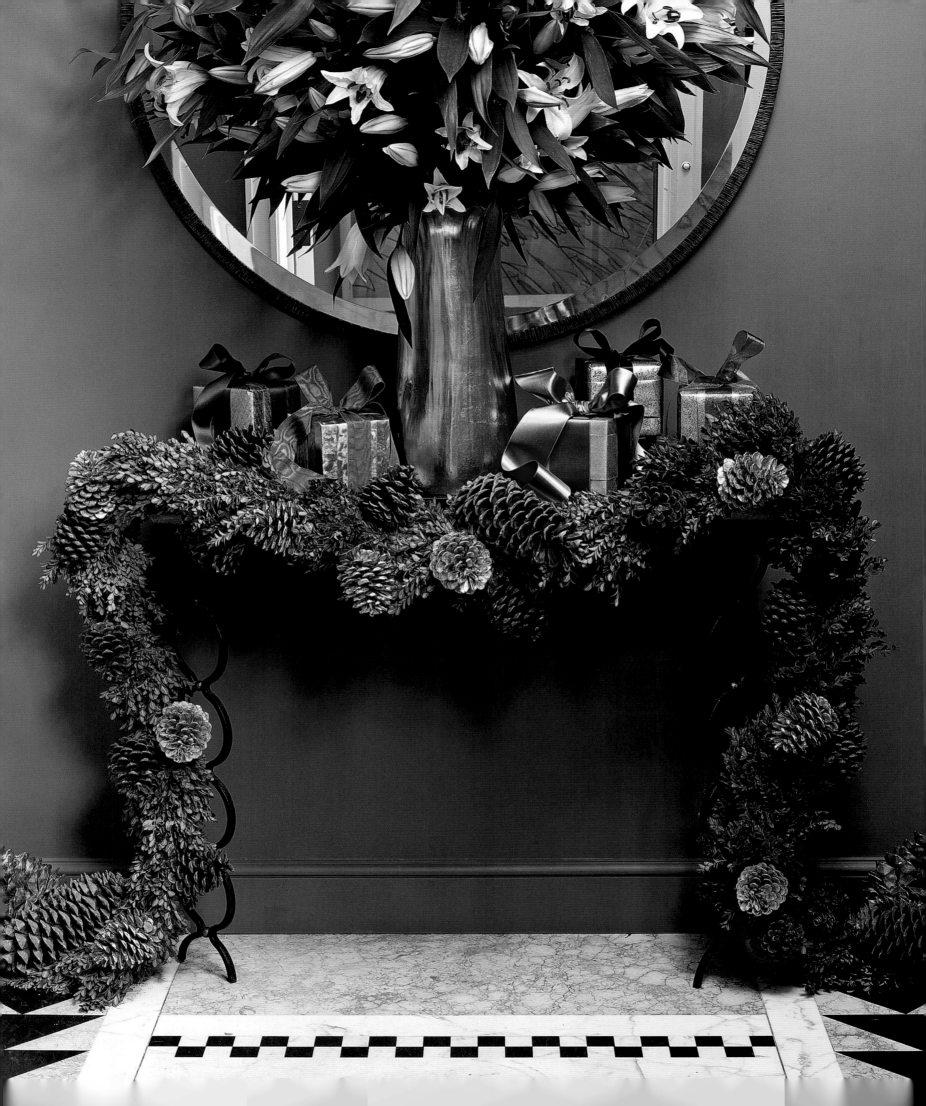

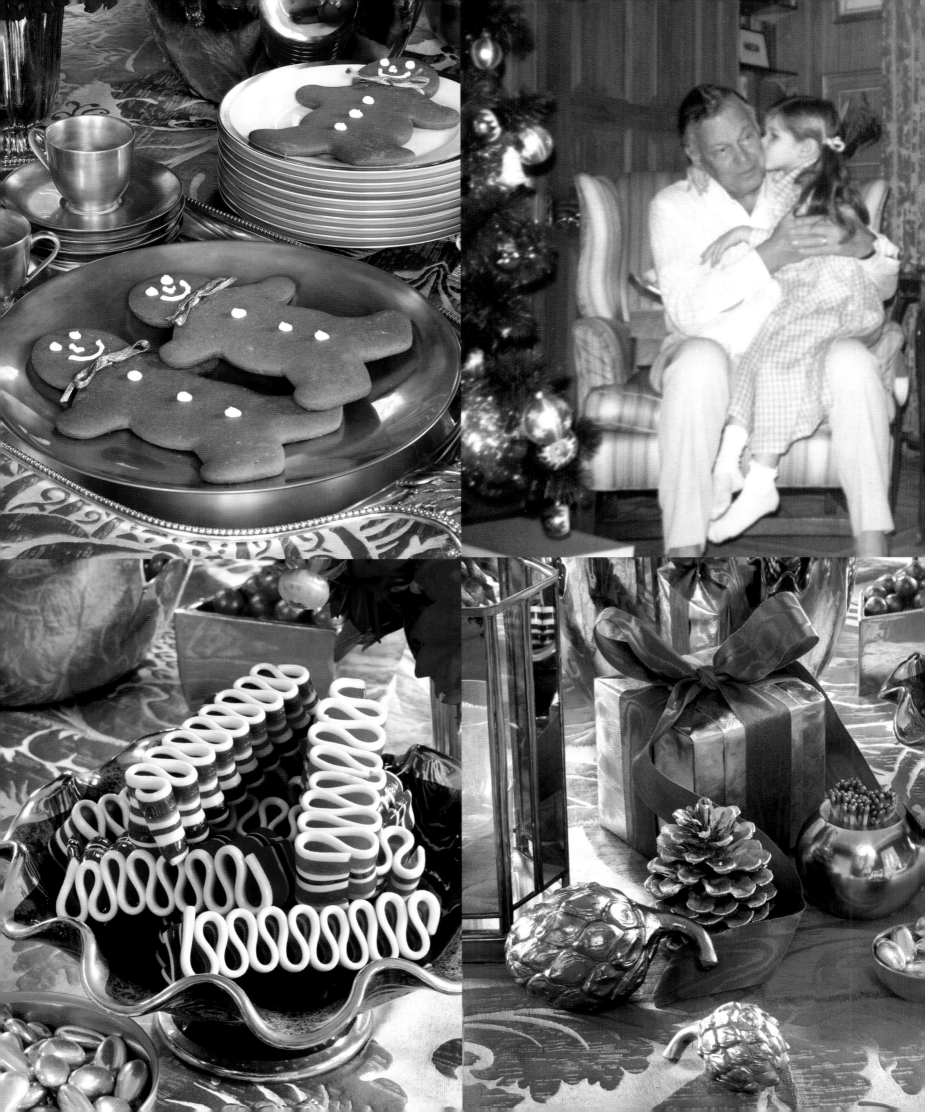

BREAKFAST TIME

We live in our kitchen. The floor, painted bright blue, is the first clue that this is not going to be an ordinary room. On the large marble-topped island, a white ceramic Scottie dog by Jeff Koons holds flowers. And then there's the big comfortable banquette, piled with pillows, that wraps a corner. More chairs surround the antique pedestal table, painted white.

This is where we all hang out and eat most of our meals. For breakfast on Saturdays, the boys can choose what they want—cereal, pancakes, eggs—and I'll serve it in colorful bowls and plates they handpainted themselves, the product of all those New York birthday parties at pottery studios (I loved to get those invitations). More of their artwork decorates the walls, and a shelf holds a revolving selection. (I've noticed you often stop seeing things once they've been up on the wall for a while. That shelf allows me to keep changing things around, so it never gets stale.)

I remember my sister, Jane, at six years old, standing outside of school and holding this enormous brownish-gray thing made of painted paper. "What is that?" I asked. "It's a sperm whale," she announced. It was almost twice her size. And my mother still has it, framed in a big Lucite box.

Art can be as simple as a handwritten note from my son. That, to me, is more precious than any masterpiece. Everywhere you look in my house, you'll see my sons' paintings and drawings. As any great artist will tell you, it's children who make the best art.

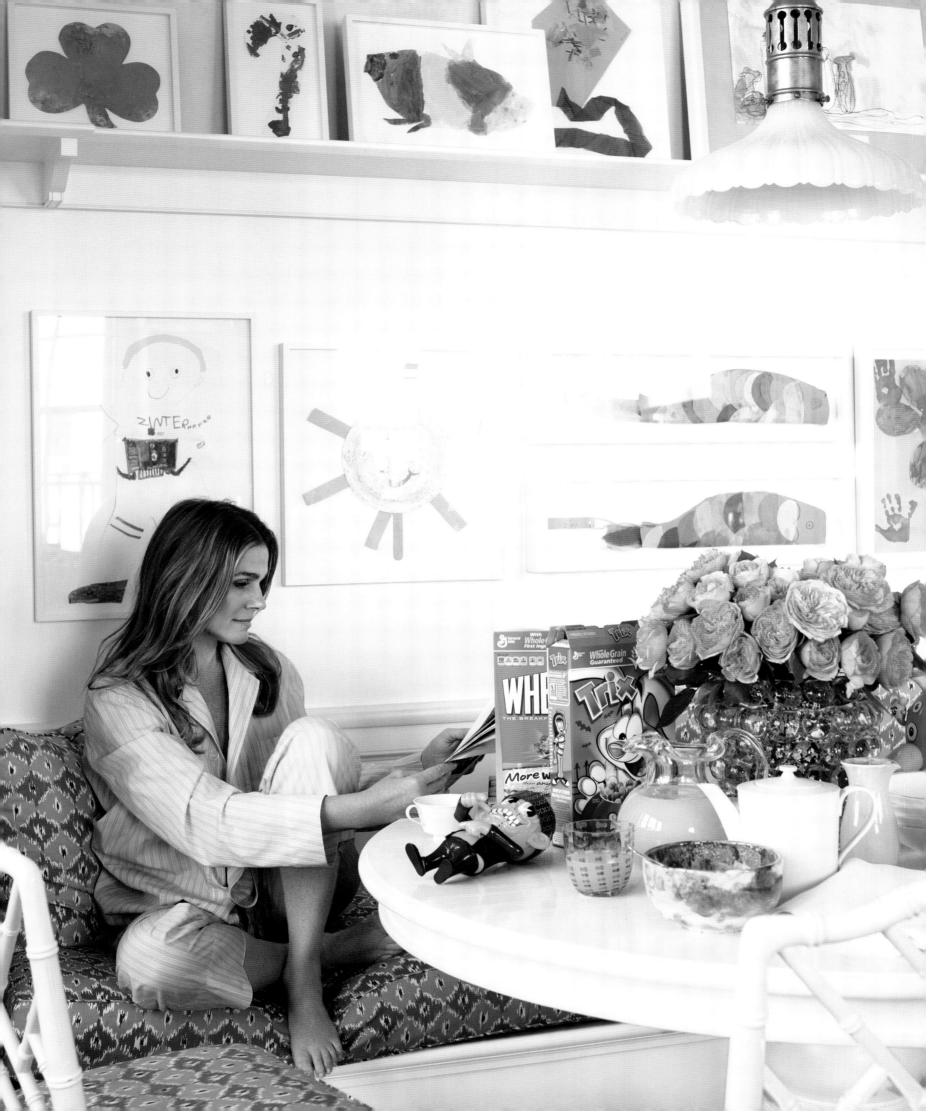

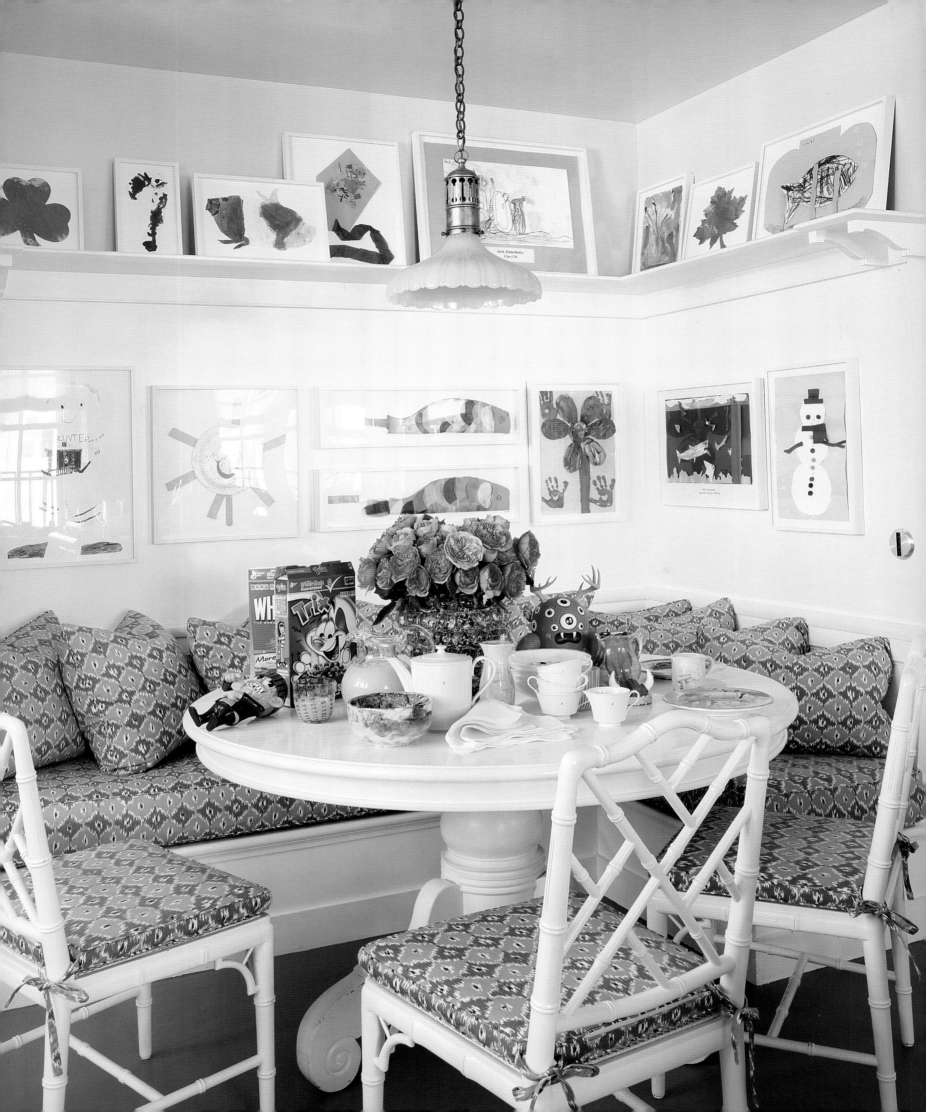

ALL THE BRIGHT,
HAPPY COLORS
GET THE DAY OFF
TO A GOOD START.

Mom used to frame everything we made, and now I'm following her example. It makes children so proud to see their work on display instead of hidden away. I figure if I take my children's work seriously, maybe they will too. And it reinforces the idea that art is not something alien and esoteric. Anyone can make art.

BEAUTY SLEEP

With pale-gray walls and minimal decoration—a plain white bed, white night tables, and just a few photos of the children—our bedroom is very peaceful. It's a calm space, a quiet refuge conducive to sleep—except when the boys jump into bed with us. Or, even worse, jump off the bed. Thank goodness our downstairs neighbors live in Europe part of the year.

There is one eye-catching object—a vintage chandelier that once graced a coffee shop in Vienna. I am passionate about chandeliers. They're glamorous and captivating. Even if you have nothing else in a space, just hang a great chandelier and it will feel special. I have one in practically every room, even in the bathrooms and vestibules. They embody light and shoot it all back to you. I can't resist them, and I keep adding to my collection.

I'm more likely to spend money on a chandelier that I'll keep forever rather than on an evening dress that I'll wear only a few times. I think it's a better investment. . . . I get to look at it every day.

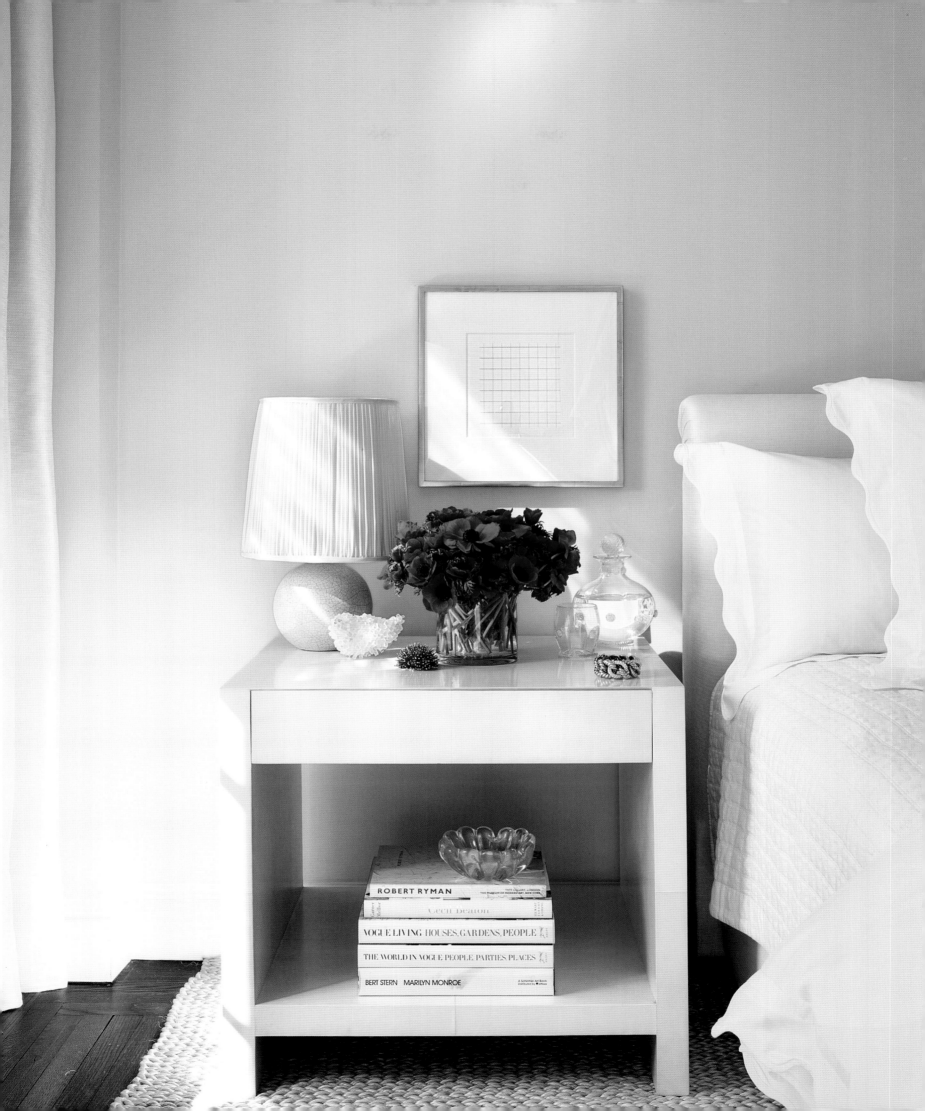

ROBERT RYMAN

Cecil Beaton

VOGUE LIVING HOUSES, GARDENS, PEOPLE

THE WORLD IN VOGUE PEOPLE PARTIES PLACES

BERT STERN MARILYN MONROE

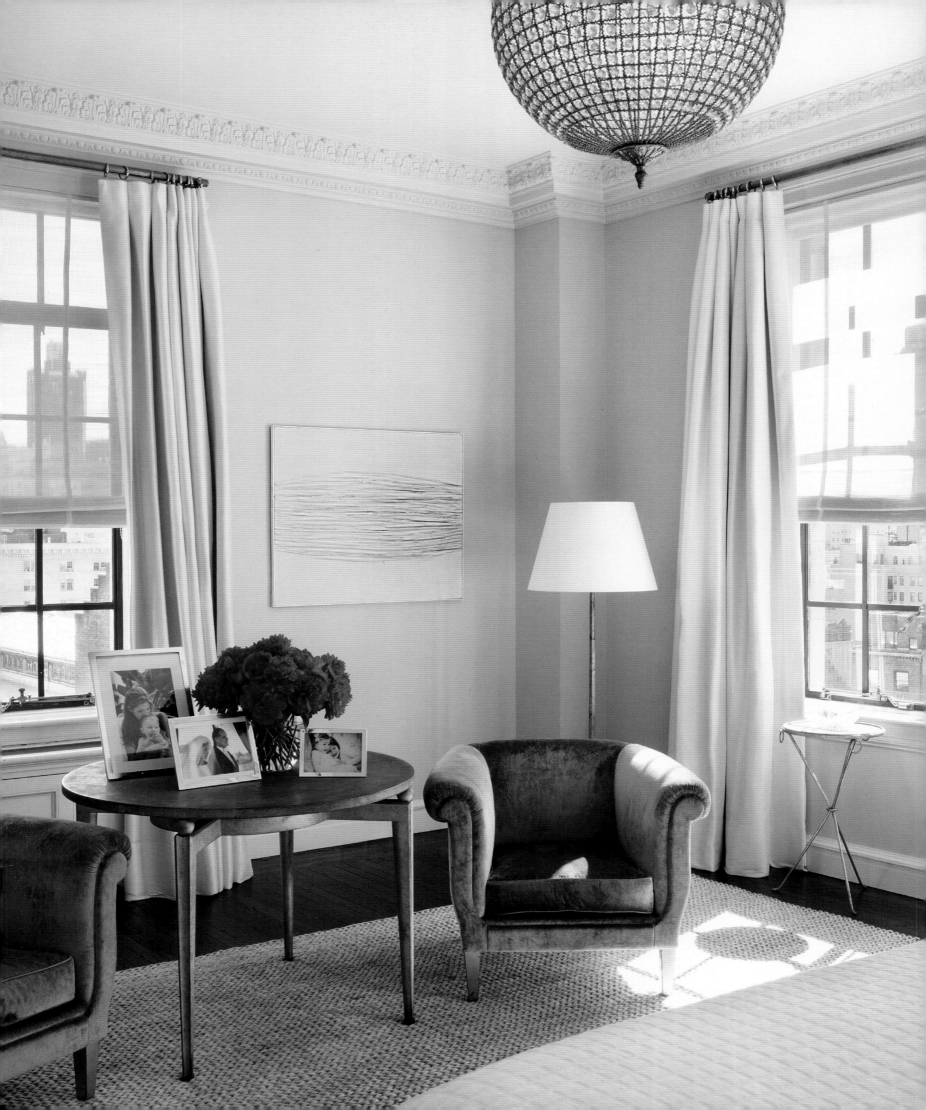

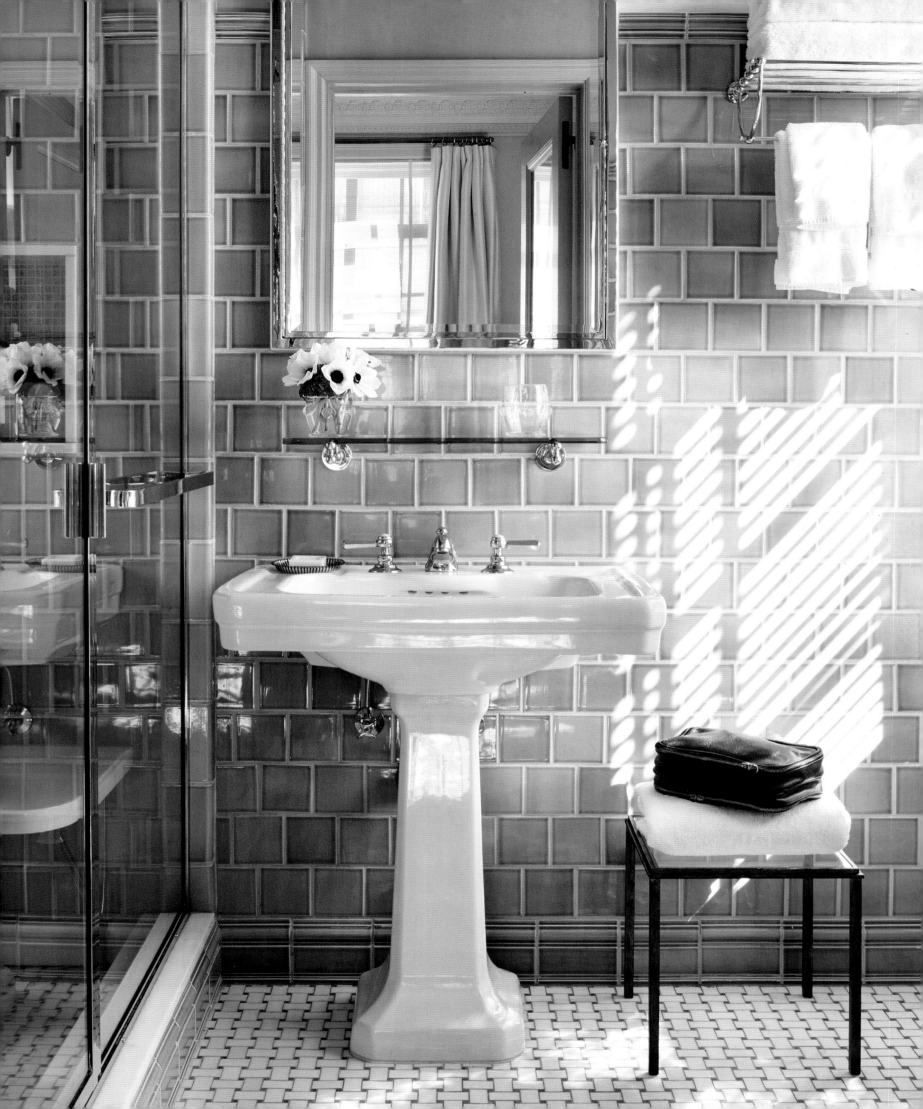

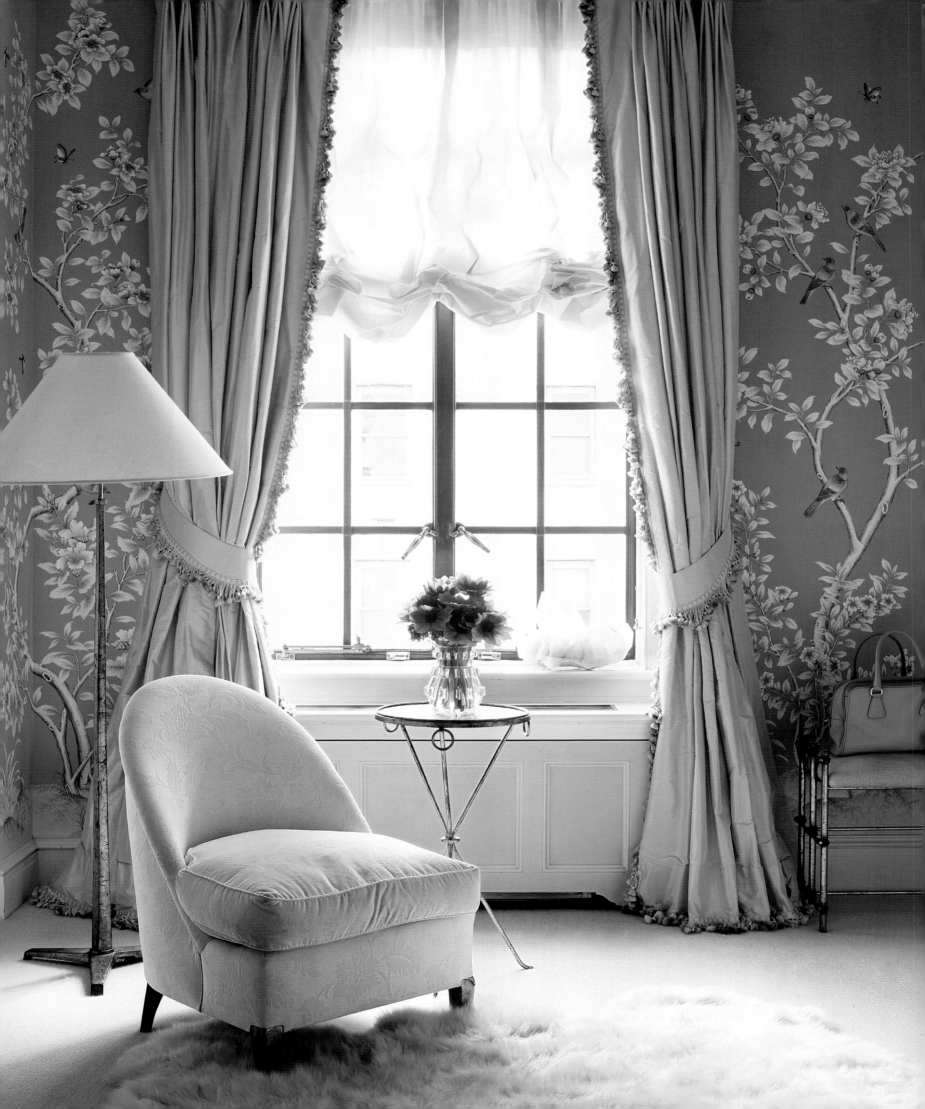

MY ENCHANTED GARDEN

When you're surrounded by boys, sometimes you need a place to retreat. Here in my dressing room, there are no skateboards to trip over or sweaty sports pants tossed on the chair. Instead, it's an ode to femininity.

The walls are covered in handpainted Chinese wallpaper from Gracie, just like my grandmother had. Whenever I walk into the room, I think of Estée. I used to love playing in her closet, pulling on her long gloves and a hat with a veil. Everything was impeccably organized, with all her shoes lined up on shelves. Her evening bags were in one drawer, day bags in another. She always knew exactly where to find things.

I remember that she had a special chaise where she could nap without ruining her hair. She had it done at least once a week. And Estée never went out without makeup. She was always reminding me as a teenager to put on some blush and brush my hair. She also informed me that jeans were inappropriate for travel. She was a woman who believed in dressing up, even for bed. I've got the world's greatest collection of nightgowns and matching bathrobes, thanks to her.

Red was one of her favorite colors. Once, when I was about four, she dressed me in shades of red from head to toe—hair ribbons, dress, socks, shoes—for a walk to the park to get a pretzel. At my graduation from college, she was a vision in a red dress and a red hat with a veil, which she never took off. Thank goodness none of my friends had the nerve to tease me about her. They were too intimidated! She did look kind of amazing.

Fashion has always been a part of my life. My mother loves clothes and so did my grandmother, and I've clearly inherited that gene. When I was fifteen, Estée took me to Paris to see the fashion shows. I sat and watched the models stride down the runway and I was riveted. The imagination, the style, and the workmanship were a revelation to me. We went to Chanel, Givenchy, Ungaro, and Valentino. In between shows, we went shopping and at the Valentino boutique, I picked out a black-and-white tweed jacket that made me feel very French and very grown-up. I still wear it and it has the same effect on me.

I draw ideas and inspiration from fashion. Here in New York, I try to go to as many shows as I can during the Fashion Weeks—Derek Lam, Stella McCartney, Michael Kors, Proenza Schouler, Alexander Wang, Calvin Klein, Donna Karan, Oscar de la

Renta . . . the list goes on and on. I want to see the new directions they're taking and what has influenced their work each season. Clothes are not only a way of expressing yourself but also a designer's way of interpreting what's going on in the world.

As far as my own style, there are certain staples that I wear year after year—a classic white shirt, a great blazer, dark jeans, and ballet flats. Much of my wardrobe is just variations on that theme. And then of course you've got to have a little black dress. These are the basics, and you can update them with accessories that are right on trend—the latest handbag, an eye-catching pair of heels, or a great piece of jewelry.

My grandmother loved big David Webb pieces. I remember standing on my tiptoes beside her at her dressing table and looking at all her bracelets, necklaces, earrings, and cocktail rings. Her summer uniform was a pair of white pants, a tunic top in bright silk or a floral pattern, and a dramatic David Webb pendant—which kind of describes my summer wardrobe as well, come to think of it. White pants became white jeans. Her taste has obviously been imprinted on me. To this day, I respond to strong shapes, luscious colors, and bold patterns—the kind of thing you see in vintage jewelry by Verdura or Seaman Schepps. And I'm still drawn to Lilly Pulitzer and Emilio Pucci clothes, simply because Estée used to wear them and those bright prints bring back so many memories.

The first piece of jewelry that I bought for myself was a heart-shaped diamond locket, made in the 1920s. Certain classics, like a great gold-link bracelet, never go out of style. My favorite piece is probably my gold Cartier tank watch, given to me by my husband to celebrate our first Christmas together. Even if I'm wearing no other jewelry, I feel finished as soon as I put it on. It's elegant and looks just as good now as it did eighteen years ago.

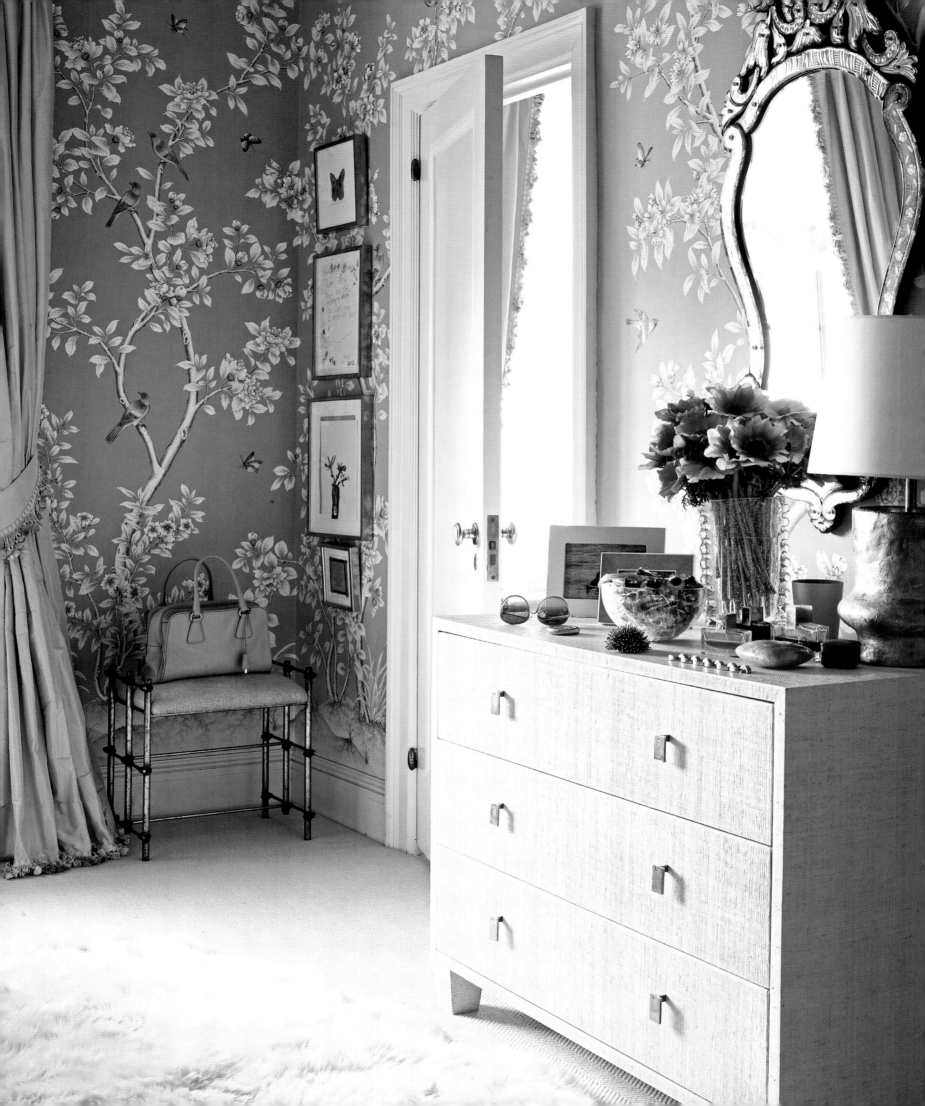

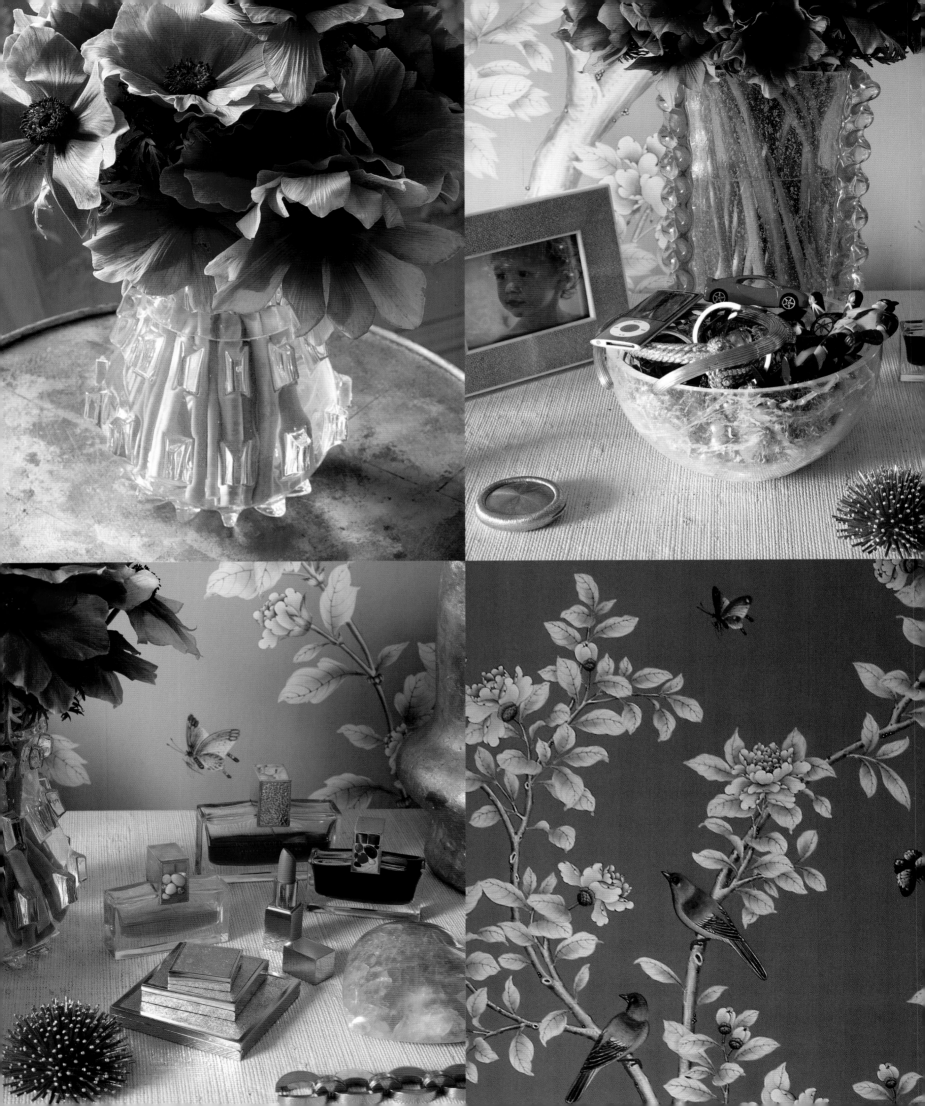

Estée used to say that you smell a fragrance with your eyes, as well as your nose. That's why the design of her perfume bottles was just as important to her as the scent inside them.

When the creative team at Estée Lauder and I were working on a new fragrance—Tuberose Gardenia—for Private Collection, the designer came up with a stunning design. The cap on the bottle would be inset with semiprecious stones, modeled after a Josef Hoffmann pin in my father's collection at the Neue Galerie. I thought it was a brilliant idea. But in the meeting to go over the stones—jade, lapis, agate, mother-of-pearl—some of my colleagues were reluctant. They said, "Well, you know it's not going to be consistent. Because these are real stones, some will be smaller and some will be larger, and the colors will vary."

And I said, "That's what makes it so beautiful." Each bottle is unique.

Everyone needs a place for personal things. Mine is my top dresser drawer. It's filled with jewelry, checkbooks, my iPod Touch, and tons of mementoes that mean something only to me—notes from my grandmother, ribbons found in a little shop in Athens, red lacquer boxes given to me by the manager of our Estée Lauder store in China. A rock-crystal bowl holds little toys that my boys loved and have since outgrown. . . . I can't bear to throw them away. Then there's a vintage compact made of brushed gold that my father gave me one year for Christmas. It inspired the design of my entire beauty line.

Memory is such a strong and powerful thing. It carries so much emotion. Sometimes you can hold on to people through their possessions. I open that drawer or just walk into this room, and all those memories come flooding back to me.

BOYS BOYS BOYS

Children have so little power in so many areas of their lives. We tell them what to eat, what to wear, when to go to sleep. That's why I like to give them some real power in one area—their rooms. Here, they should be totally free to express themselves. Let them pick out the color of the paint on the walls. I'll admit it. This can backfire on you. My son Jack wanted a red bedroom and I thought, Great! That's a bold choice.

This turned out to be one of my biggest decorating mistakes. The room felt frantic—not good for a seven-year-old boy. We kept the ultramarine-blue furniture, with red trim, but quickly repainted the walls in a more calming color—white. He is a baseball fan, so we framed an autographed New York Yankees jersey and put it over his bed.

My other son, Will, loves the ocean, so his room is blue. He's into surfing and skiing and snowboarding. We blew up a photograph of him surfing in Montauk and hung that on his wall. He's always taking things apart, so there are usually some screwdrivers, along with plastic art figurines from Kid Robot, on his desk. And you can't go wrong with bunk beds and a beanbag chair—they're classics.

Children are natural collectors—they acquire stickers, baseball cards, Matchbox cars, robots . . . and they don't want to give any up. How many sets of LEGOS does one child need? Let's face it. They're serious hoarders.

I've developed a few strategies for containing all this stuff. Desks with cubbies or multiple drawers are a good solution. Big bins with labels in the boys' closets also help keep things organized. Also, containers, baskets, furniture with drawers . . . whatever it takes to create some order.

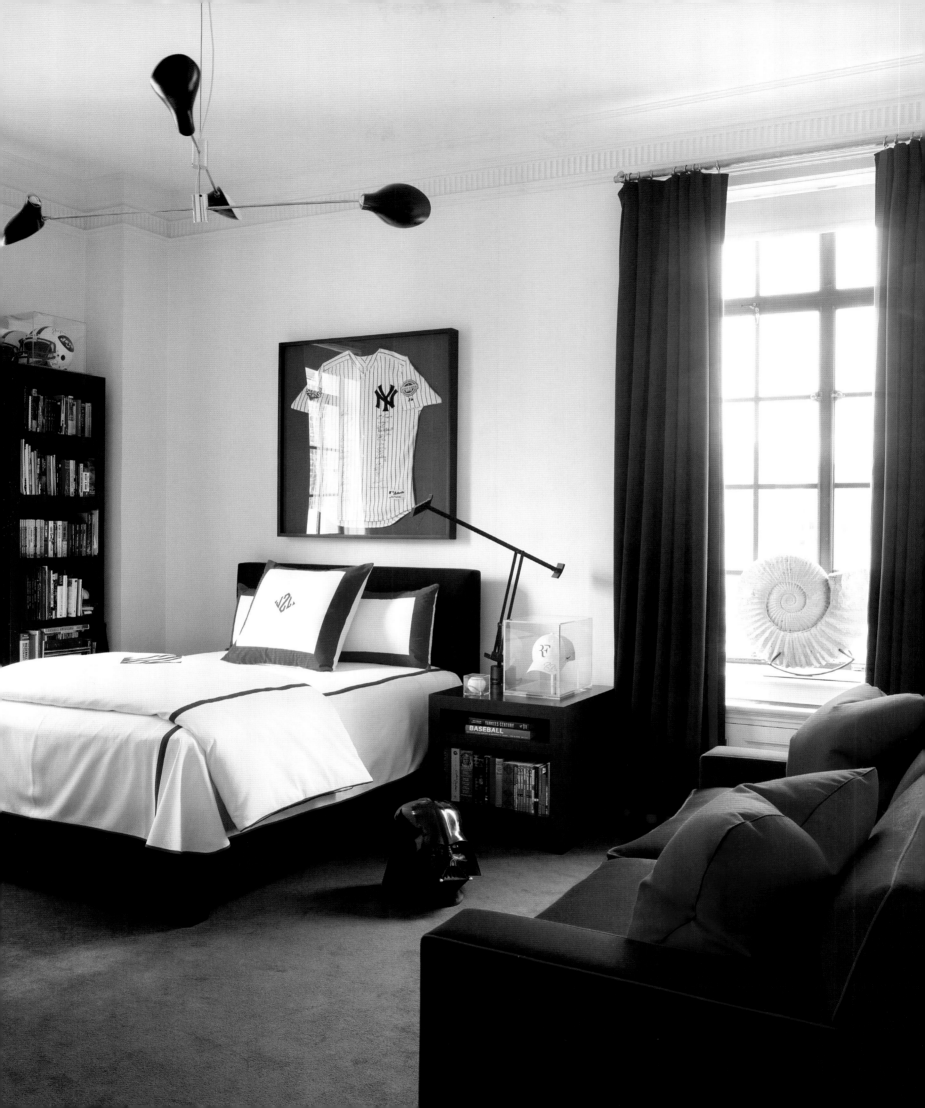

I loved doing my sons' rooms. Now I wish I had more to do, but I'm sure we'll be repainting and redecorating as they get older. People evolve, and rooms should too. I feel as if I'll never be completely finished.

SATURDAY

It's Saturday morning, and where am I? In a comfy chair, having a leisurely cup of coffee with the newspaper? No. I'm out on the street, waiting to put the boys on the bus to baseball practice on Randall's Island. Or, if I'm even luckier, one of them has a game, and I'm sitting watching a doubleheader for hours and hours. Me, and all the dads. (Eric does many sports with Will and Jack, but he does not like baseball. So that falls to me.)

Then, when we get home, one son wants to go to a movie and the other asks if he can have a few friends over to play. Next thing I know, I've got five little boys in swooshy pants—those polyester athletic pants with the Nike swoosh that my sons would wear all the time if I let them—and we're all going to Shake Shack, a hamburger joint, for lunch. We walk in and I get in line to order hamburgers, French fries, and milk shakes while the boys try to find some seats. They run into a friend from school and end up squeezing in with him, but there's no room for me at the table. So I eat my hamburger with utter strangers and then gather up the troops.

I have to say I love boys. I never had a brother. I did not have tons of male friends because I went to an all-girls school for more than half my life and was quite sheltered growing up. My two sons have taught me so much. They are innocent. They love their mom and dad. They hate to brush their teeth. They don't care about crinkled homework. They can watch ESPN for hours. They prefer to run instead of walk. . . .

A few years ago, Eric and I took Will and Jack on a trip to Europe. We wanted to introduce them to Rome, Venice, and Vienna. Every night, I would tuck them into bed in the hotel room. I always gave their room a last look before we checked out, and I noticed one thing: they had never unwrapped the soap!

I am constantly fascinated, mystified, and surprised by my two sons, and I'm sure they would say the same about me.

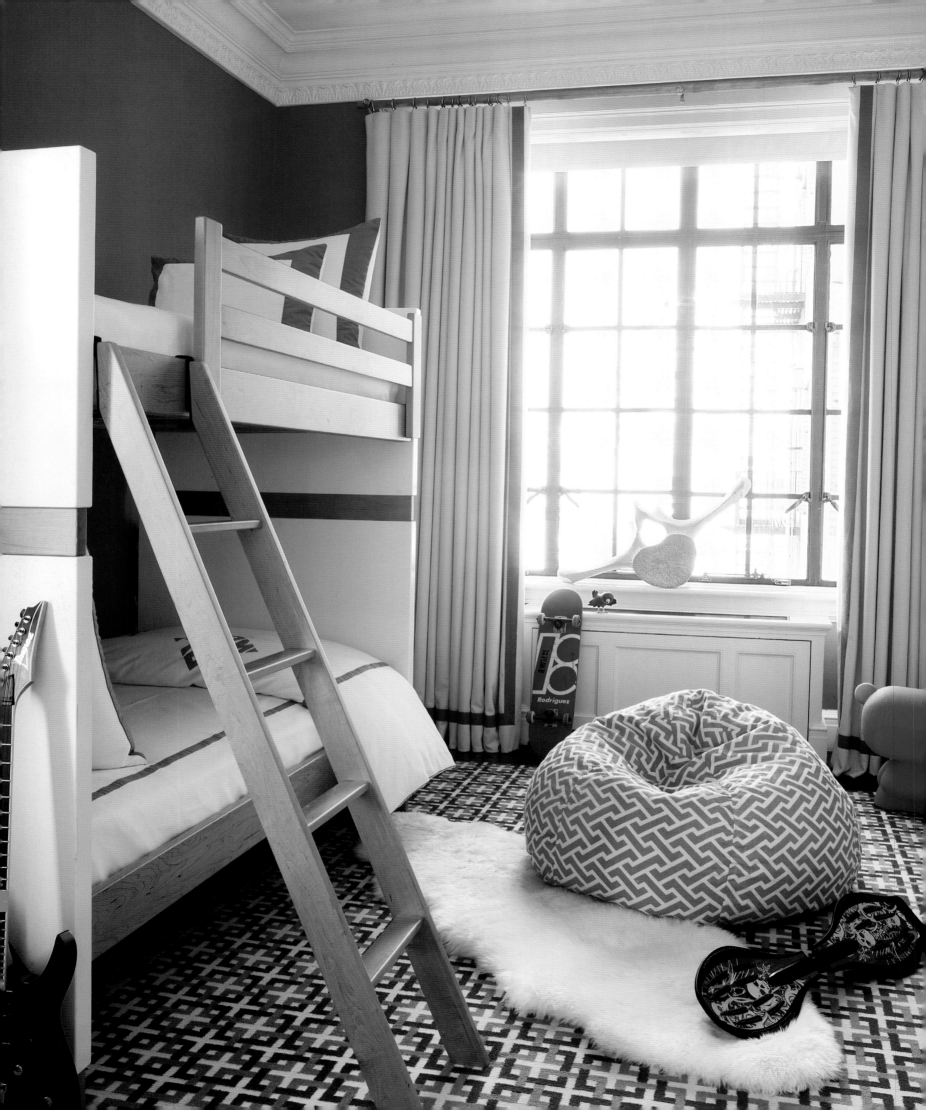

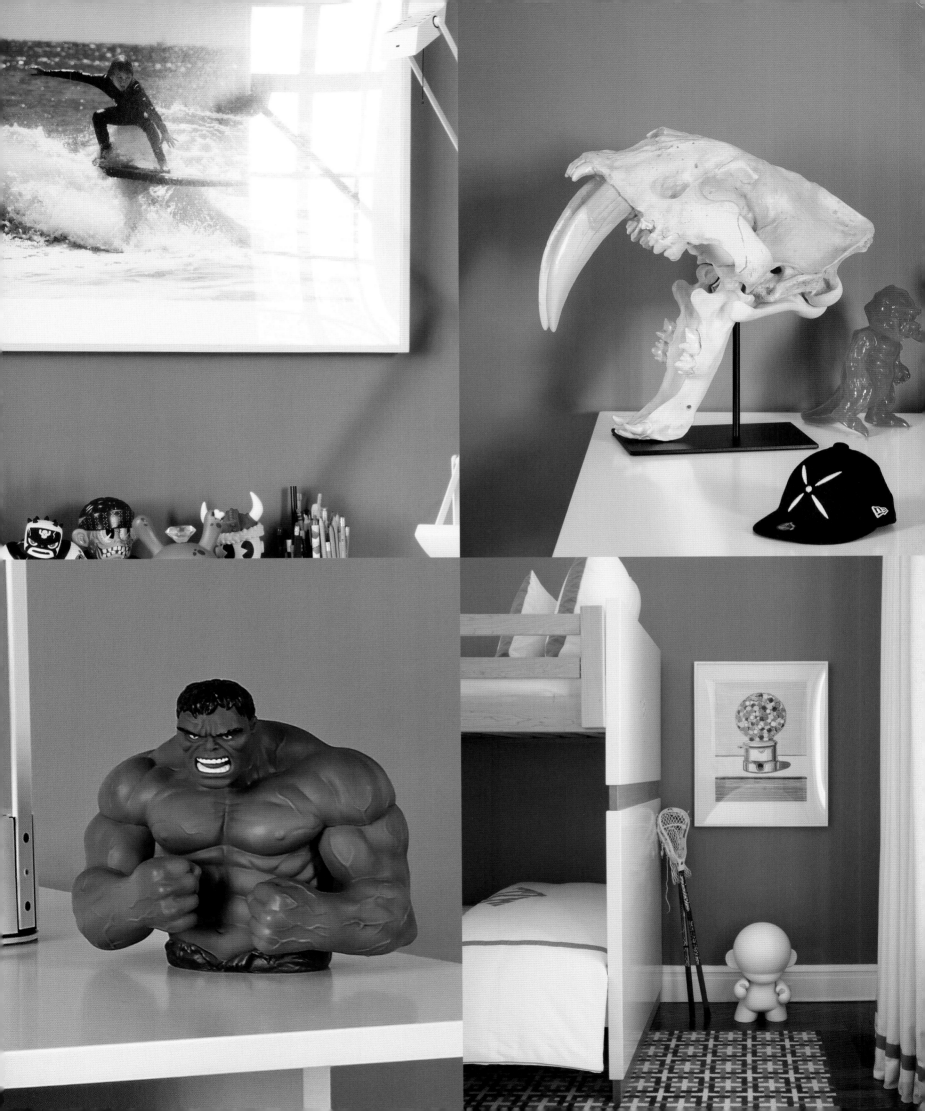

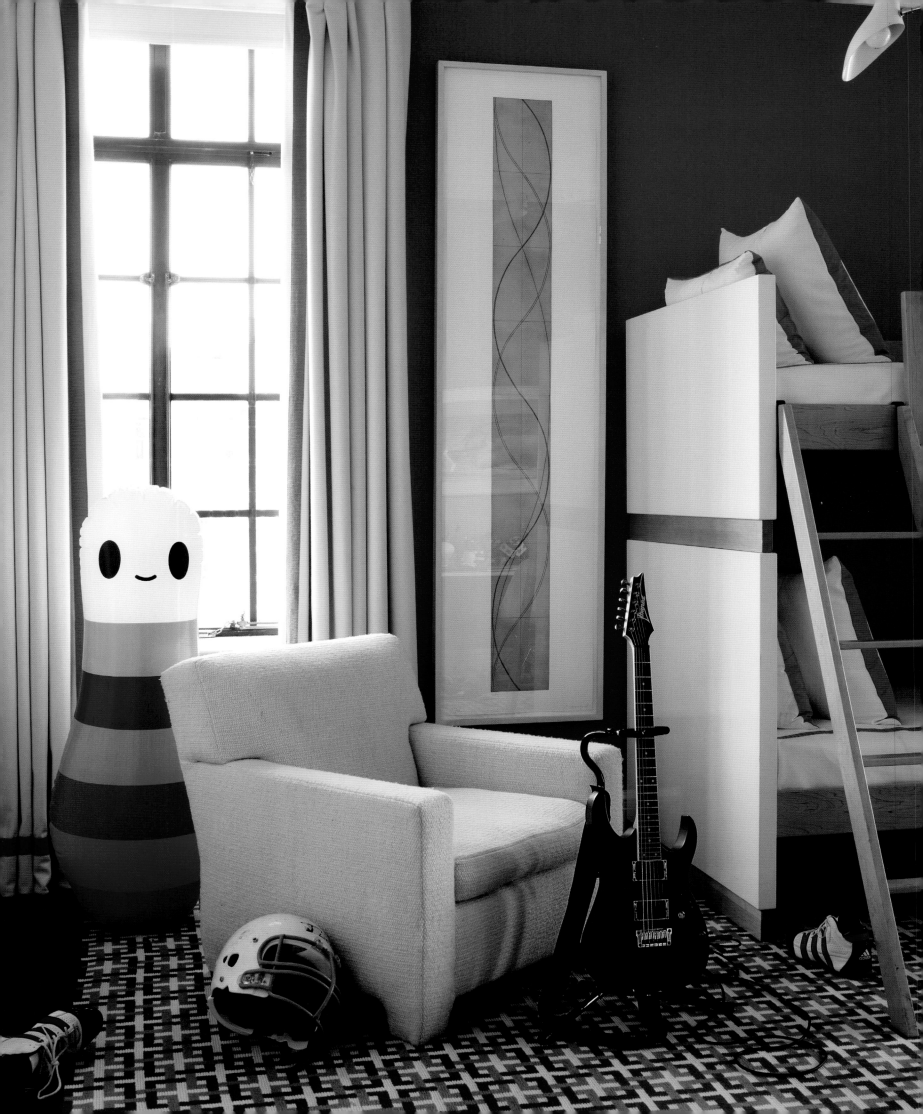

As my mother said, "You only have one chance to be a good mother. Try your hardest." No one wants to come home after a long day and do **Wordly Wise** vocabulary words, but my sons appreciate it, so I quiz them. Eric loves to read aloud to them from the books that were his favorites as a child. Parenting is about one generation giving to the next. You replicate the traditions you grew up with and create some of your own.

WORK

I still get a thrill every time I walk into the office and see the American flags waving just outside my window and all those skyscrapers lining the streets. It's one of those quintessential Manhattan views, the kind you'd see in old Hollywood movies about young women in the big city, like *Breakfast at Tiffany's, How to Marry a Millionaire,* and *The Best of Everything.* I'm right in the heart of New York, with all this energy around me.

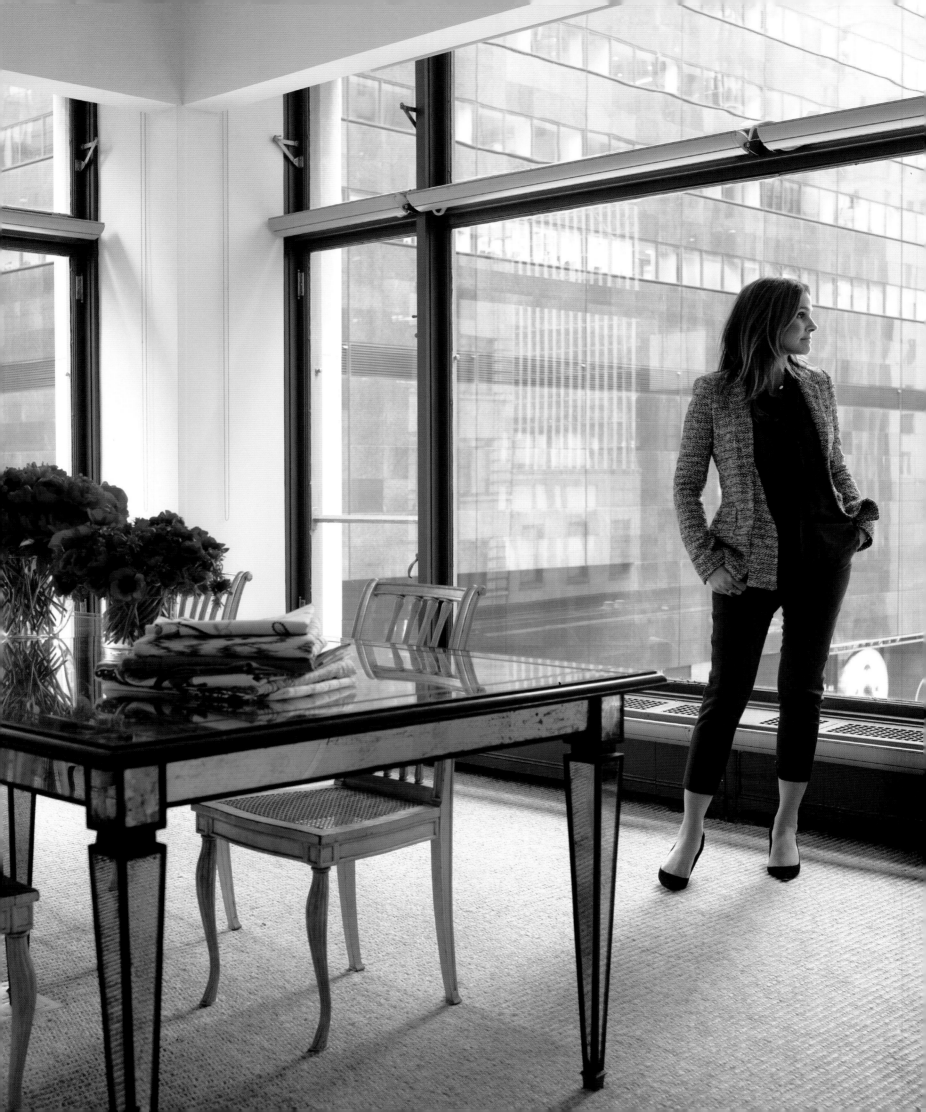

It's a good setting for a new challenge. When I decided to launch my own line of makeup—plus a few other products I can't live without—my father reminded me that Estée was about the same age as me when she started out. It's a little daunting to follow in her footsteps, but there's also a nice continuity. I have the benefit of her knowledge and experience as well as my own. I've grown up in the beauty business and I know exactly what I need, and hope other women want: mistake-proof makeup. Simple, uncomplicated. Just the essentials—a sheer foundation, an illuminating bronzer, lip and cheek cream with a subtle blush of color, a rose-scented lip conditioner, hand and body moisturizer—you can put it on almost without thinking and get on with your day.

When I went looking for an office for my new company, it had to be within a certain range of the Estée Lauder corporate headquarters in the General Motors Building. I'm still very involved with Estée Lauder as Style and Image Director, and wanted to be able to run back and forth easily. A space just a few blocks away in the Fuller Building sounded tempting. It's an Art Deco gem, and many of the floors were specifically designed for art galleries, with large windows and high ceilings. But when I first walked in, walls up against the windows were blocking the view. It didn't matter. I fell in love with the space instantly. I knew that once the walls came down, it would be light and airy and perfect.

I think an office should feel inviting. Over the past year or two, I'd been collecting various things that I loved—furniture, art, swatches of possible fabrics—for the space. Then I brought in Jacques Grange to help me put it all together. After working on my apartment with me, he knows what I want almost intuitively.

In the center of the main room are two sofas, back-to-back, underneath a crystal chandelier—an arrangement that announces to visitors, as soon as they walk in, that this is not going to be the typical office environment. Instead of covering the sofas in one of those innocuous institutional fabrics, we upholstered them in lushly patterned velvet in a mossy shade of green, with a blue floral design. It's classic, with a twist . . . sort of Old World, but the colors are definitely not. And the coffee table is just as vivid, with azure blue and white tile for a top. The mix of color and pattern is unexpected, and that's what makes it fun. I have a habit of fluffing up the throw pillows—another splash of pattern in bluey greens and white—because this is where we like to sprawl out and talk. There are a couple of comfortable Art Deco chairs nearby, upholstered in a nubby white tweed that shows off their shape. We can have an impromptu conference here without formally sitting down at a conference table. Although my conference table is not exactly formal. . . .

Estée loved coming into the office every day. And she taught me another very important lesson: since you spend so much time in your office, why not try to make it as comfortable and appealing as it can possibly be?

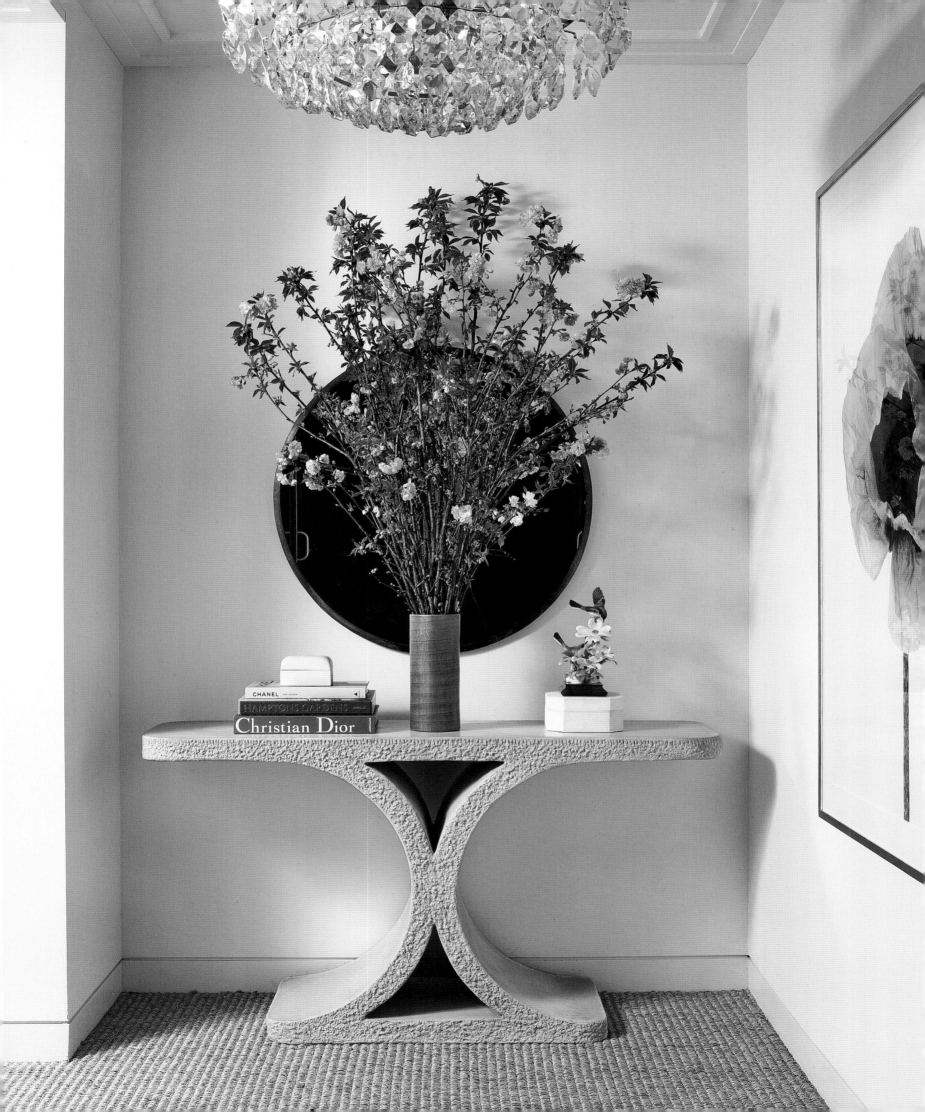

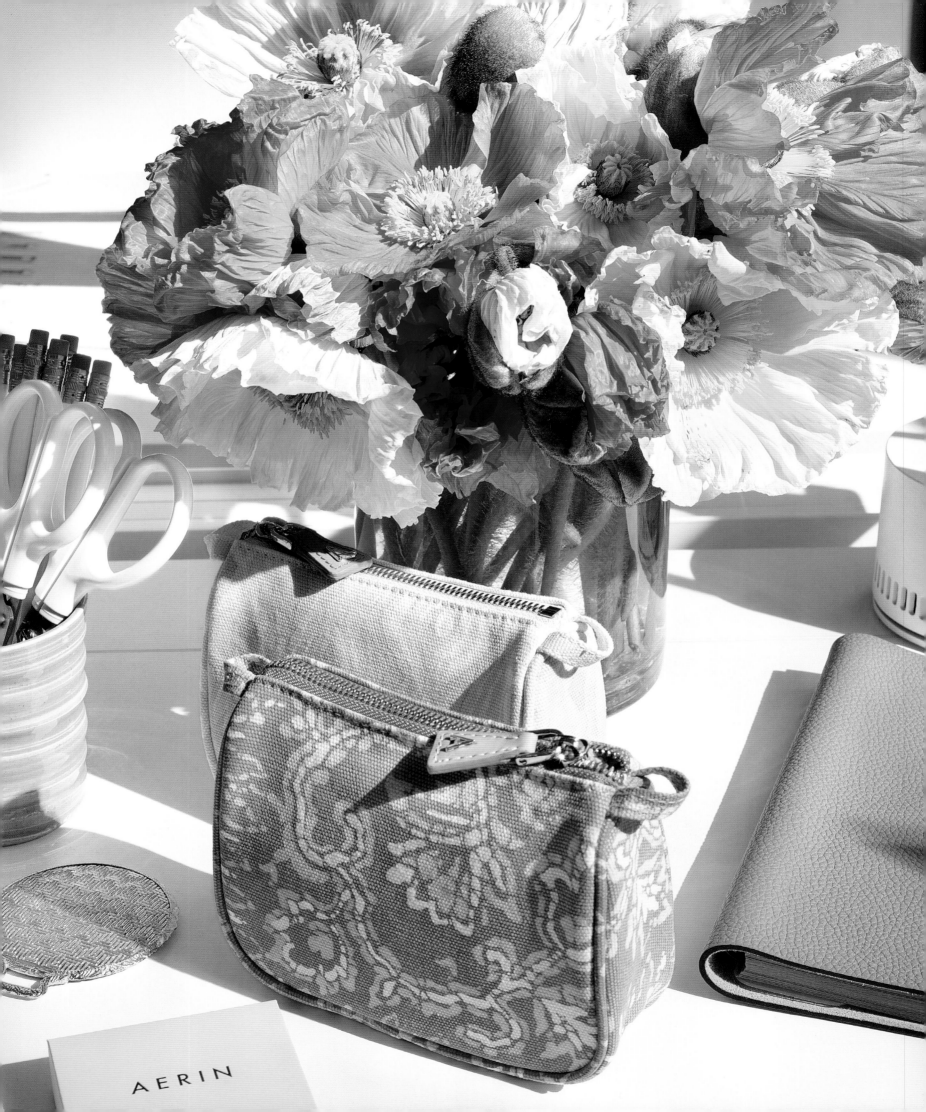

Instead of a serious mahogany furniture suite, a mirrored dining table designed by Karl Springer in the 1950s anchors my conference room. Some people would think, That's crazy. But I find it beautiful. Feminine and fanciful, it adds a touch of Hollywood glamour to the office. You could also consider it my homage to Estée, who loved smoky mirror. Once again, she was right about its magical properties. I like to present my latest products on this table because it makes anything instantly look better.

A long, low sideboard by André Arbus, finished in alluring gold leaf—very French, 1940s—gleams against one wall. Above it hangs a painting by Helen Frankenthaler. I was at Art Basel in Miami when I spotted a different painting she had done. Back in New York, I went to the gallery that had shown it and walked out with this instead. Love at first sight.

In a way, it represents what I want my brand to be—luxurious, modern, and with an element of surprise. The surprise of the painting is that it's done on wood. I adore the rich, vibrant colors. It says a lot about me.

Some of my art isn't hung at all; it's just propped against a wall. I like that more casual look. I can move it, change it, pull a different piece out in front. It feels almost like a gallery. There are a lot of pure-white walls and a lot of empty space, and that's deliberate. I want our thoughts and ideas to fill it, and there's no room for that if every square inch is cluttered with furniture and every bit of wall is covered with pictures.

Jacques and I were very restrained. Only a few well-chosen pieces appear, with enough room around them so they can breathe. Everyone's life is already cluttered and our minds are so crammed that there's something very peaceful about having a little emptiness.

On the floor, sisal again—my favorite. I use it in my home, so why not here?

Art books are set out in the waiting area, instead of the usual stacks of magazines. They're more tempting and evocative, and immediately set a different tone, as if you're browsing through someone's library. The books feel more personal, and so does the furniture.

Classic or quirky, there's no question that each piece has personality. If you've got a lamp or a chair that no longer fits into your home, you could try bringing them into the office. The Bagues chandelier in the main room used to hang in my front hallway. And I found a place for other hand-me-downs, like a couple of Estée's old chairs. They used to be painted a dull green. I had them gold-leafed, and now they look much younger.

Why can't an elaborately carved and gilded eighteenth-century French mirror (that used to hang in Estée's dining room) coexist with a contemporary blue-tiled coffee table? Both have great shape and style. But it's the contrast that makes you look at them in a new way.

The design studio feels clean and white and bright. It's one big room where we all work side by side, at long white tables. There are no cubicles. How can you expect people to think outside the box if they're boxed in?

Also, I want to be right in the center of the creative process rather than off in a separate office. I like the spontaneous conversations that occur when everyone can see what everyone else is doing. It leads to all kinds of collaborations. One idea sparks another.

We also installed a small kitchen. I'm always ordering food for the office (it's the mother in me). I like to keep a selection of snacks on hand—fruit and nuts, candy and cookies, a bit of chocolate. . . . You have to feed creativity!

I'm constantly inspired, challenged, and energized by art, so of course I've hung some pieces in the studio—like the dazzling flower images by photographer Paul Lange. My favorite florist, Zezé, put me on to his work. I love the huge scale and the saturated colors. It's a contemporary version of the great Irving Penn's flower portraits.

Fabric swatches and photos pulled from books and magazines are tacked up on inspiration boards. We're currently working on a new line of fabrics for Lee Jofa, picking out various designs from their archives to play with. We might change the color or the proportions and rescale the pattern to make it feel more modern. It's actually similar to what I've done at Estée Lauder for years, exploring our archives and retrieving certain elements—like an unfinished perfume formula or a great package design—and reinventing them for today. The fabric on the AERIN makeup bag happens to be a vintage pattern that we found and tweaked, to get just the right shade of pink.

A long, low, wall-to-wall cabinet is spread with prototypes of china for Lenox and other works in progress—picture frames, paperweights, place mats, suede coasters, quartz wine stoppers, hairbrushes, combs, soap dishes, sun hats. The modern woman wants more than just makeup, so we're creating products for the desk, the dining room, the vanity, and the closet. The concept, in two words, is everyday elegance. These are decorative accessories that you can use all the time to add a little lift to your surroundings.

Everything is constantly being critiqued and refined. Now it's my name on the door and on the products. It's exhilarating, but it's also a big responsibility. I'm committed to making everything the best it can possibly be.

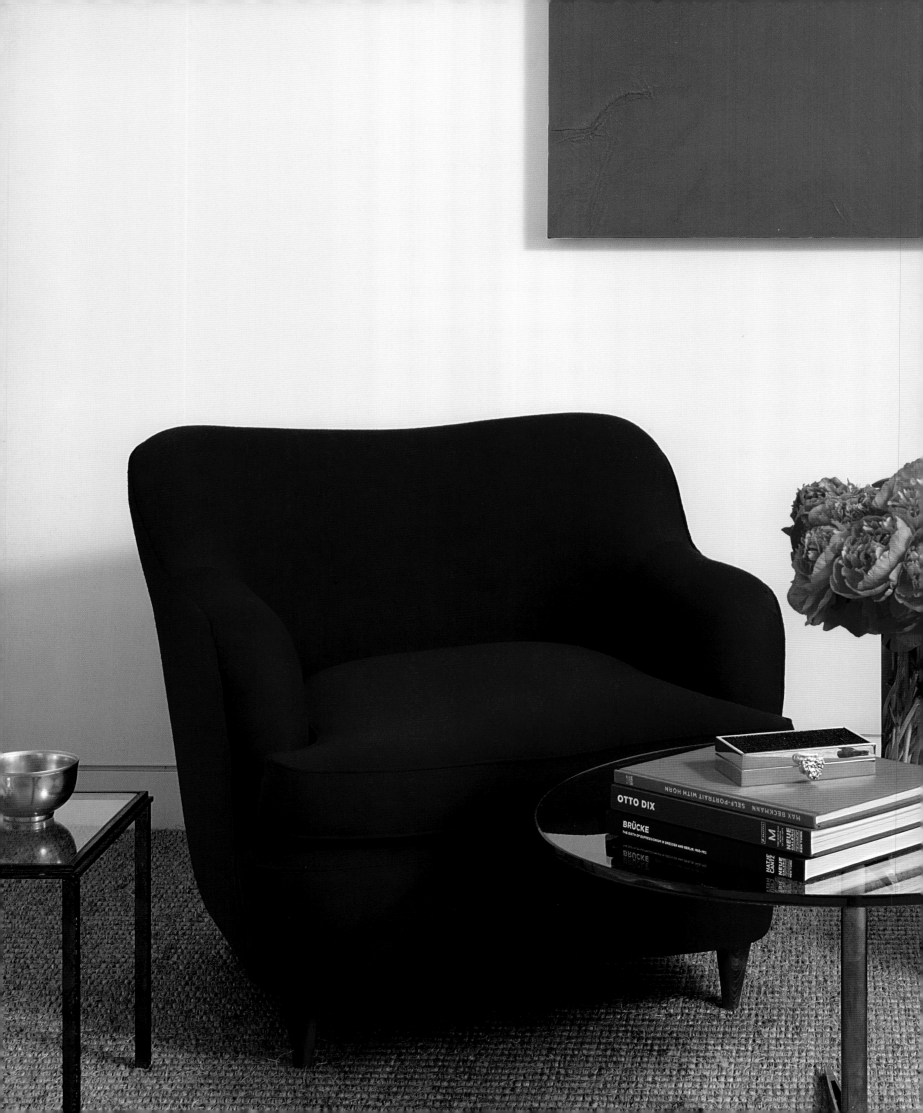

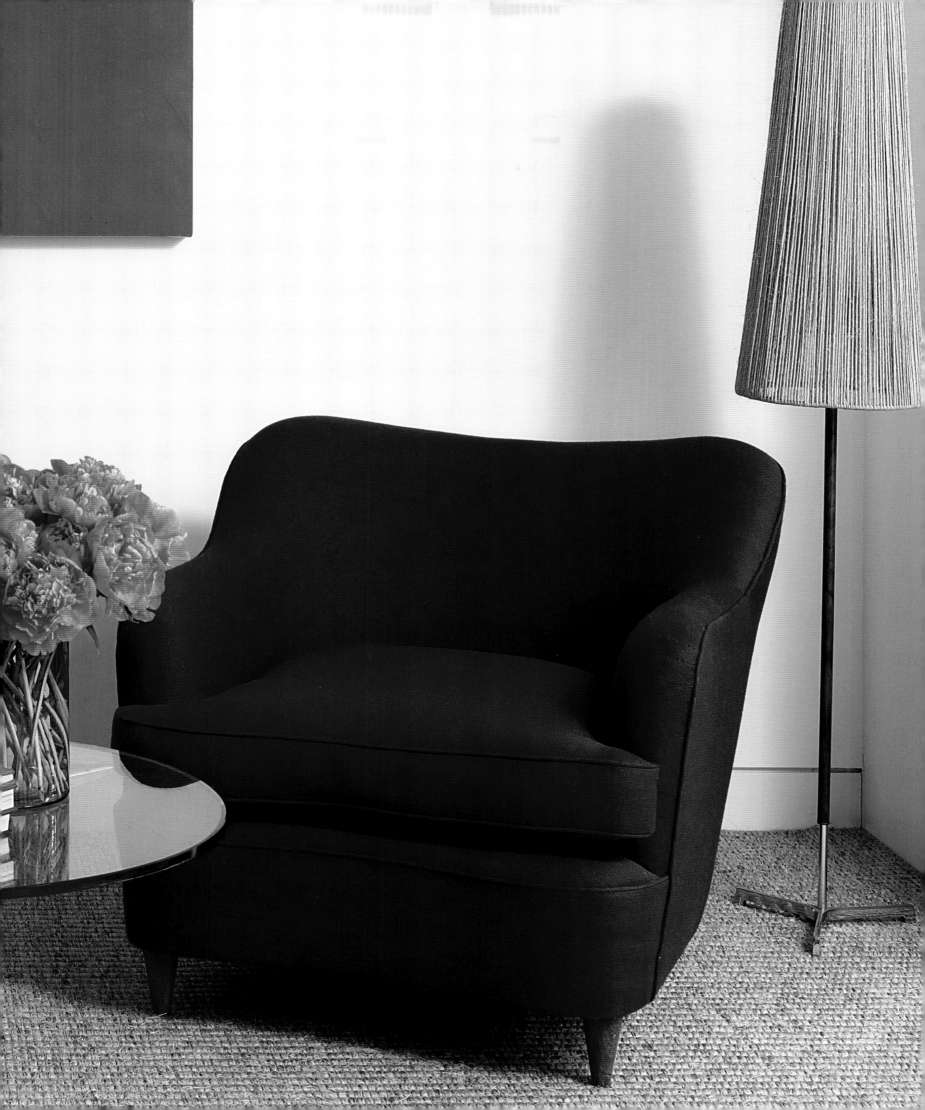

WHAT'S ON MY DESK

MY MACBOOK PRO

It's so beautifully designed and easy to use. I couldn't live without it.

WOMEN'S WEAR DAILY

I've been reading it ever since I was in college. If you want to know what's happening in fashion, retail, business, and beauty, just pick up *WWD*.

LIPSTICKS AND GLOSSES

I've always got a few makeup samples to test out as I narrow down the choices and decide on the new colors. This is one of the best parts of my job.

FRAGRANCE SAMPLES

Developing a new scent is a fascinating process. It's emotional rather than cerebral. I like to wear a sample all day to see how long the fragrance lasts and how other people react.

SHELLS

I started collecting them when I was a child, and they still seem magical to me. I love all the various shapes and colors and patterns. We're doing a version that looks as if it has been dipped in gold, to take it to another level of luxury.

CANDLES

We're making our own, which means more samples to try, in different scents. The container is elegant, just a simple glass that you might want to reuse for pencils or flowers.

SOMETHING FROM MY BOYS

Everyone needs his or her very own Kid Robot.

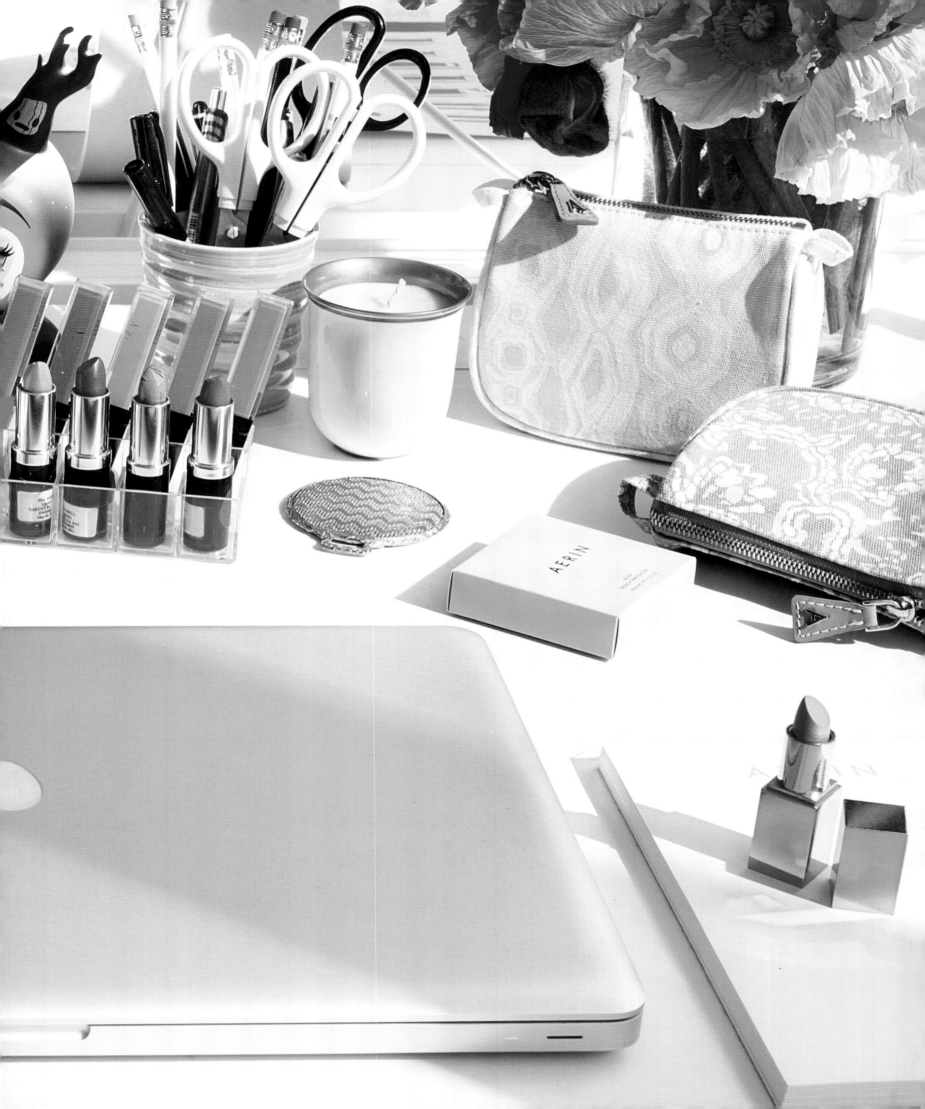

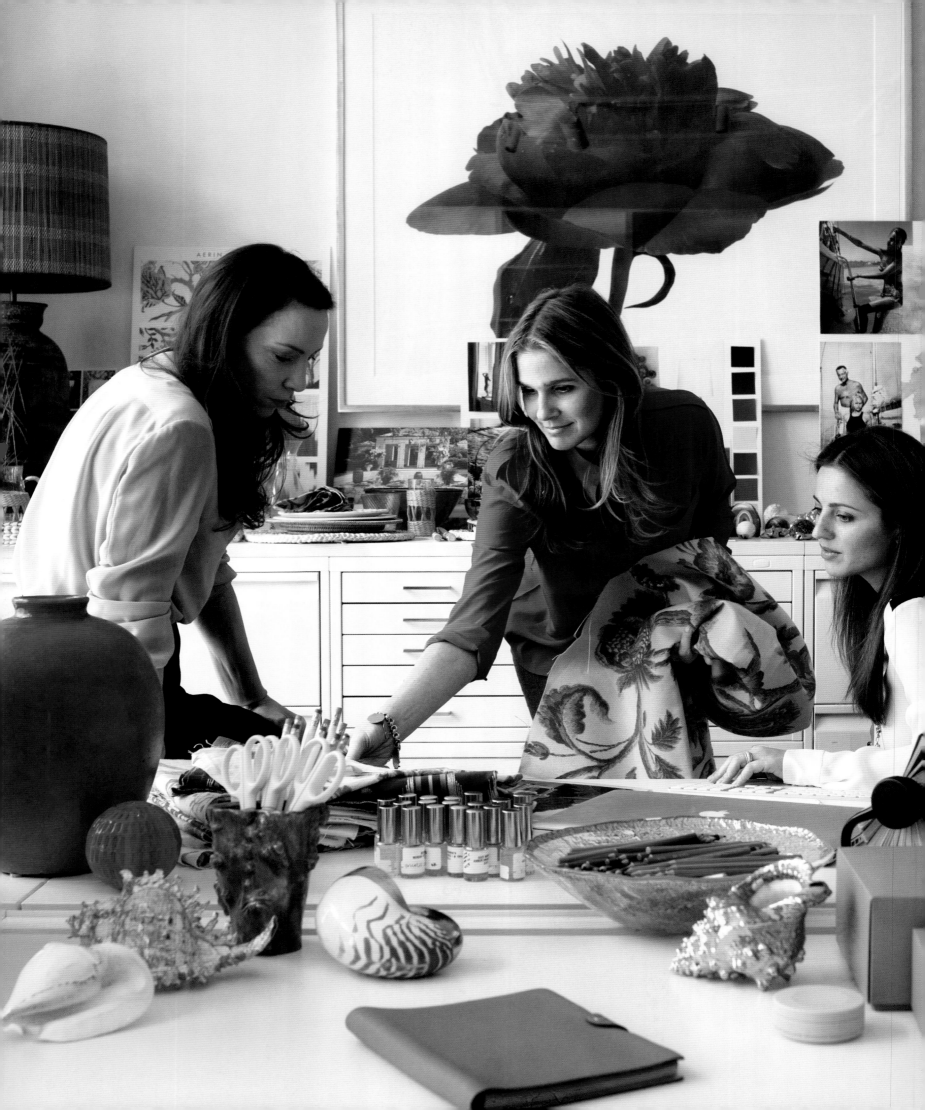

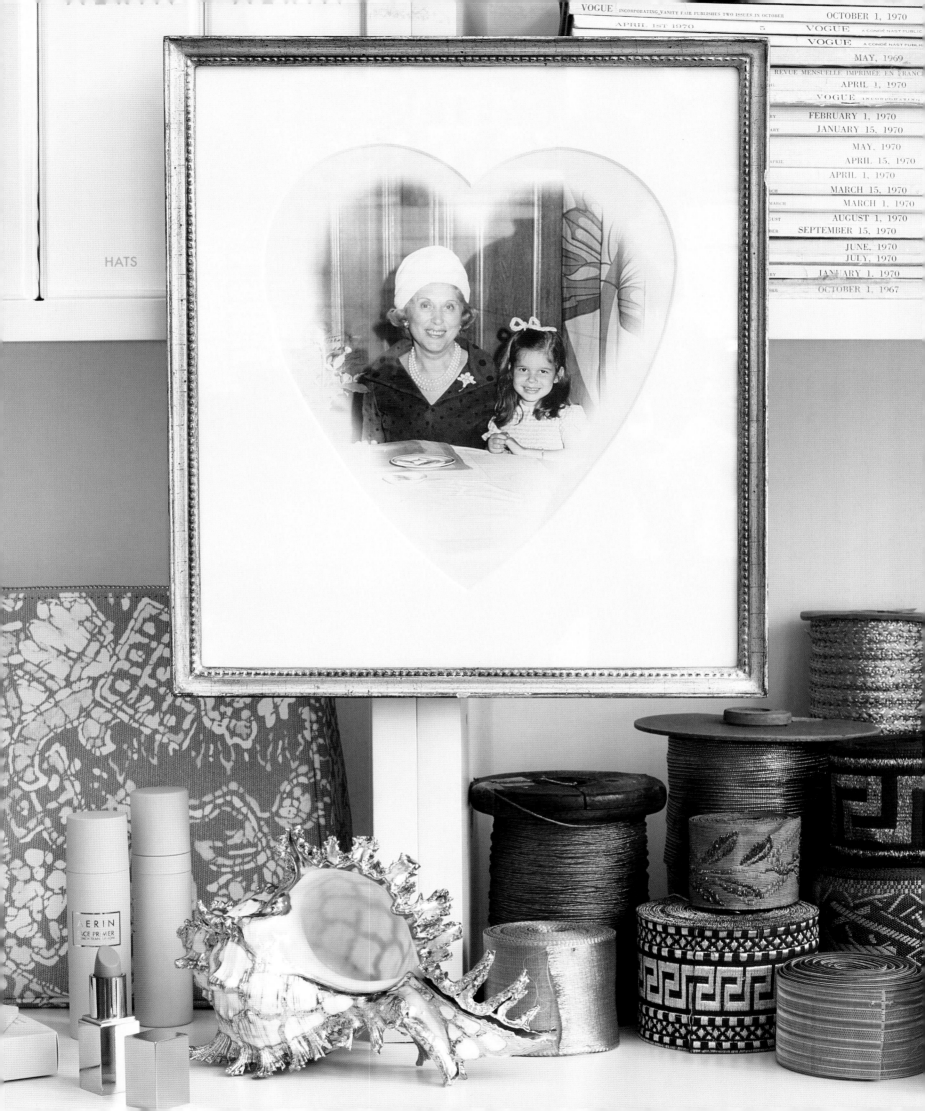

INSPIRATION CAN COME
FROM ANYWHERE

All you have to do is keep your eyes open and let your mind range free.

I'll take a walk on the beach and pick up shells, smooth stones, and gnarled branches of driftwood. A chunk of cloudy blue-gray sea glass could become the model for the kind of glass I want for my scented candles.

When I step into a flower shop, I'm overwhelmed by scent and color. The window of a candy store can have a similar effect on me. When my dad was the US ambassador to Austria, I used to love browsing through Julius Meinl, a gourmet food shop in the heart of Vienna. Inevitably, I wound up at the pastry counter. They make the most exquisite cakes, decorated with the thinnest imaginable sheets of edible gold leaf. And then there was Demel, another Viennese landmark, where you can order a hot chocolate and sacher torte in an elegant, mirrored room that transports you back to the turn of the century. Each confection is a work of art. Even the boxes are extraordinary. I collect them, to reuse for things like jewelry and ribbons. And I always feel completely justified in buying more treats, because I want that box!

When something is done so well, right down to the packaging, I not only admire it, but it also makes me see all sorts of possibilities. Many a time I've detoured from my route in Paris just so I can walk past Ladurée, another famous tearoom. All I need to do is gaze at the trays of macarons in the most delicate Impressionist colors to have an epiphany.

SAYRE

PARSONAGE

GEORGICA

HITHER

HIBISCUS

Yves Saint Laurent
David Teboul

RUDI GERNRE

CHANEL
CHARLES-ROUX

LISA FONSS

FASHION PHOTOGRAPHY
THE BOOK OF PERFUME
CHANEL and her world
CHANEL

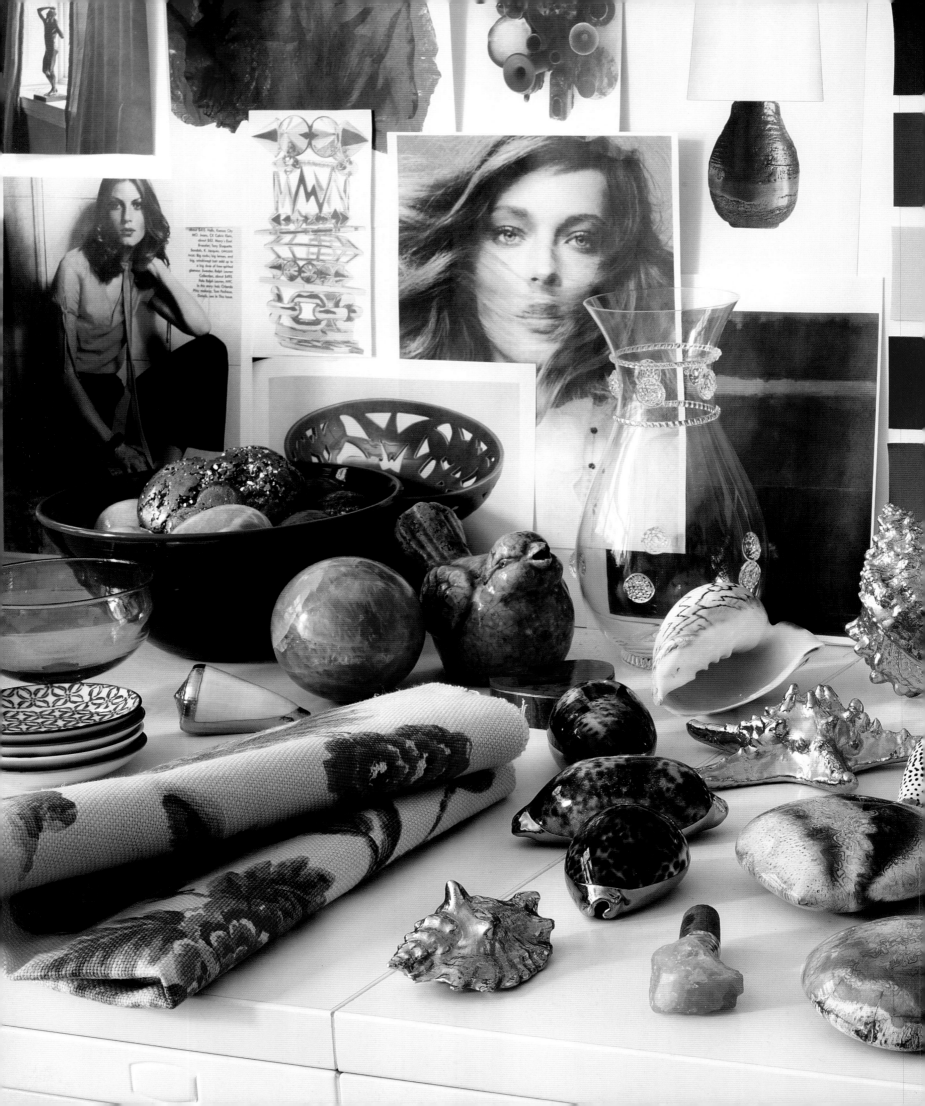

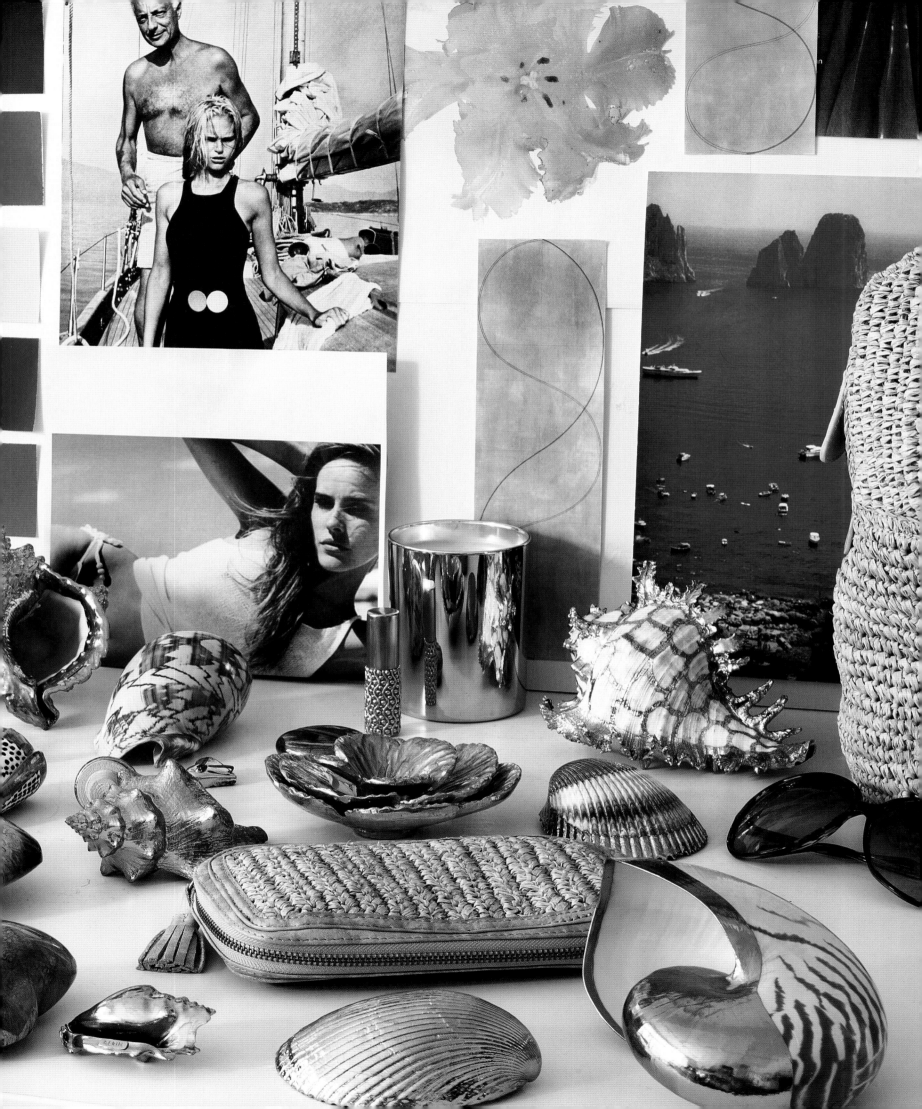

COUNTRY LIFE

Estée always wanted a house with white columns, like Tara in *Gone with the Wind*. That was her idea of perfection and her definition of success. White Grecian columns embodied elegance to her. She even designed a lipstick case modeled on a fluted column, and it was so popular that it's still in the line today.

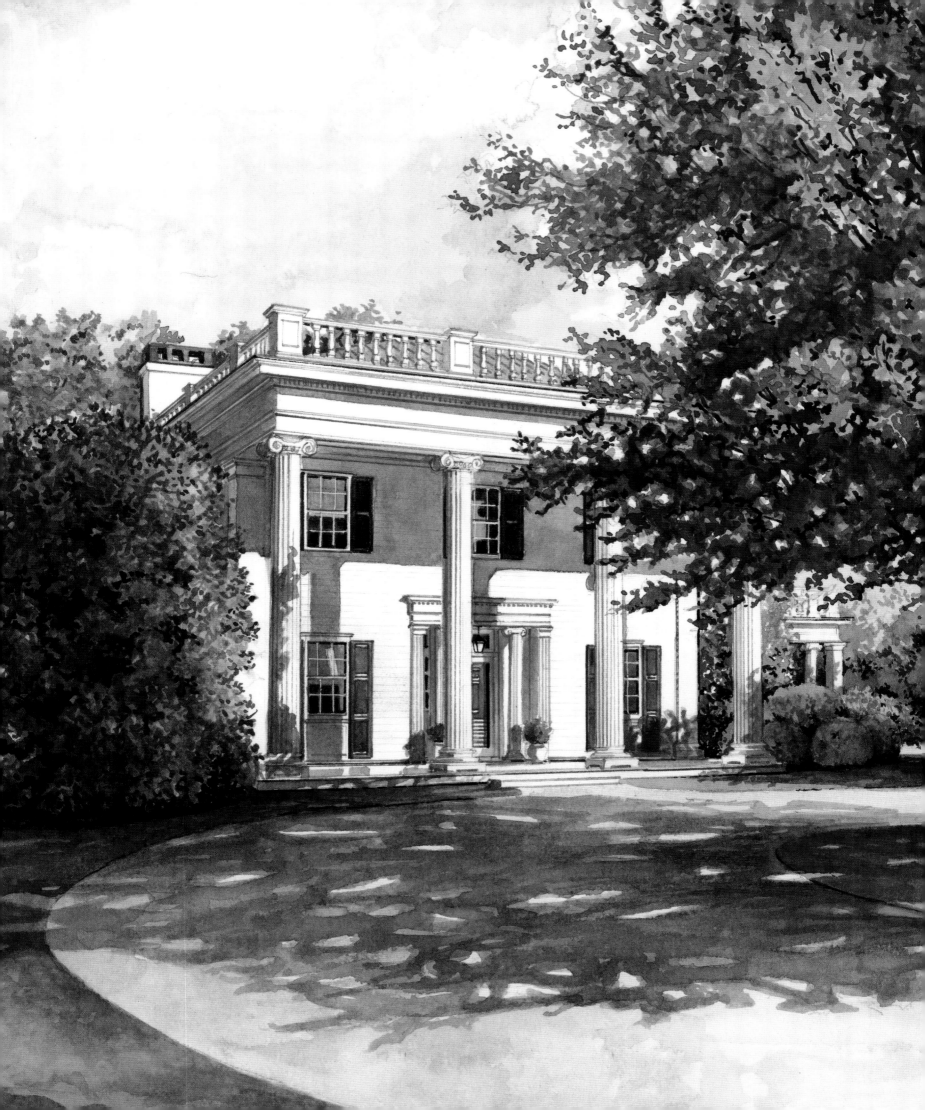

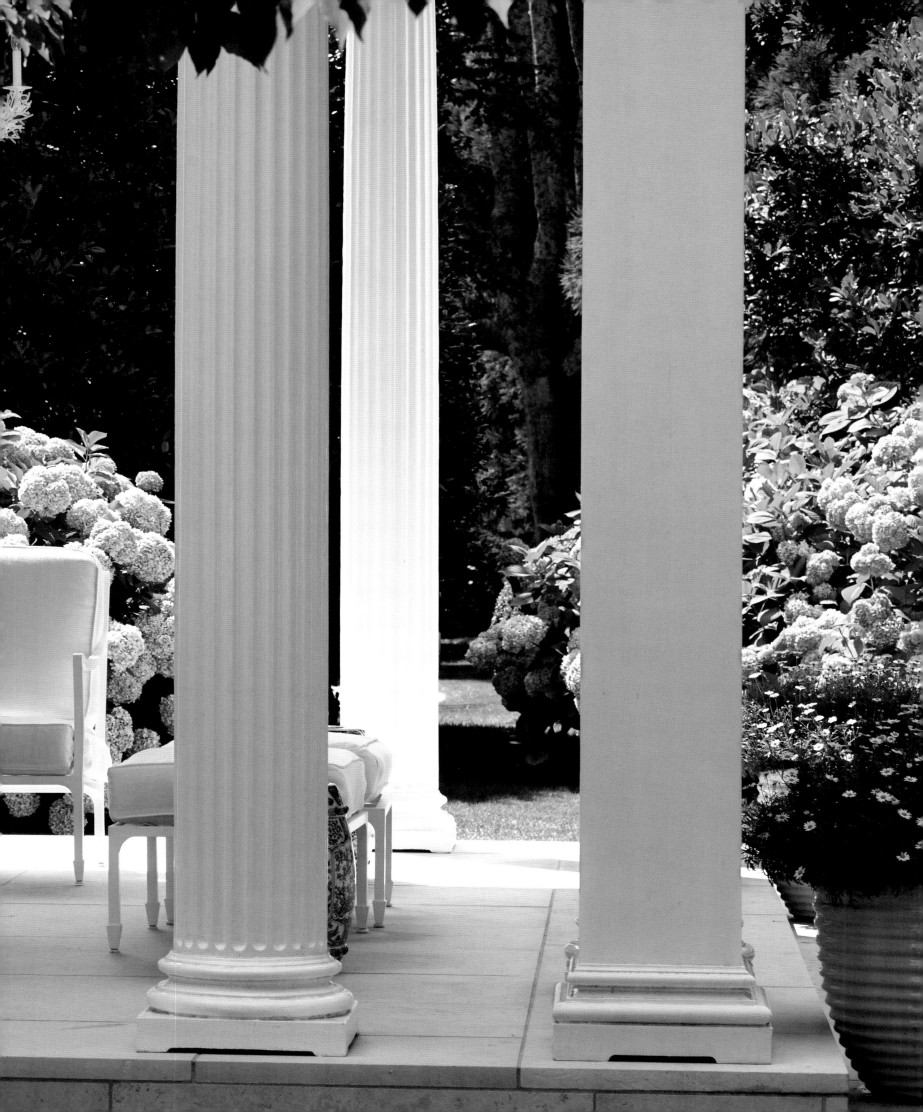

When my parents began spending weekends in the Hamptons, Estée wanted to be near us, so she looked for a house to buy. It still amazes me that she managed to find one with her beloved white columns, within walking distance. She was one of those magical people who could just make things happen, or at least that's how she seemed to me when I was a little girl. She had this sixth sense. If there was a contest to guess the number of jellybeans in a jar, you can bet that she would name the exact number and win.

Now her house is our house, and my children run through the rooms I knew as a child. When we first moved in, everything was just as she had left it. Houses are a kind of autobiography, and hers are very revealing and very consistent. Estée wanted life to be pretty. She loved lots of fabric and lots of pattern—curtains, pillows, and carpets in all sorts of exuberant florals, ikats, and geometrics. She adored charming little cachepots, fine china, and old silver. Mark Hampton helped her with the decoration and it was definitely more formal and elaborate than my parents' house. Jane and I were thrilled whenever we were invited to spend the night with her, because everything felt more dramatic and special.

Family was all-important to Estée, and she was always ready to scoop up her grandchildren and spoil us with treats. Extravagant and fun to be around, she loved jewelry, caviar, and spaghetti and meatballs. In her dressing room in her Manhattan townhouse, she had a little refrigerator filled with box after box of chocolates. "Take more than one," she would tell us, like a co-conspirator. After dinner in the country, we would jump in the car and head over to the Candy Kitchen for their homemade ice cream. She would let us stay up late with her, watching TV. When we couldn't keep our eyes open any longer and were getting ready for bed, Estée would come in wearing one of her pretty bathrobes and wedge-heeled slippers (to make her look taller) and tuck us in.

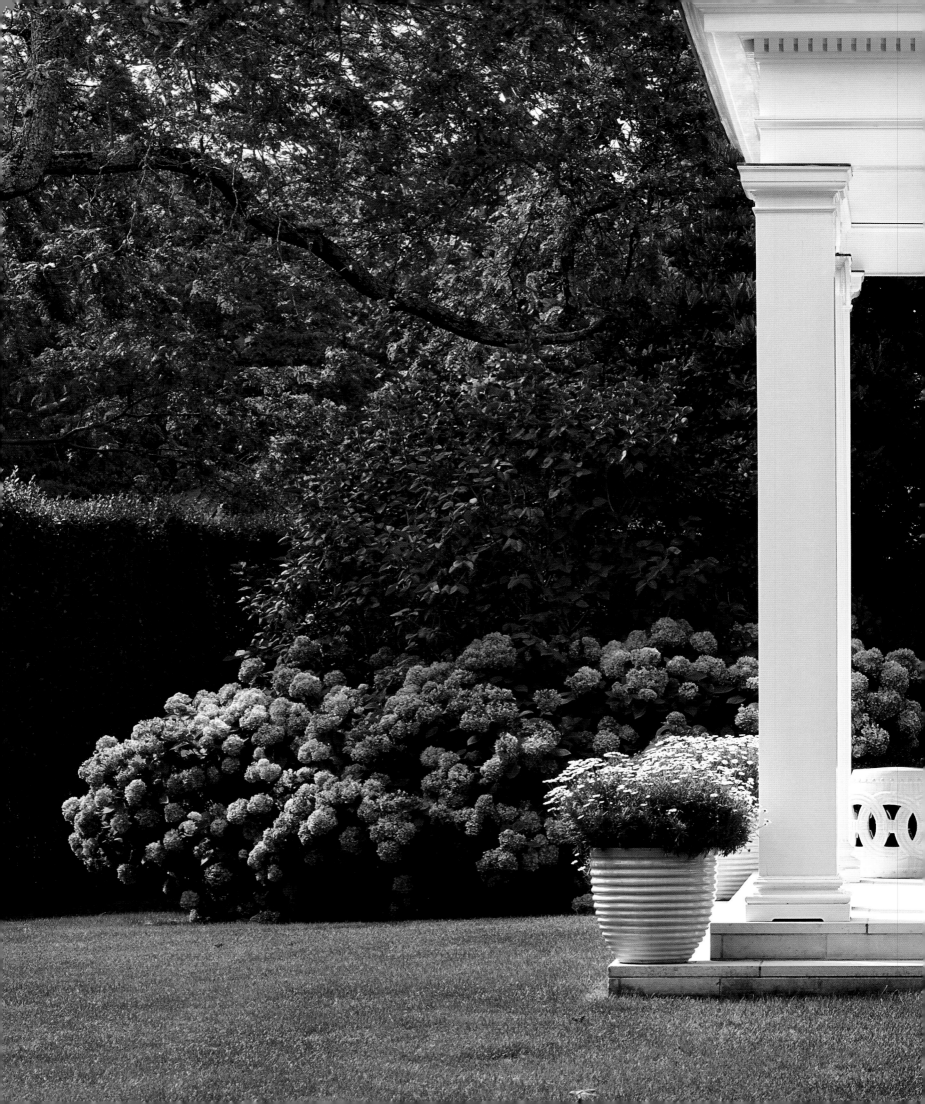

I love the idea of her house being part of my life, even though Tara and layer after layer of fabric is not my style. But I embrace it and enjoy it because it reminds me of her. In fact, we lived in the house for almost two years before I dared to touch anything. Then I was practically forced to do a renovation because we were bursting at the seams. The Greek Revival house was built in the 1950s and it had two bedrooms—not enough space for my family and all the friends we like to invite to come stay with us for the weekend.

So we built a two-story addition in back, with three bedrooms upstairs and a new kitchen and family room downstairs, which we desperately needed. (Let's just say that Estée did not spend much time in the kitchen, so that room wasn't a priority.) And then I took a good look at all the other rooms. The idea was to refresh each space but keep her spirit alive.

Her good, classic furniture anchors each room, but there might be a different paint color on the walls and a few unexpected accessories. I can still feel her presence, but now I've made the house my own and updated it to suit my family.

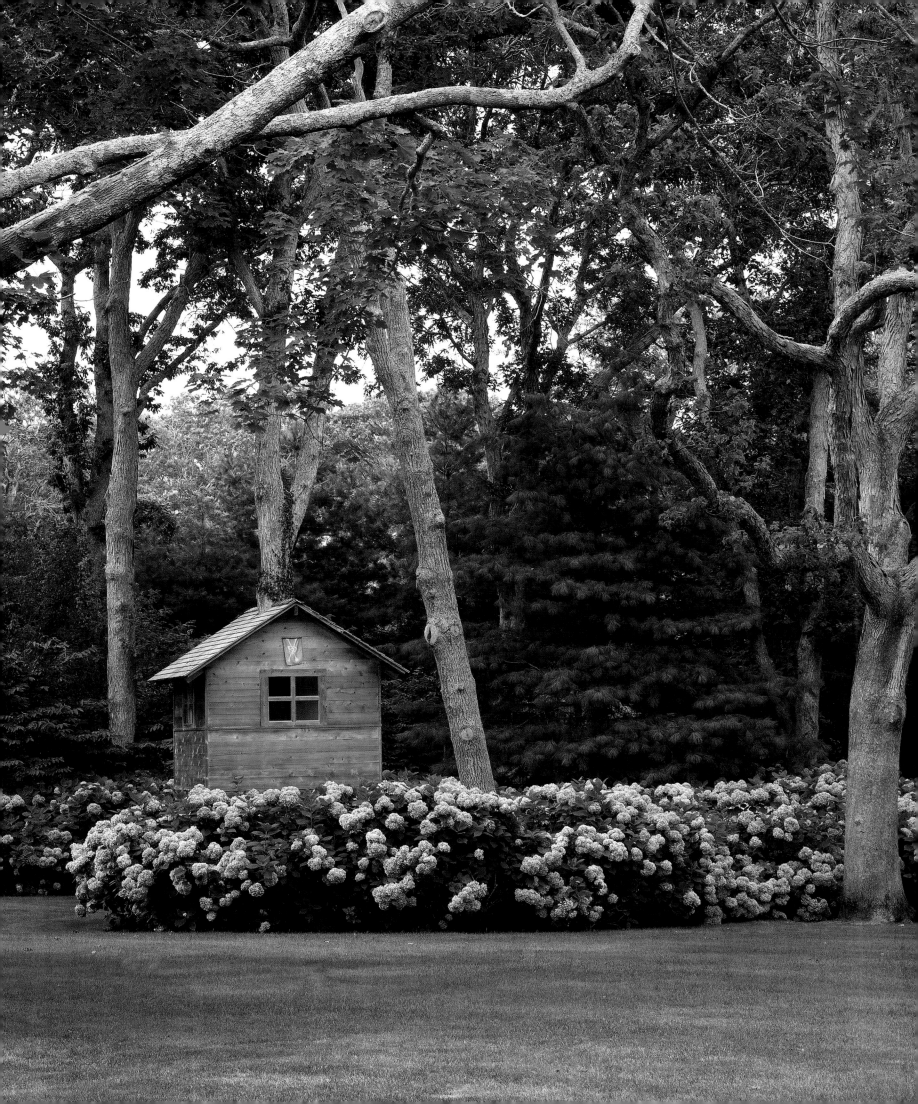

I want people to walk in and feel that this is a warm house. Classic, but not uptight. It's about heritage, but with a twist. And that twist reflects me.

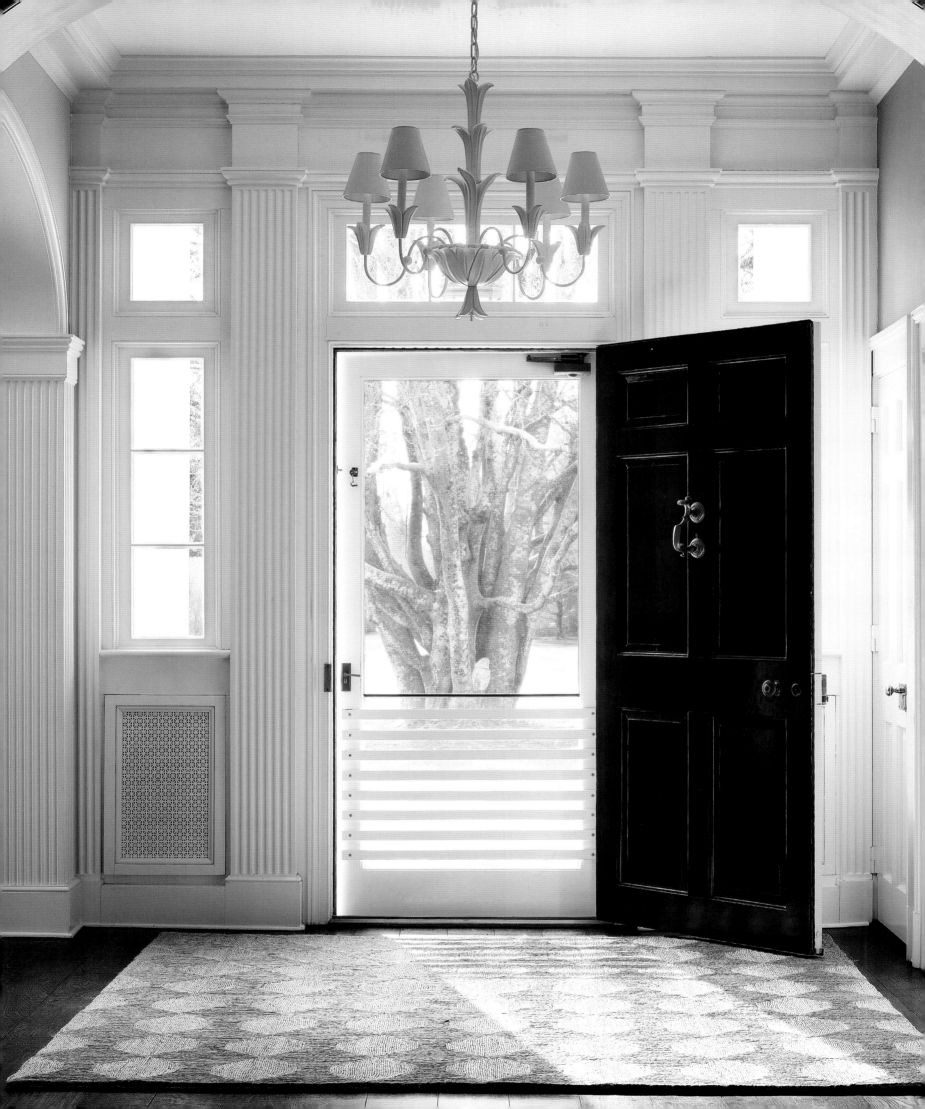

LIVING ROOM

Before the renovation, my family and I hardly ever went into the living room. I remember it vividly from my childhood—all that blue-and-white porcelain was fascinating to me. But looking at it as an adult, it somehow felt too formal and precious. Estée's Chinese carpet in shades of dark blue and white would have been perfect for a villa in the south of France in 1952, but not for a young family at the beach. I rolled up the rug and replaced it with simple sea grass, which can handle any sand that gets tracked in. It also has this particular, subtle scent that says summer afternoon to me. Then I painted the walls in a delicate shade of lavender.

A new coat of paint refreshes a room. Be brave and pick an actual color instead of the same old off-white. That lavender was not an obvious choice, and it turned the room in a whole other direction. Suddenly the familiar blue-and-white porcelain looked amazing. The unexpected color made the room modern.

Otherwise we kept the furnishings—Estée's coffee table inset with Delft china, the sofa upholstered in Prussian blue, a pair of antique chairs in a Fortuny-esque blue and white. I added some new pillows and reupholstered the two easy chairs by the fireplace in crisp white. White is always fresh and clean. The room feels more casual now, and it's a place where people might actually want to sit.

The blue-and-white vases lined up along the mantel show how I like to display similar objects by grouping them together. They have more impact that way. And it doesn't need to be fine porcelain. The idea with a collection is that quantity is quality.

When Estée lived here, no table was ever empty. She had silver-framed photographs of family and friends—Princess Grace, the duke and duchess of Windsor, Nancy and Ronald Reagan—scattered all around the room. I grouped my favorites on one round table, skirted in white taffeta with a blue bullion fringe.

I love skirted tables. I use them everywhere. They can work in the center of a room, in a corner, or next to a sofa. Putting a piece of glass on top protects the fabric and keeps it looking pristine.

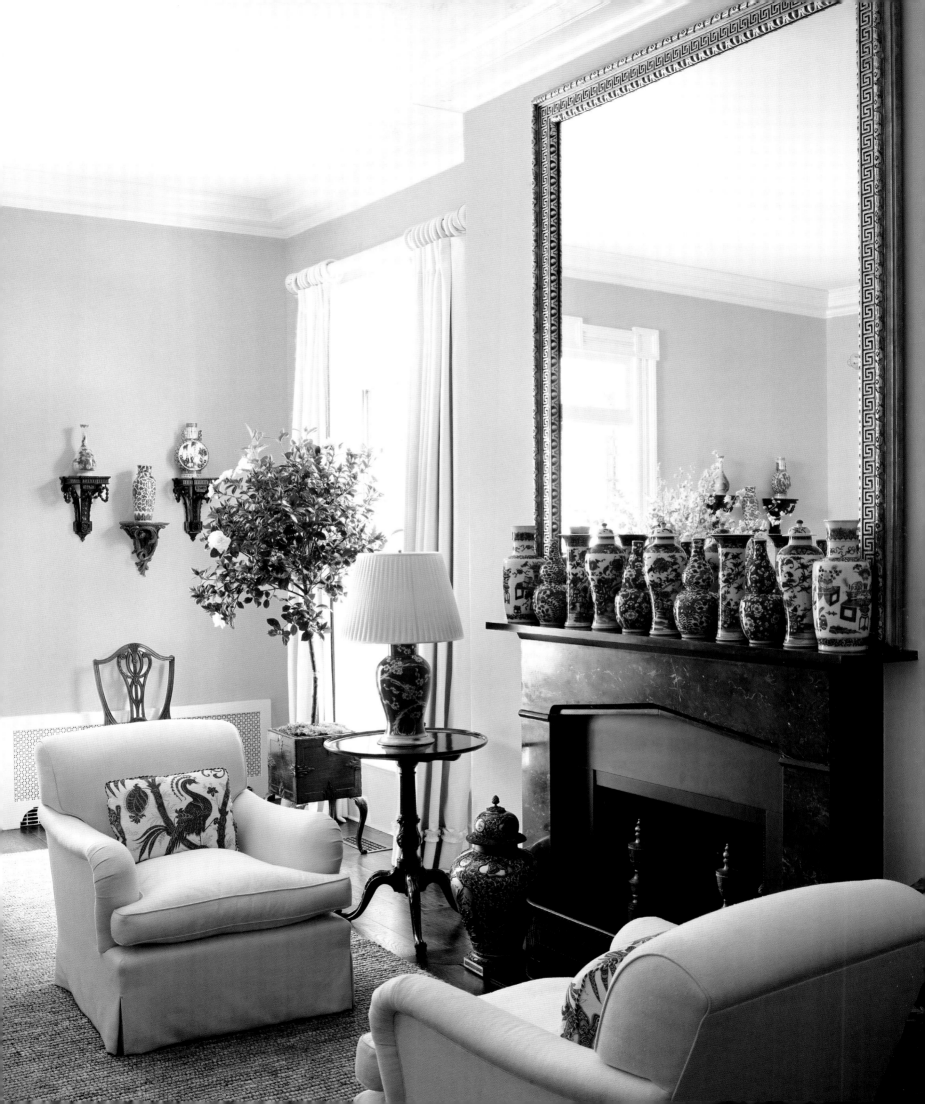

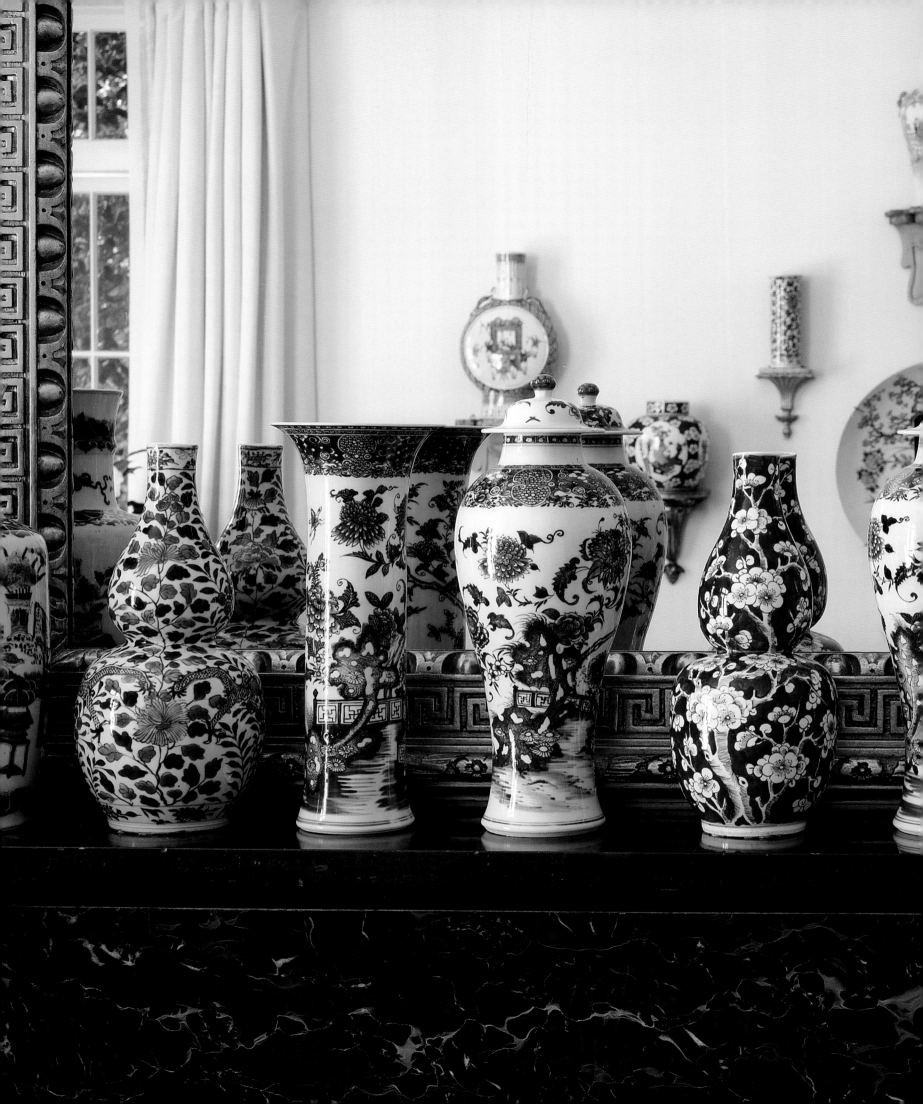

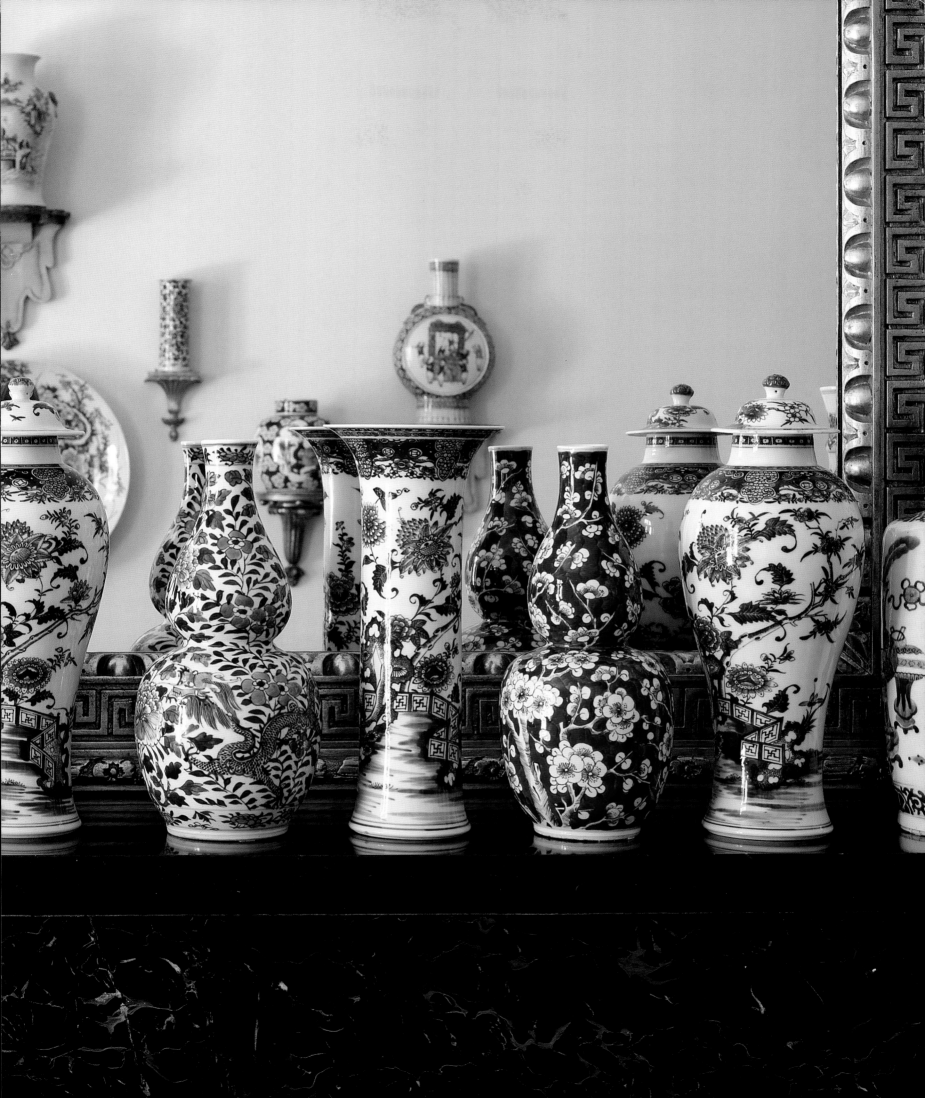

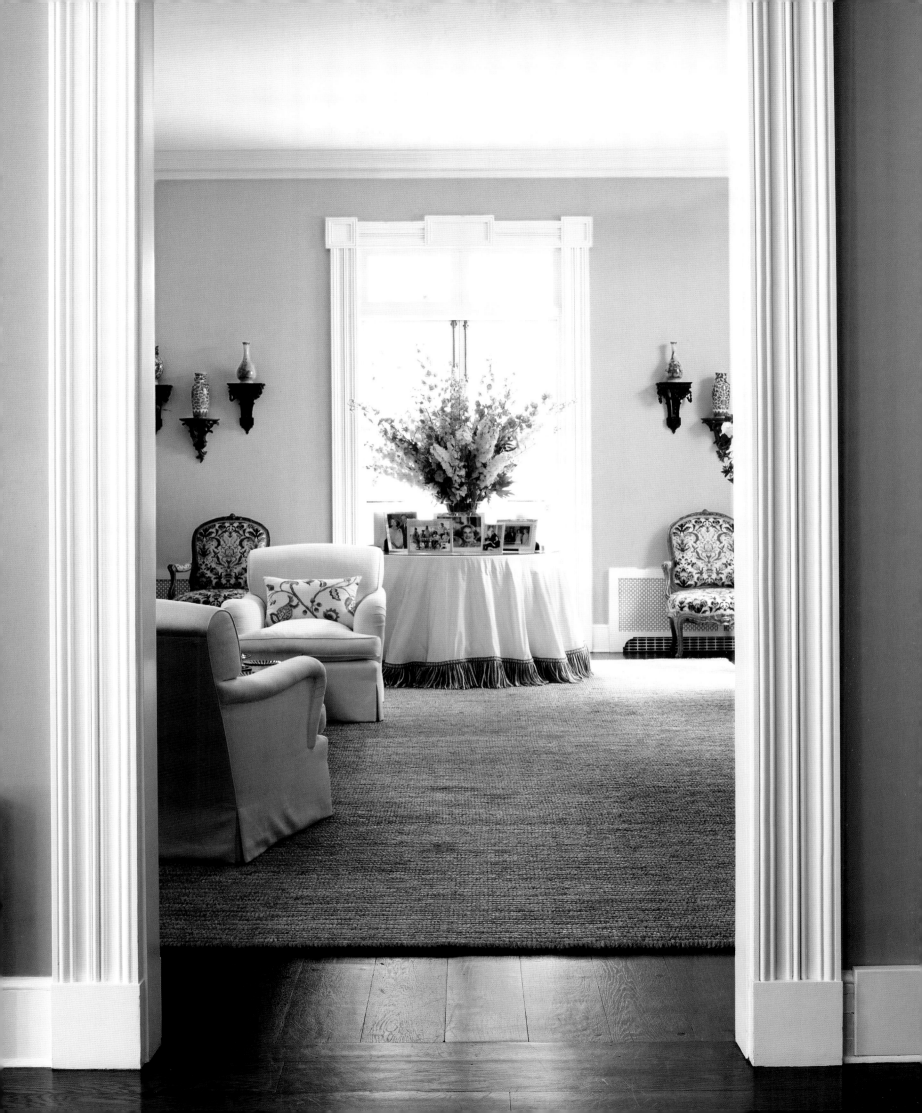

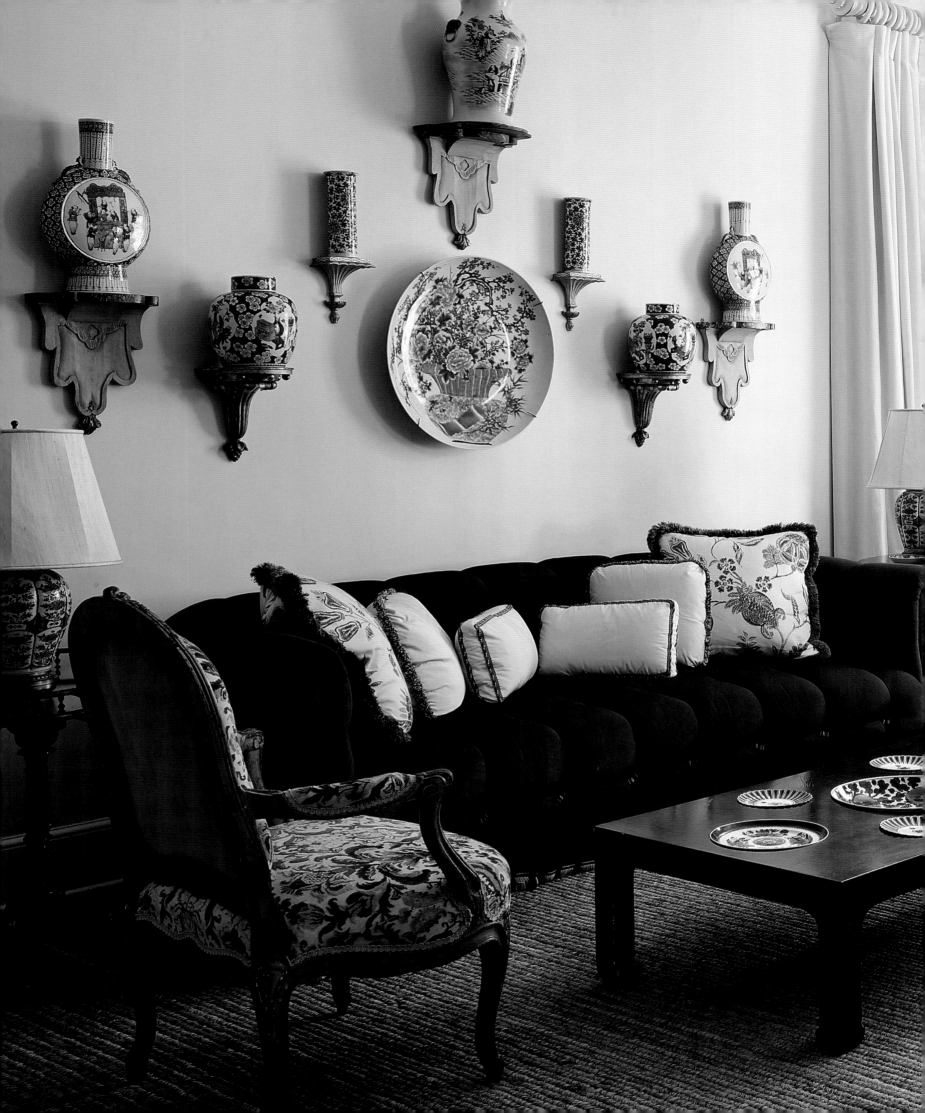

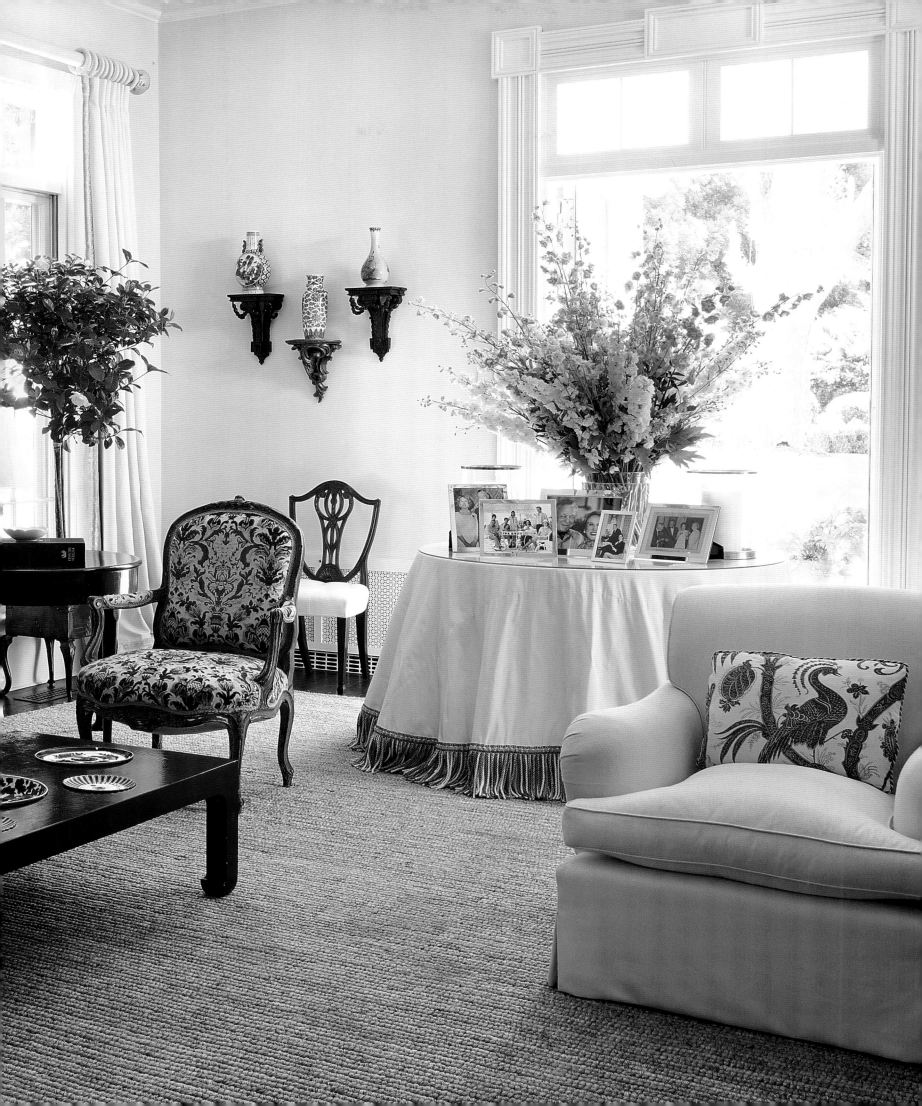

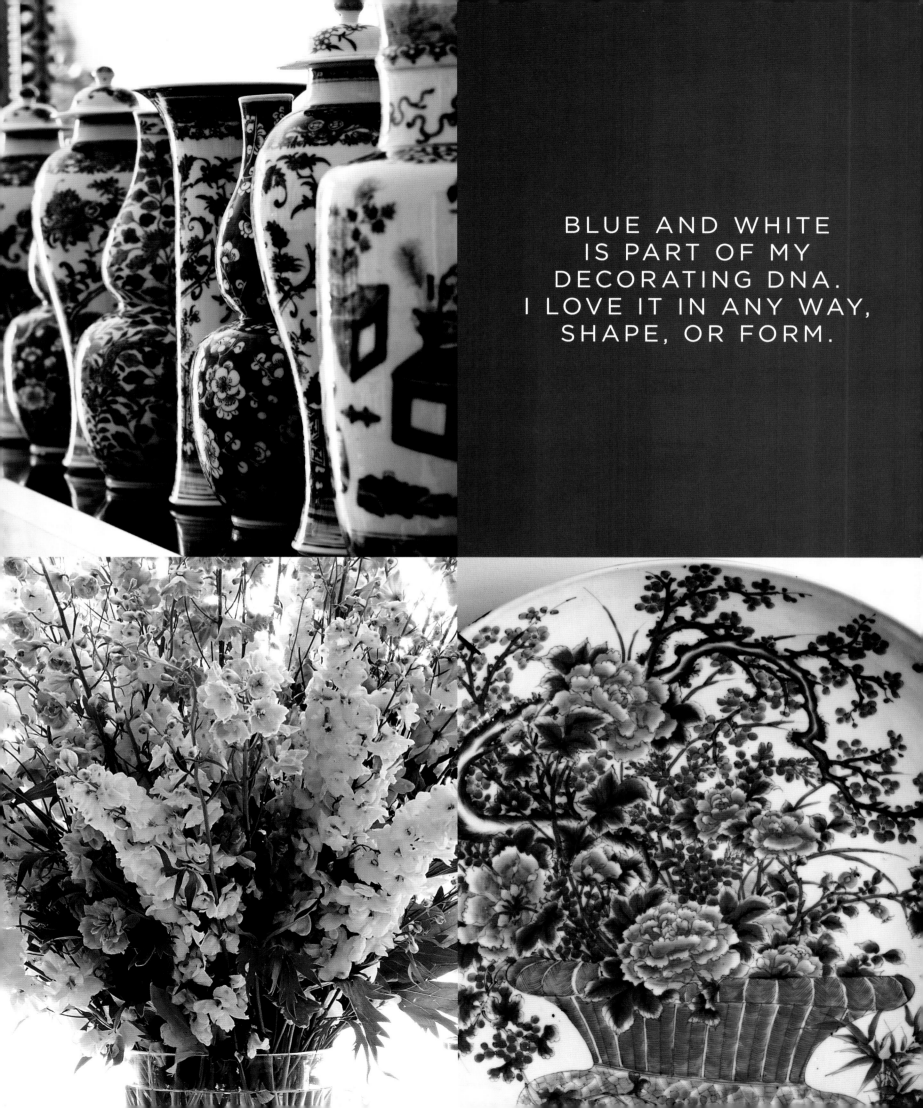

BLUE AND WHITE
IS PART OF MY
DECORATING DNA.
I LOVE IT IN ANY WAY,
SHAPE, OR FORM.

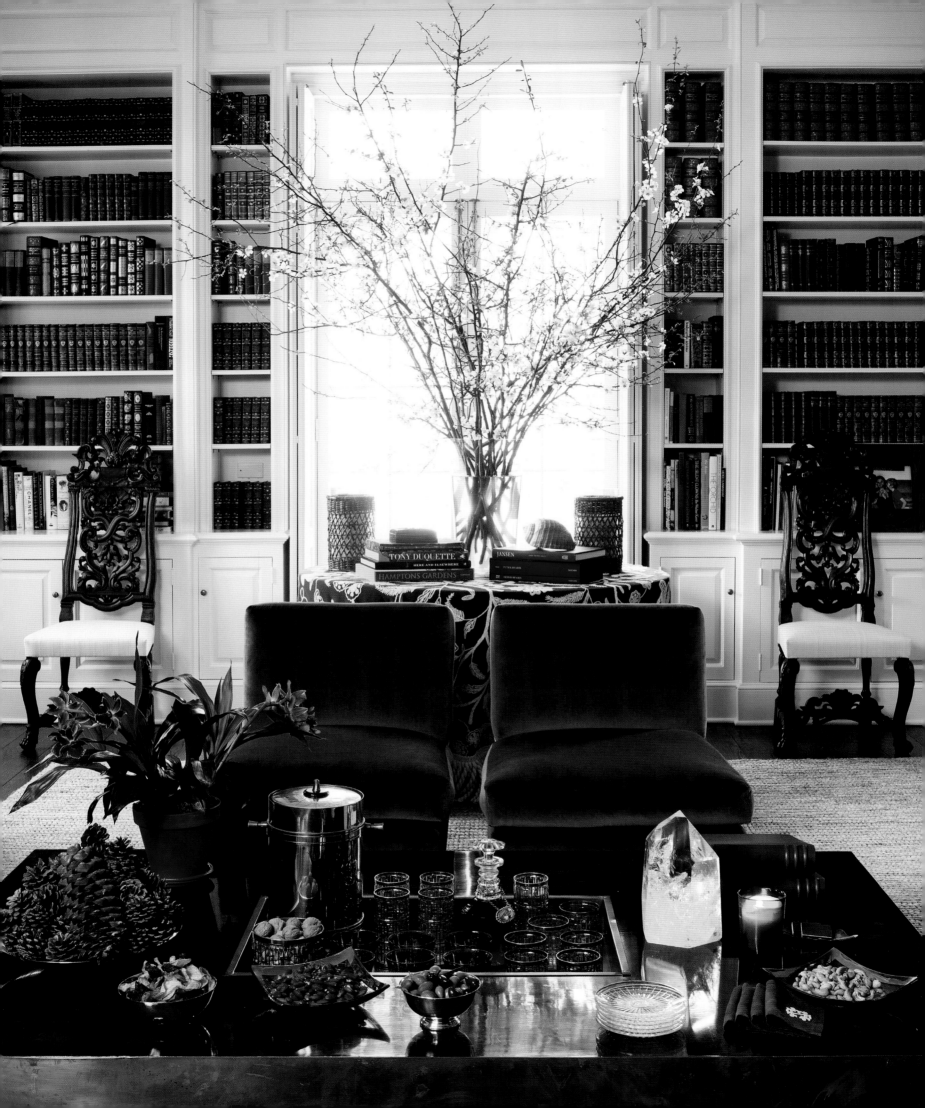

LIBRARY

The library functions as our second living room. We spend so much time in here, settling into the big, comfortable club chairs for conversations that can last for hours. It's a great room for entertaining. In summer, I'll open the French doors and guests can move in and out. In winter, we'll light a fire and gather around it for drinks. And no one has to get up for a refill, because the big square Willy Rizzo coffee table has a niche for bottles built right in.

The books on the shelves have been there for decades. To add instant character to a room, just fill it with books—fiction, history, biography, and those great oversized volumes on art and photography. I can spend hours looking through old interior-design books on a rainy day. I also keep a big wicker basket laden with vintage magazines—copies of *Architectural Digest* and *Town & Country* that I found in the attic. Or I get them on eBay. People pick one up and end up reading it from cover to cover.

My grandparents chose the traditional landscape paintings that hang on the walls. They used to be scattered all over the house, but I decided to group them together, once again, for more impact. The tables are covered with talismans, things that are precious to me—painted driftwood from my children, family photo albums, stones that I've picked up on the beach. Together, all of these bits and pieces add up to a strong sense of personality. Full confession: this room didn't come together instantly. At first, I painted the walls in a bright shade of pumpkin, which turned out to be a little overpowering. I lived with it for a while, hoping it would grow on me. It didn't.

So I repainted the room in a chocolate brown, with creamy white bookcases. I've always loved chocolate brown. To me, it's very warm and inviting. Some people might think it's an unusual choice for a summer house, but that's another reason why I chose it—to be a little different. And the color actually works year-round. Brown feels cool in summer and cozy in winter.

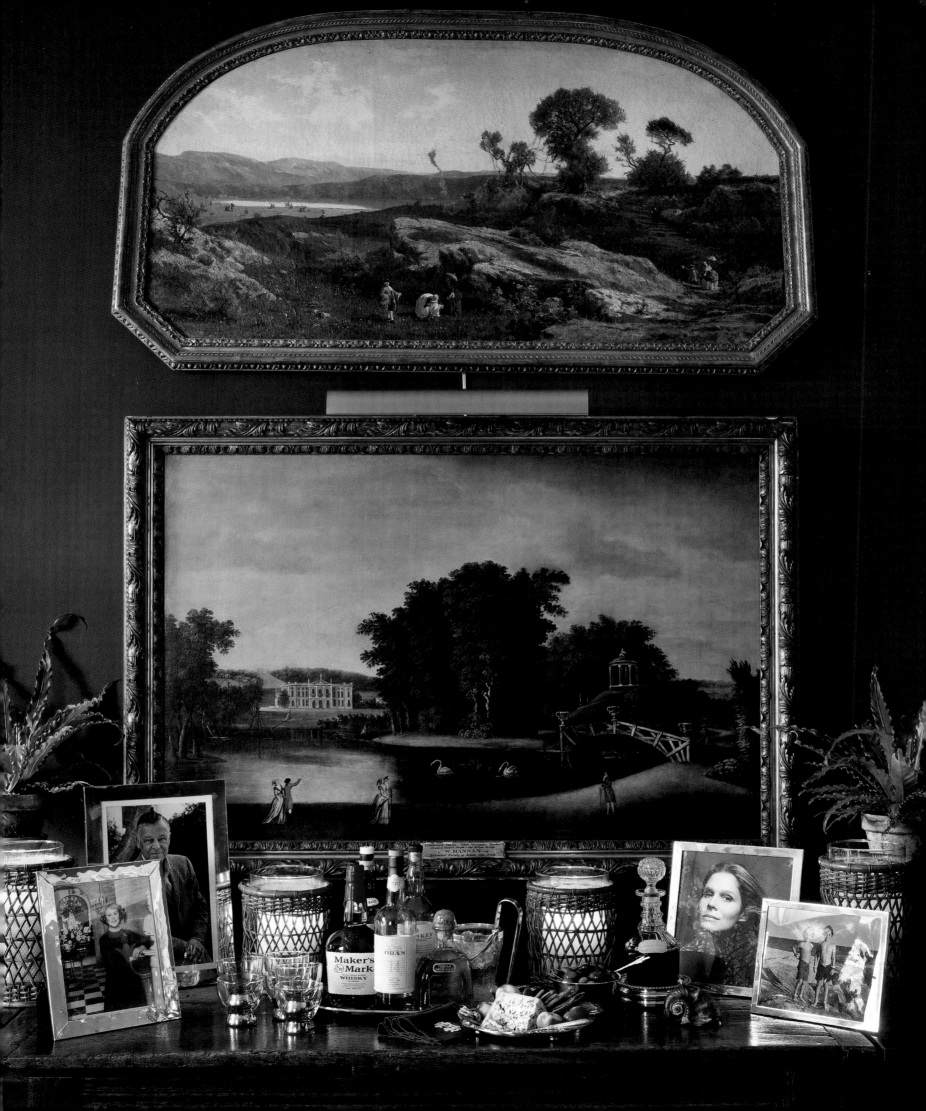

Color is a powerful thing. It affects us viscerally. That doesn't mean you should be afraid of it, though. If you don't like a paint color, you can always change it. The important thing is to give it a try. If you don't, you'll never know.

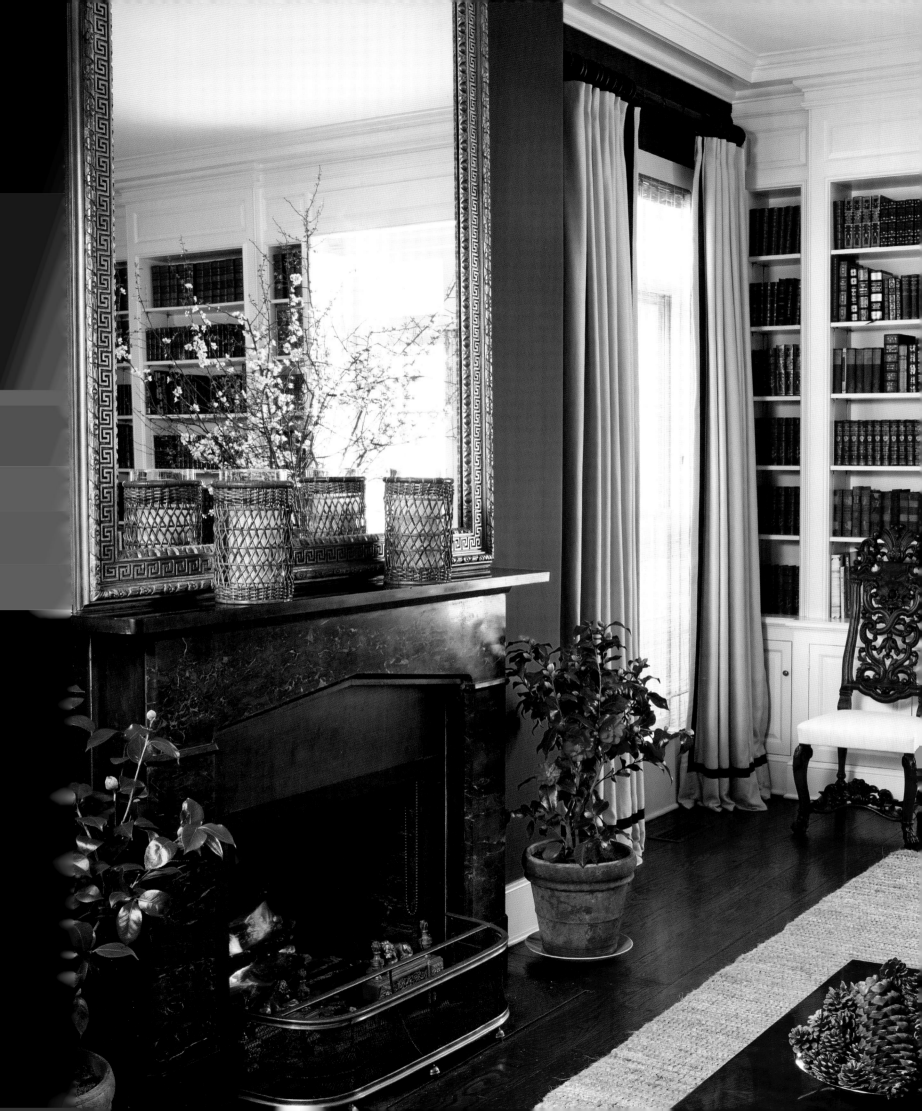

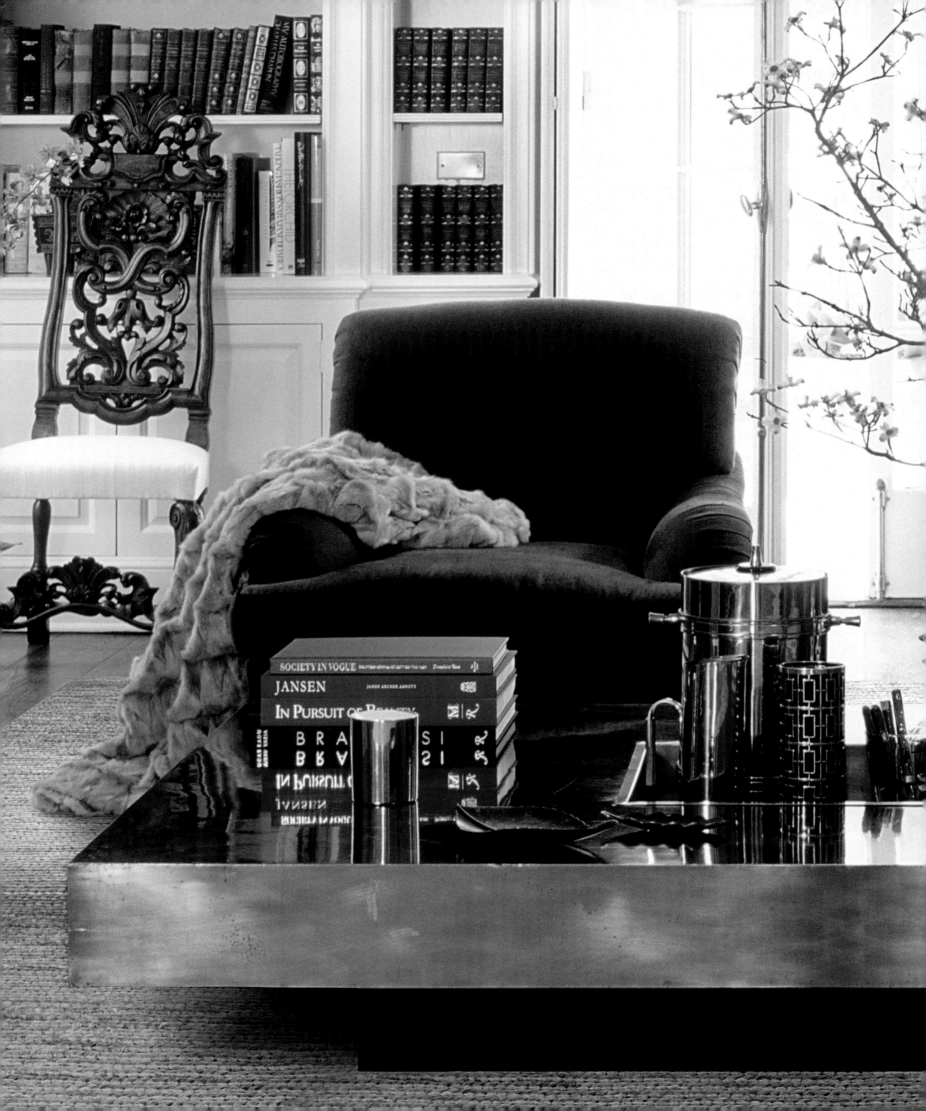

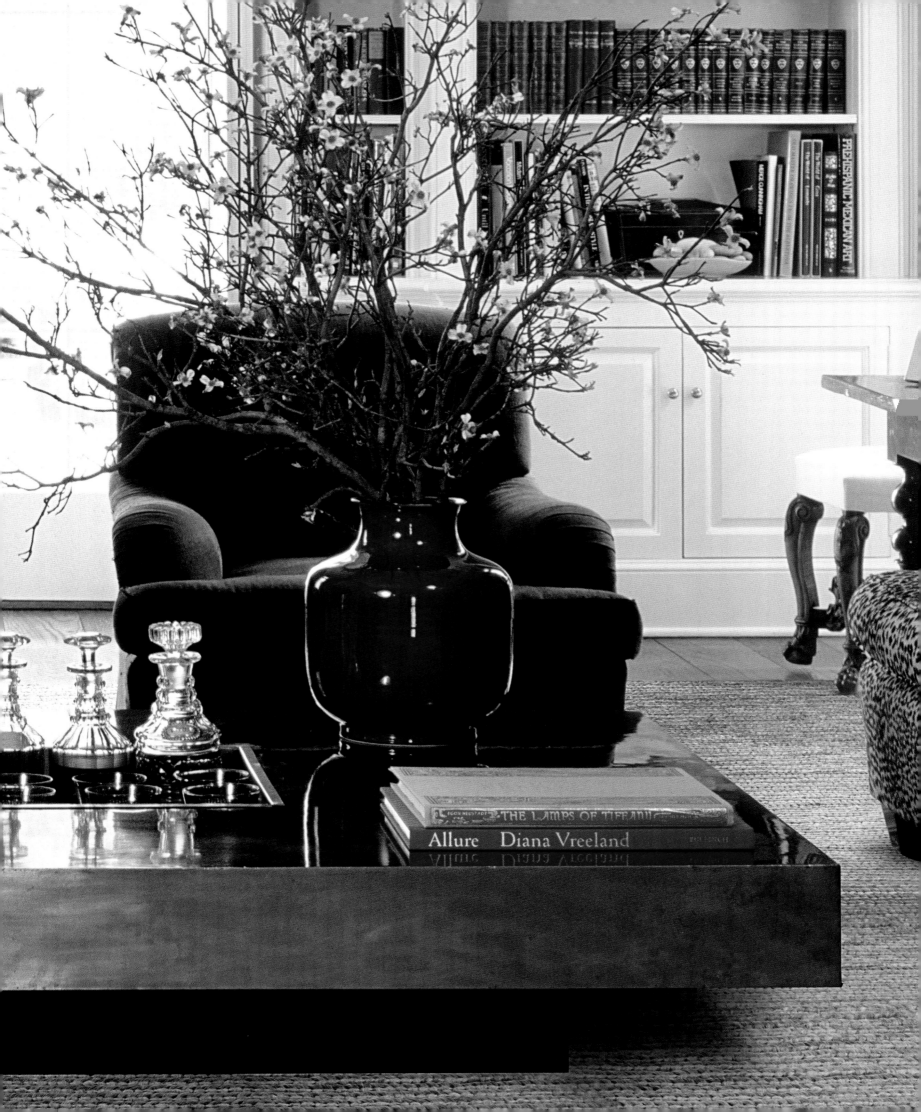

DINNER IN THE COUNTRY

When a leak damaged the beige fabric on the walls in the dining room, I decided to look at it as an opportunity instead of a disaster. I thought, That's it for beige. Why not go bigger, bolder? Blue and white were Estée's favorite colors. Wouldn't it be fun to really play them up here?

A dining room happens to be a good place to experiment with a strong color. Since we're only in that room for a few hours at a time, I felt I could take a risk. A color that could get tedious 24/7 is more like a treat here.

I painted the walls a deep Delft blue, with white woodwork. Estée had put up lots of decorative brackets in the living room to display her blue-and-white porcelain. When I spotted some great carved brackets in London I had to buy them (it may be genetic) and put them in the dining room too. Then I threw in some fantasy—instead of lightbulbs in the old Waterford crystal chandelier, there are blue candles. Everyone looks more attractive by candlelight. The room glows.

Estée was famous for her formal dinner parties, and she had a proper English rectangular dining table in this room. I took it out and replaced it with a round English Regency table. This one can seat six for an intimate supper or expand to accommodate twelve. I like that flexibility.

When we first moved in, I was going through the drawers in Estée's night table and found some of her old seating charts. Everything was carefully thought out and nothing was left to chance. Her table was always set with beautiful flower arrangements, fine china, polished silver, linen napkins, and English crystal.

It's a pleasure to live with the things that once belonged to her. But if I bring them out for a party, I'll do it my own way. Dinner might be a casual buffet, with roast chicken, steak, or a tempting pasta. All the food will be set out on the sideboard, so people can take exactly what they want and then sit down to eat. The tablecloth is made from the same floral fabric that I used to redo the guest room. I had some left over. Why waste it? I love the pattern—more blue and white.

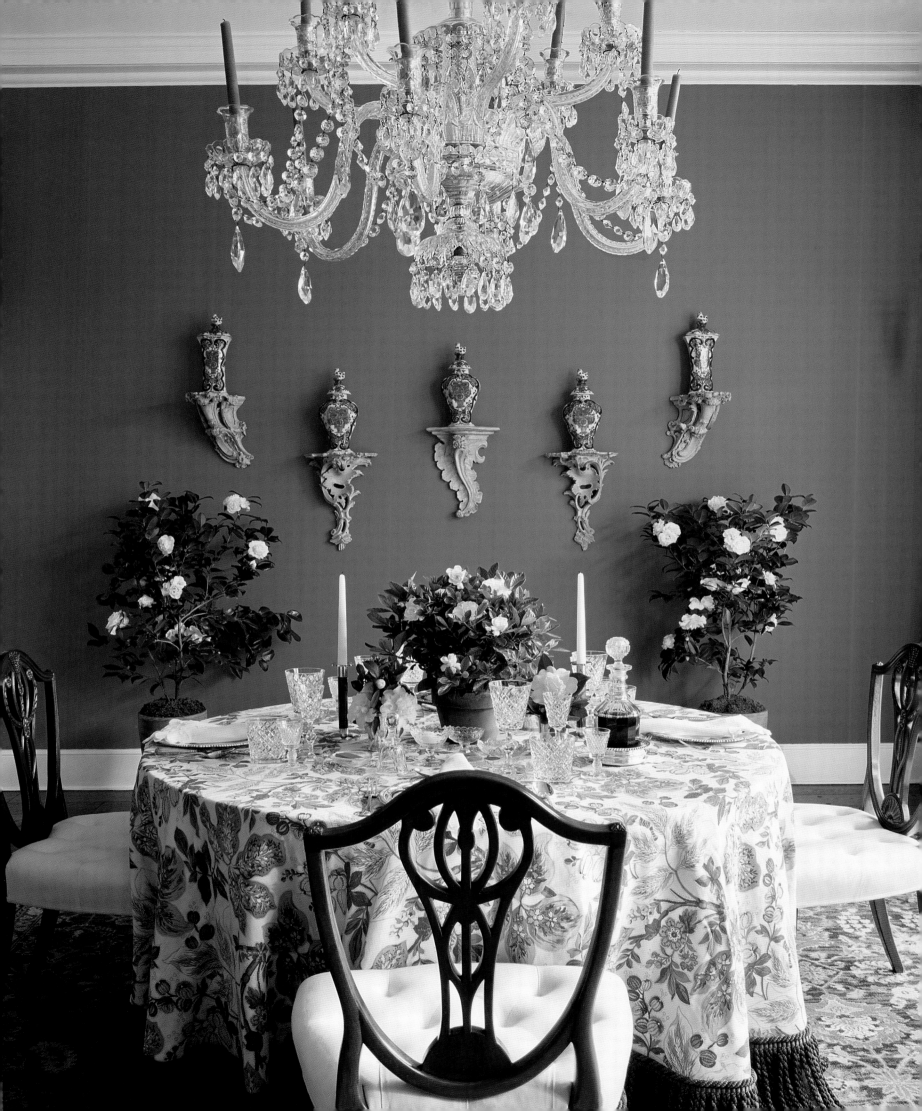

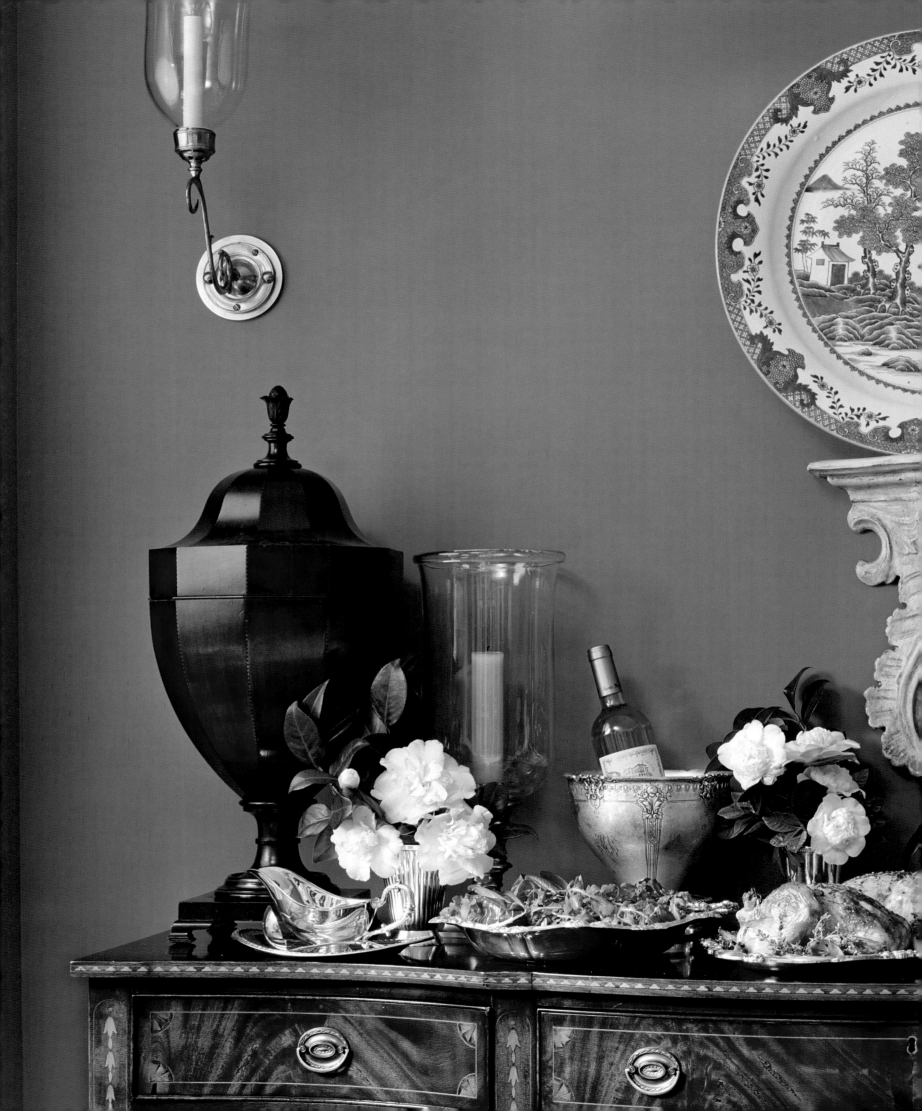

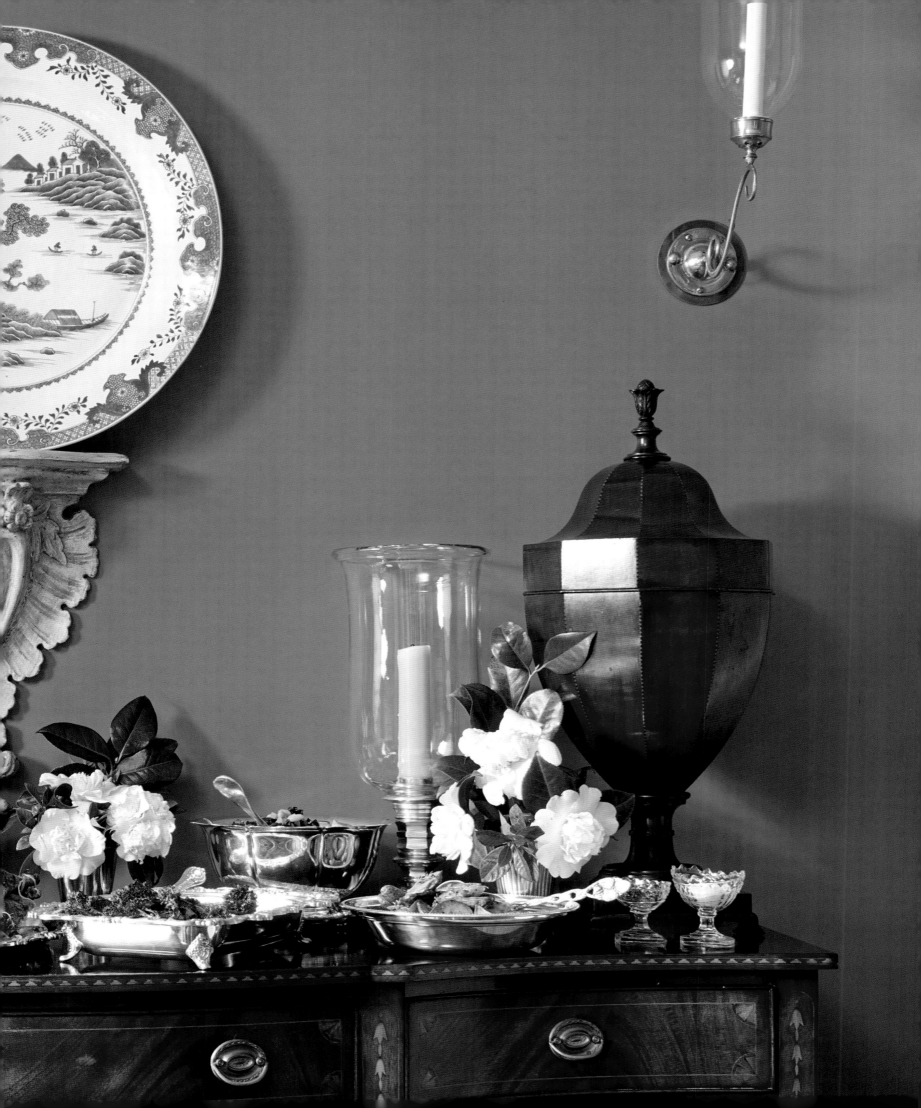

I like mixing old and new—antique crystal and silver chargers from my grandmother with new candlesticks from Asprey and my wedding silver from James Robinson. Then I cut some of the gardenia blossoms and put them in little mint julep cups.

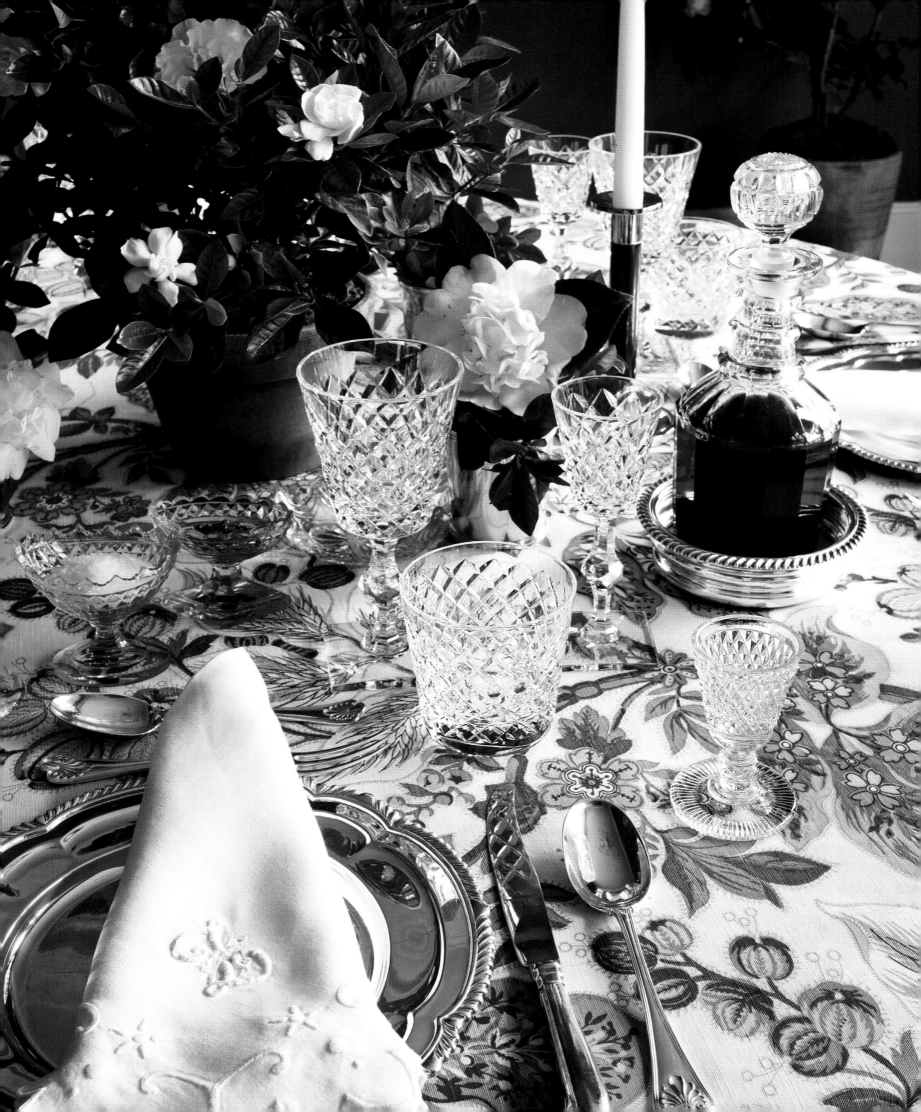

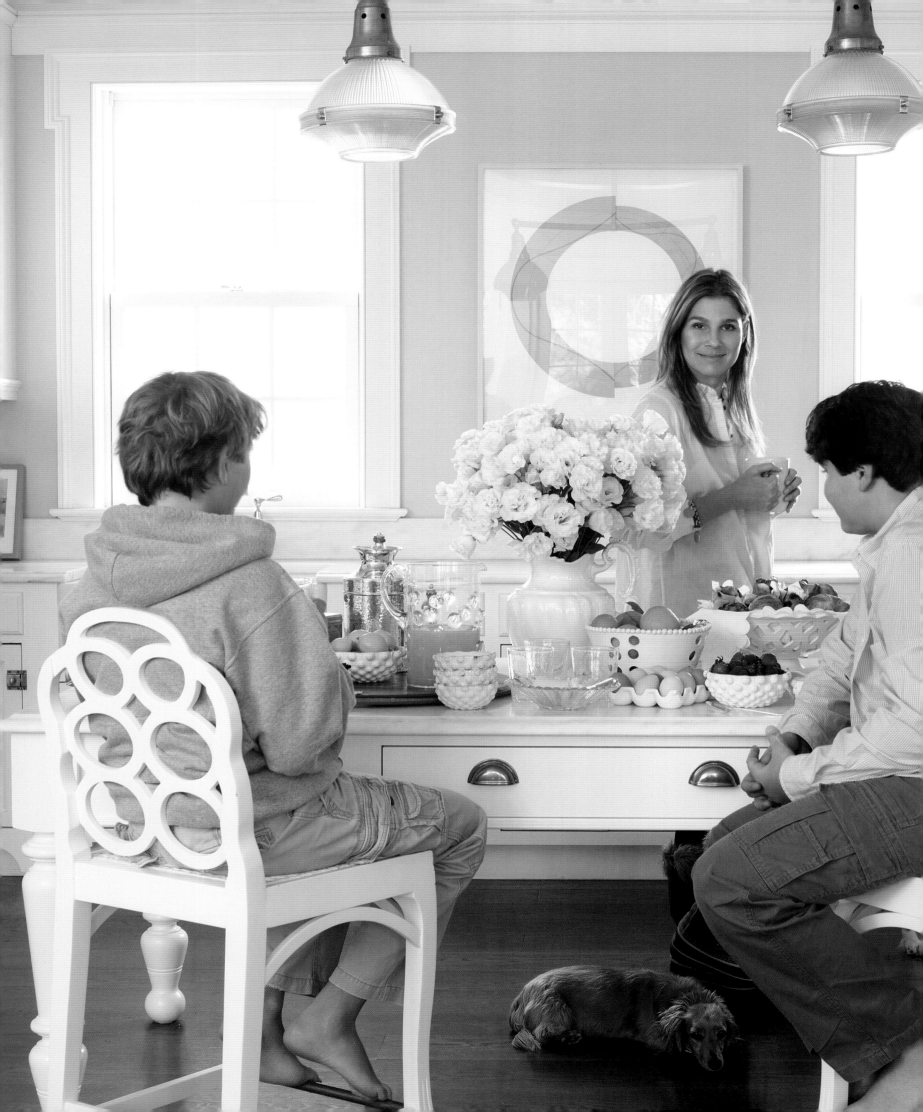

BREAKFAST WITH MY BOYS

On Saturday morning, I like to wake up before everyone else and make a big country breakfast—pancakes, eggs, bacon, muffins. My dad loves to cook, and he used to do the same thing for Jane, my mother, and me. It's wonderful not to be in a rush. Sometimes we're all in pajamas till late in the morning.

I'm constantly in and out of the kitchen. With various boys around—not only my two, but also umpteen friends—someone's always hungry. I've usually got a few children and grown-ups lined up at the island, ready for a snack. The island is painted white and it looks like an old farmhouse table, with a thick, indestructible slab of marble on top. The boys can pull up a stool and eat (I made sure the stools are comfortable), or do their homework here on Sunday.

When we were planning the space, I thought about how we were going to use it. Of course we needed room to cook, but for us it's just as important to have room to sit and socialize. The old kitchen was definitely not a place where people would want to hang out. Estée didn't cook the way we do, with friends gathered around as we get dinner ready. We'll open a bottle of wine and everybody will pitch in. With all the talk and laughter, the party is already off to a good start.

I like to look out at the trees when I'm standing at the sink, so each sink is under a window. No curtains block the sunshine, and that makes the room feel light and airy. We painted the walls and the ceiling sky-blue. It's almost like being outside.

When we're in the Hamptons, it's family time. We go to the house to relax and be together, and we use it all year long. Out here, the boys can just open the door and run outside to play. In summer, the breeze carries the scent of fresh-mown grass and roses from the garden. In autumn, we pick out pumpkins and buy apple cider at the local farmstands.

I love that moment of arrival, of unlocking the door after a long week and walking into this warm, familiar house. On Friday, I may drive out with the boys right after school, and the first thing I do when we get here is make a fire in the family room, if it's cold outside. Then I'll go upstairs and put on the lights and open the windows. When Eric arrives, we'll all have an easy dinner together, and maybe watch an old movie before we go to sleep.

It's wonderful to have no particular plans for the day—no meetings, no lunches, no schedule. Pure freedom. In the morning, I'll get dressed and take a walk with the

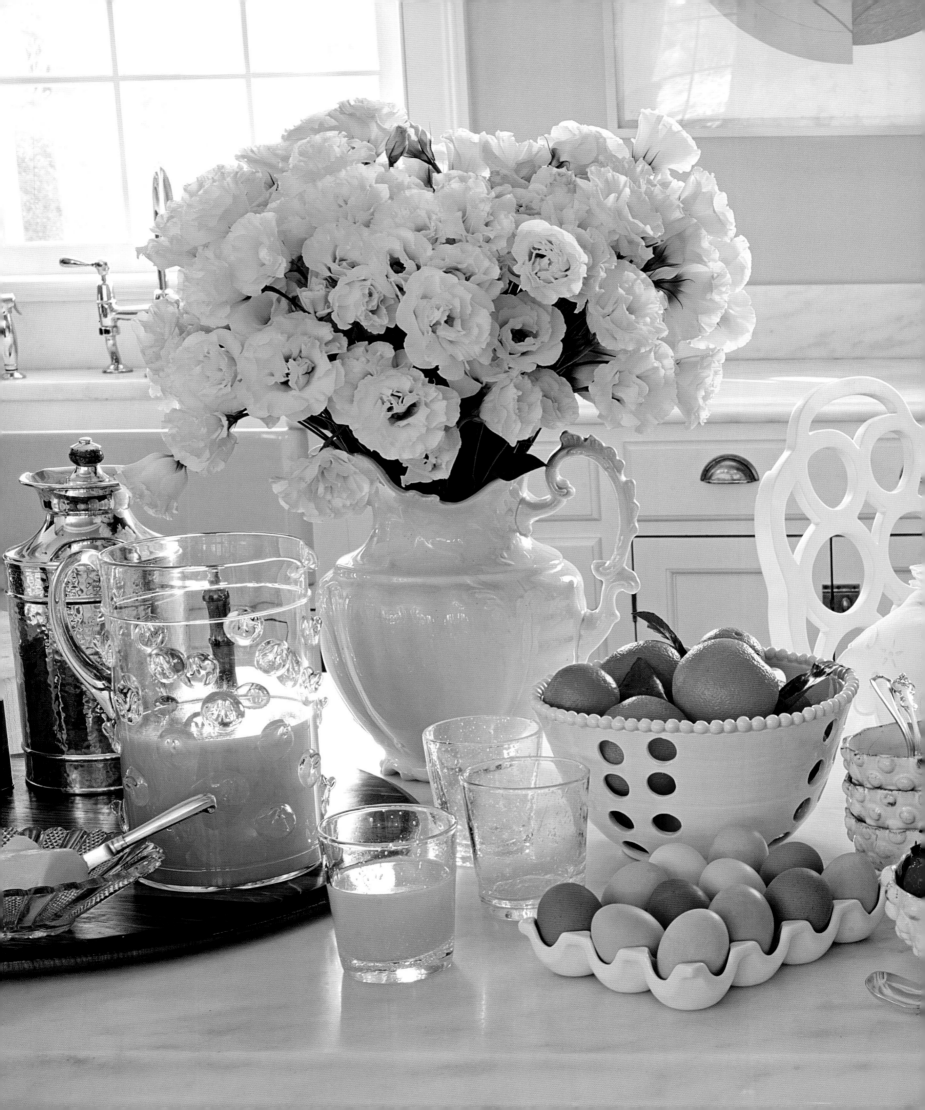

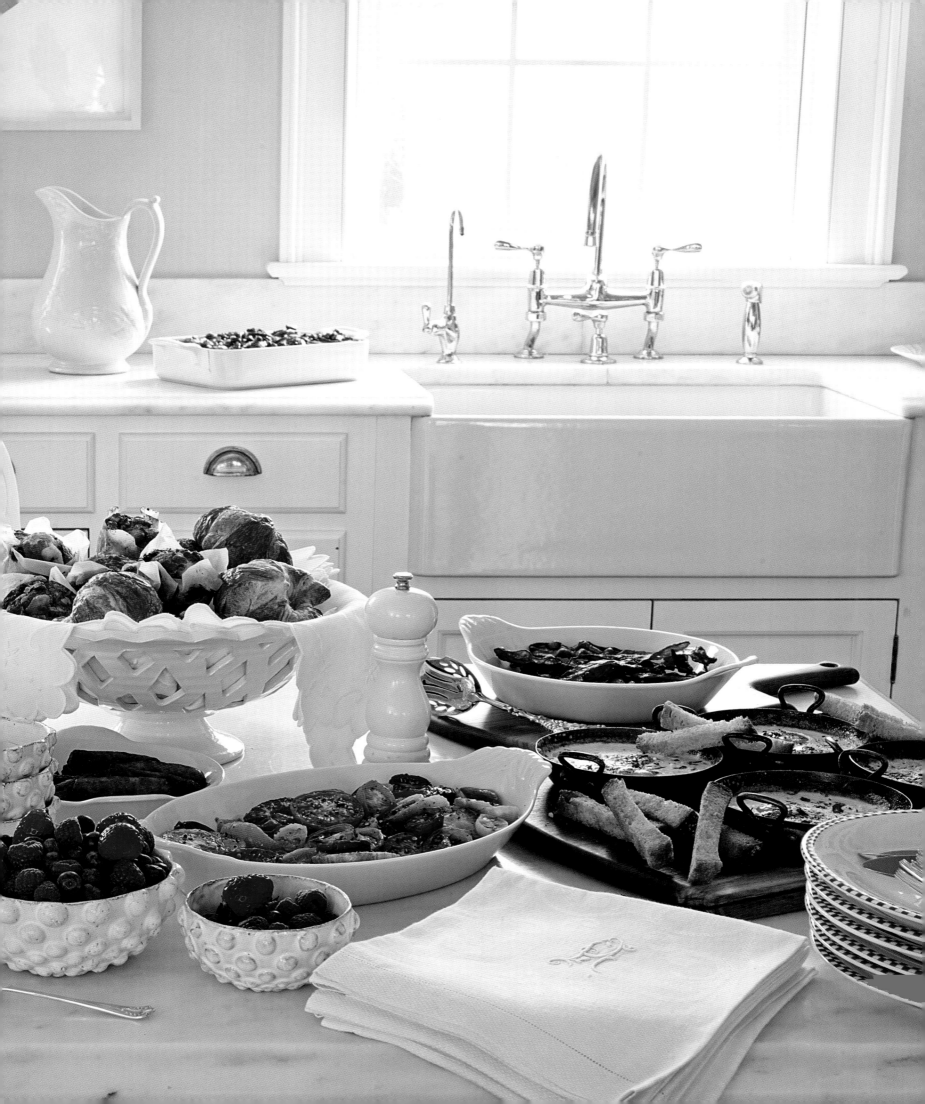

dogs and a cup of coffee—my favorite way to start the day. The kids might invite some friends over to play basketball. If the boys and Eric are totally engrossed in sports, I might head into town to browse through the bookstore or see what's in the antiques shops. I used to line up to get into Sage Street Antiques, and I try not to miss the East Hampton Antiques Show in July.

When we're out here, I'm reminded of my own childhood. The program hasn't changed that much (although my playtime was more about Barbie than basketball). We spend long, sunny days at the beach, where the boys will go skimboarding or surfing. If the water's calm, we might take the boat out so they can go wakeboarding. Eric and the boys gave me a mountain bike for Mother's Day one year. On a crystal-clear Saturday afternoon, we'll all get on our bikes for a long, meandering ride, exploring the countryside. Then there's tennis, swimming, sailing, paddleboard, Ping-Pong, baseball, football . . . the fun never stops with two boys.

We live outdoors here. I feel closer to nature. I'll take long walks on the beach and pick up shells that I'll set on the mantel. In autumn, leaves and pinecones take their place. The boys will pitch a tent in the backyard and build forts and stay out late, shooting hoops on the driveway until it gets too dark to see the ball.

Now that we've added some extra bedrooms, we can have lots of houseguests. My attitude is, if we're cooking, we might as well invite a few more people over . . . and then, before we know it, it turns into a party. With all the great local produce brimming from baskets at the farmstand, it's easy to be spontaneous.

I have great memories of clambakes and barbecues. It doesn't take much effort to grill some fish or a few steaks and make a big green salad. We'll set up a bar in the living room so people can just step in and out through the French doors and help themselves. I'll throw a tablecloth over the picnic table and light a few candles and we'll eat outside. Mismatched pitchers of sangria are set down in the middle of the tables. When the kids are done, they can get up and run around and play flashlight tag while the adults sit and talk and have another glass of wine.

Whenever I get a little frantic before a party, I think back to my dad's gatherings. He would spend the day making homemade pasta and then invite twenty-five people over to share it. If a dish didn't turn out exactly as he had planned, it was no problem. He taught me that it really doesn't matter what you serve, but how you serve it. And he handed out every plate with love.

Crudités

Watermelon Gazpacho

Steamed Lobster
WITH LEMON BUTTER

Grilled Corn on the Cob

Summer Peach Pie

Lemon Mint Iced Tea

Rosé

Our summers in this house are very much like my summers as a child. It's gratifying, as if I've come full circle, to do the same things with my boys that my parents used to do with me.

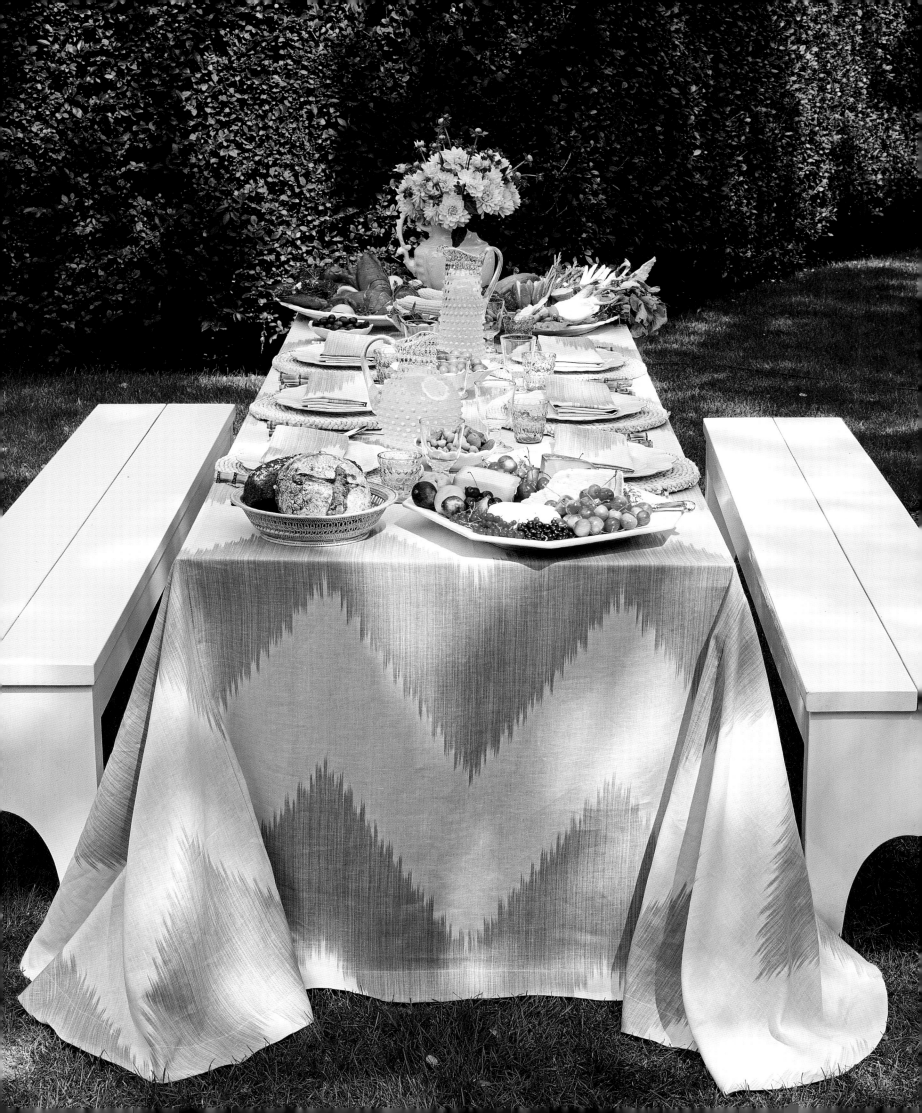

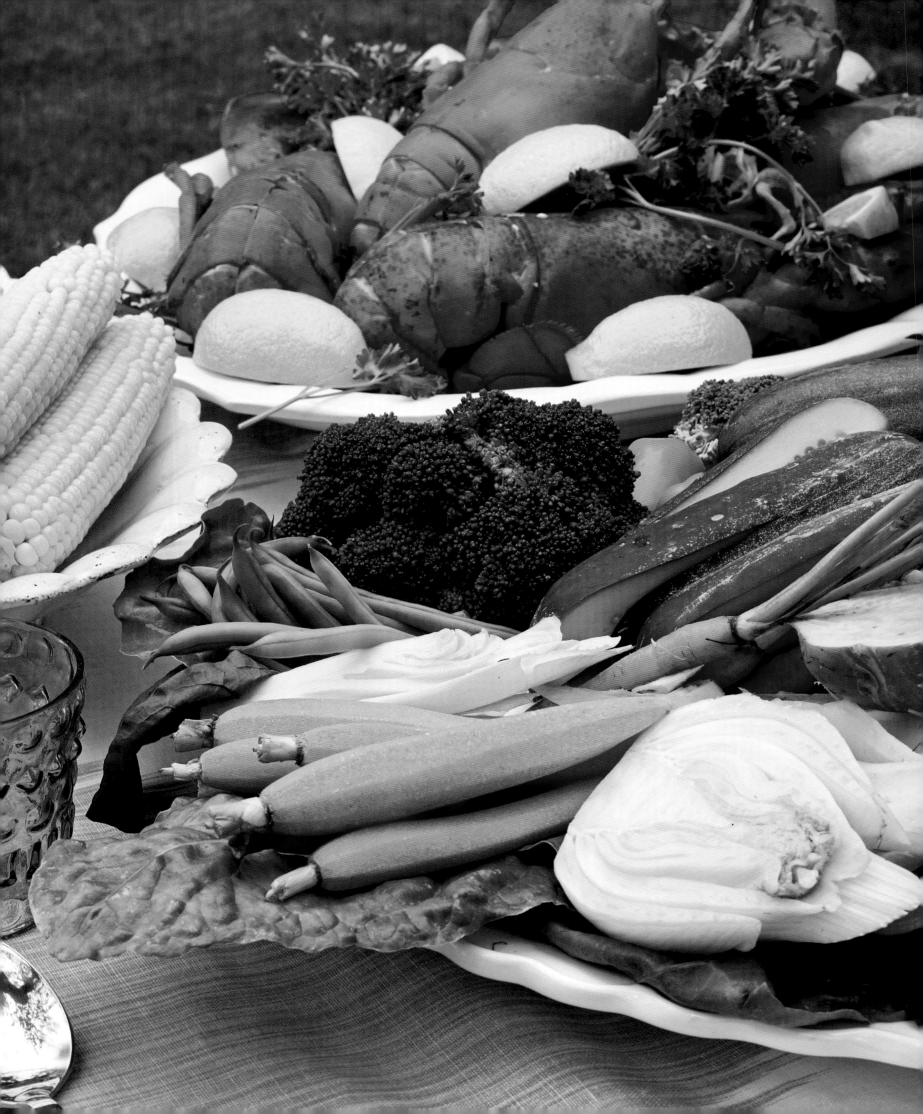

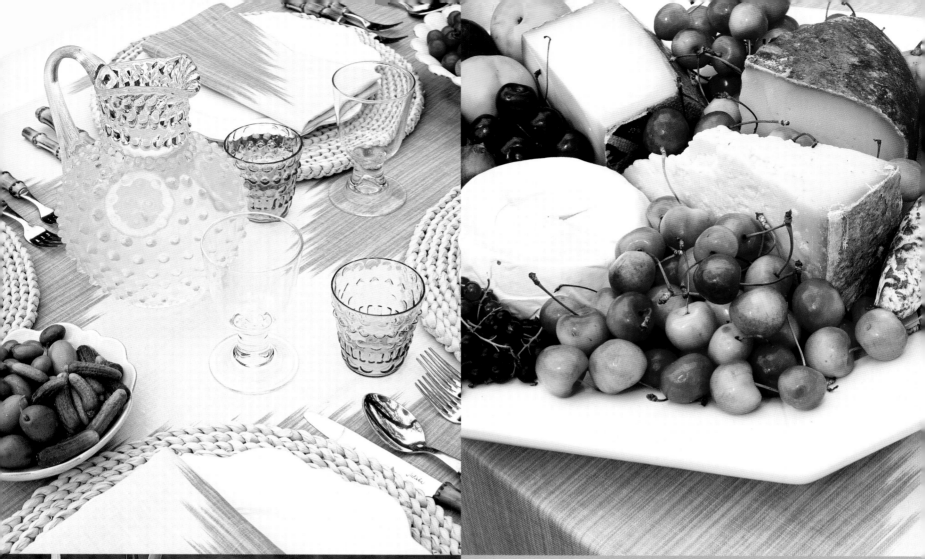

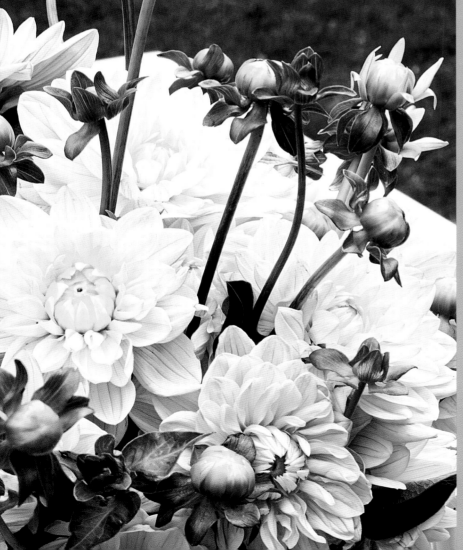

IN SUMMER, EVERYTHING'S FRESH AND RIPE AND IT'S EASY TO MAKE A GREAT MEAL.

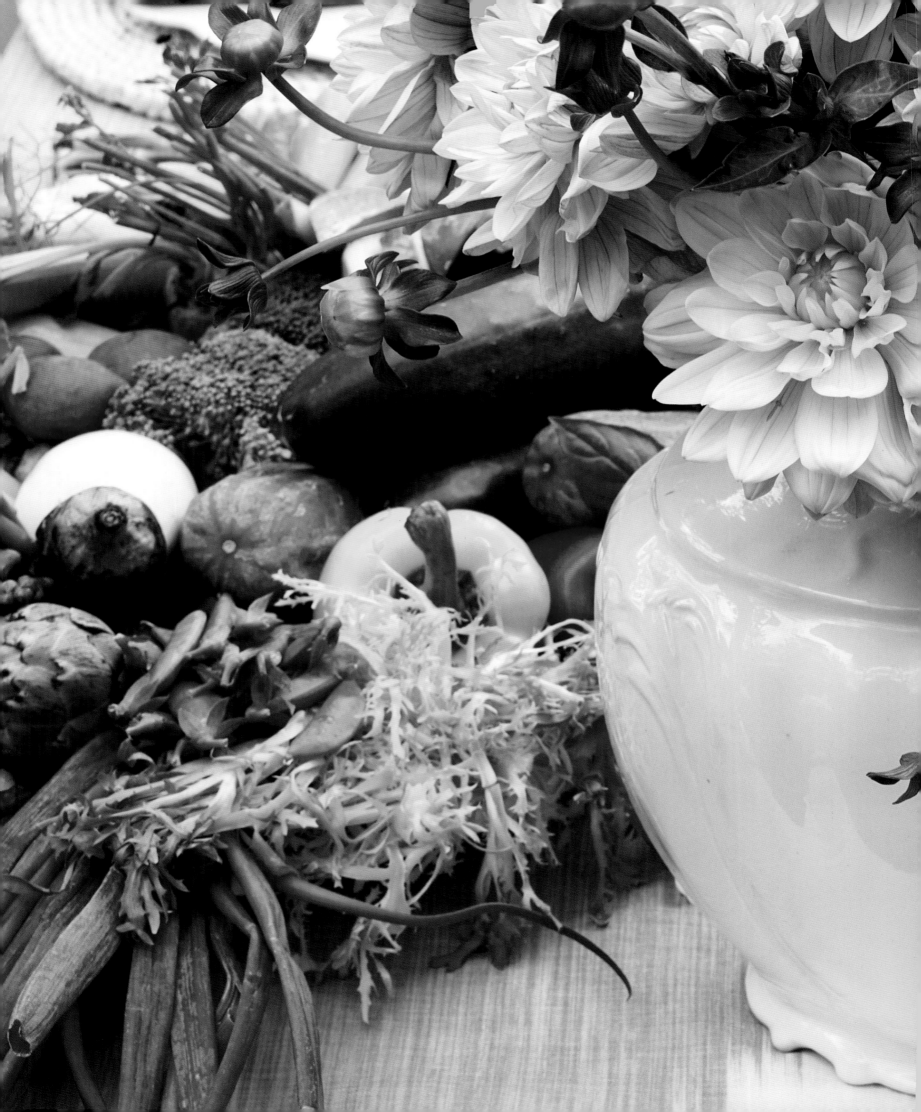

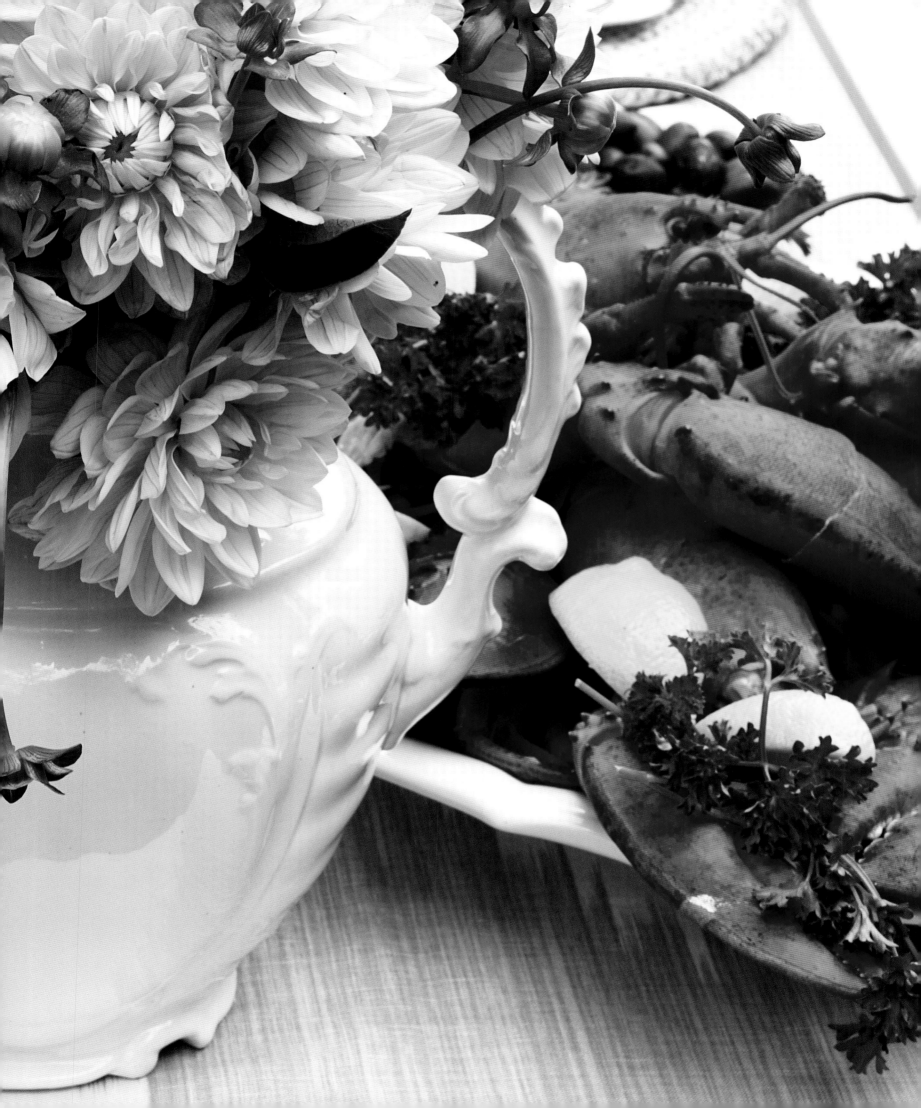

One of my great pleasures is to go out into the garden in the early morning and gather flowers for the house.

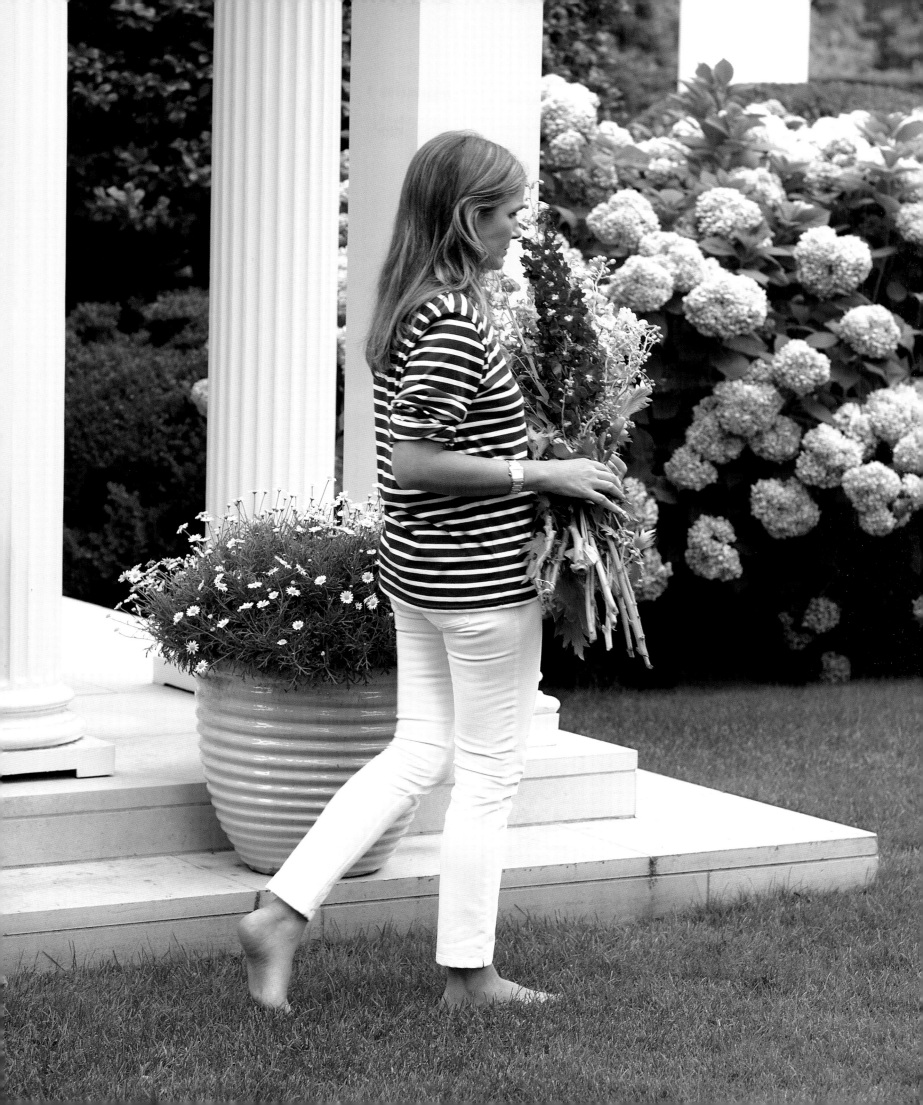

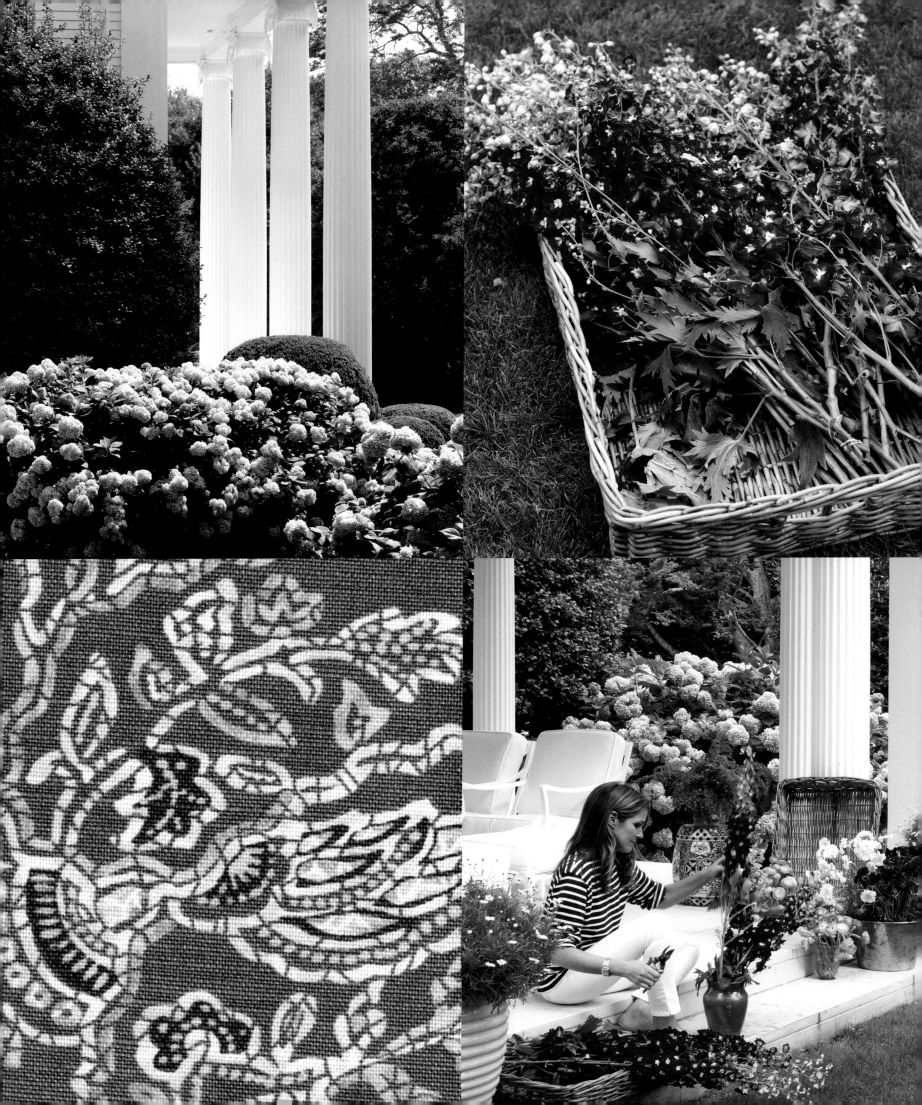

THE PALETTE IN MY GARDEN RELATES TO THE PALETTE IN MY HOUSE. IT'S HEAVY ON BLUE, WHITE, AND PURPLE.

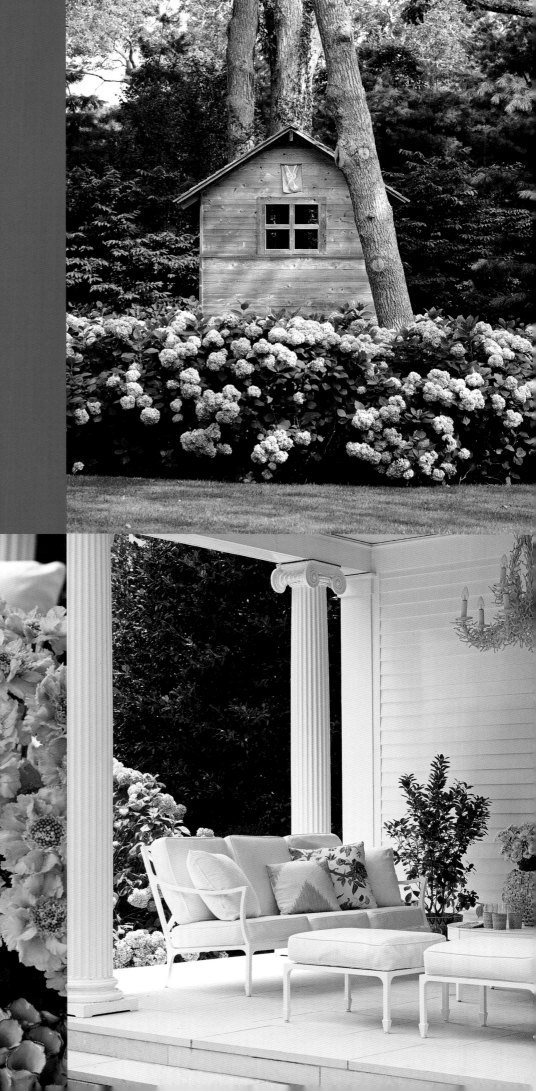

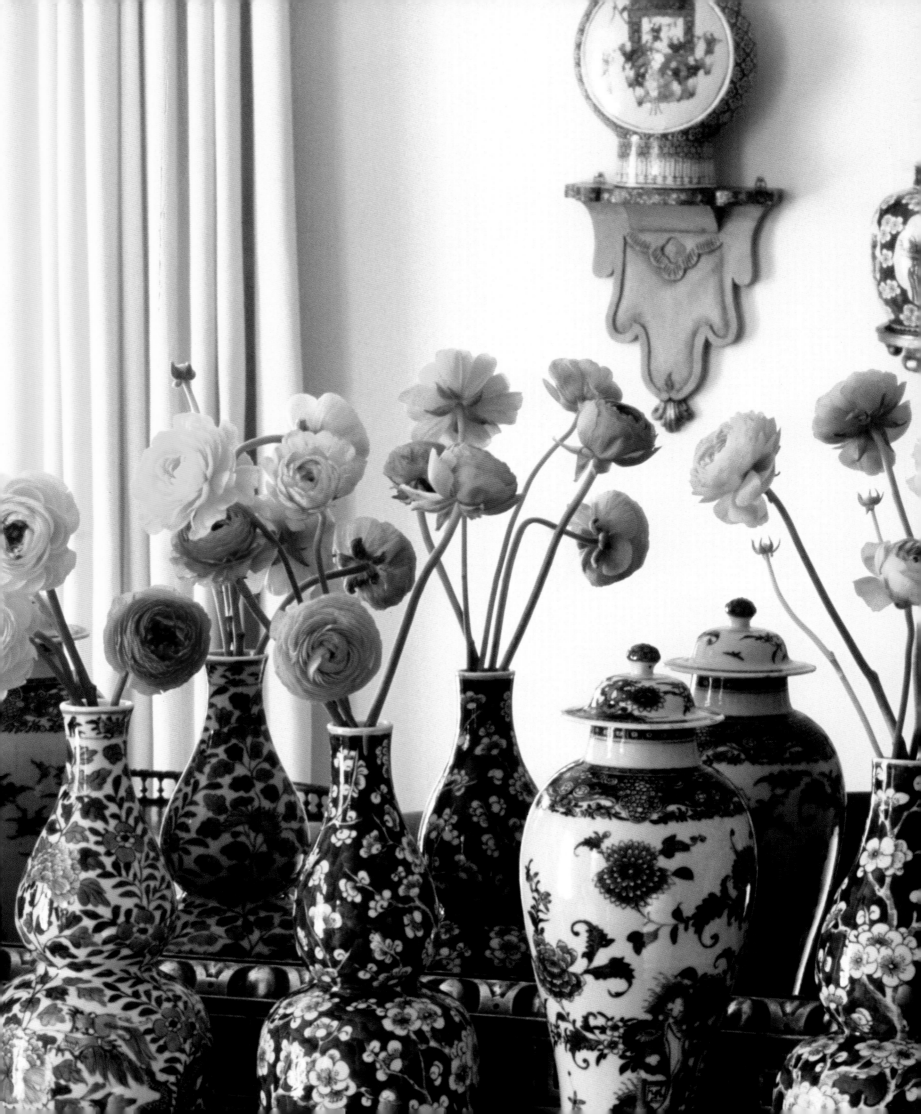

Perry Guillot, who did the landscaping for us, planted a cutting garden with roses, dahlias, and peonies. Then there are the hydrangeas, which flourish out here, growing so fat and tall that I can cut tons of them and never feel their loss.

I also like to stop by the local farmstands and see if they have any wildflowers for sale—columbine, black-eyed Susan, lupine, Queen Anne's lace, goldenrod. They bring a bit of the countryside into the house.

A very simple arrangement, often with just one type of flower in a single color, appeals most to me. It's easy and it looks homemade, which is the effect I want. I don't like anything too forced or artificial.

Having a collection of vases in various heights means I can accommodate all sorts of flowers. Sometimes I'll improvise with something unexpected, like a Mason jar or a silver mint julep cup. It looks very pretty, filled with a few sprigs and set by the sink in a bathroom. If I have enough flowers, I'll put them in every room in the house. It's such a simple way to make everyone happy.

COLLECTING

An antique cabinet sits on the landing that leads to the upstairs rooms. It's nice to place a piece of furniture there, because it creates a sense of arrival. And this cabinet sparks a visitor's curiosity: What's behind those glass doors?

When I was a child, it was filled with Estée's collection of handpainted porcelain birds, and I wanted nothing more than to play with these strange and wonderful objects. Since I was forbidden to touch, of course they were even more attractive. Occasionally she would take one down to show me, and I was so excited that I practically held my breath. We called them Dodi birds, and they're part of my decorating DNA—along with her Gracie wallpaper. Estée was feminine to her core and she loved birds and flowers. I loved them too and a part of me still does, even though my style is much more tailored than hers.

Instead of birds, I collect shells. I'm fascinated by the way nature has created all these forms, like sculpture. No two are quite the same, and the colors are amazing. I'll walk along the beach and look for interesting specimens. There are always a few in my bag when we come home from vacation. And I can never resist taking just a quick look inside the Shell Shop in Sag Harbor.

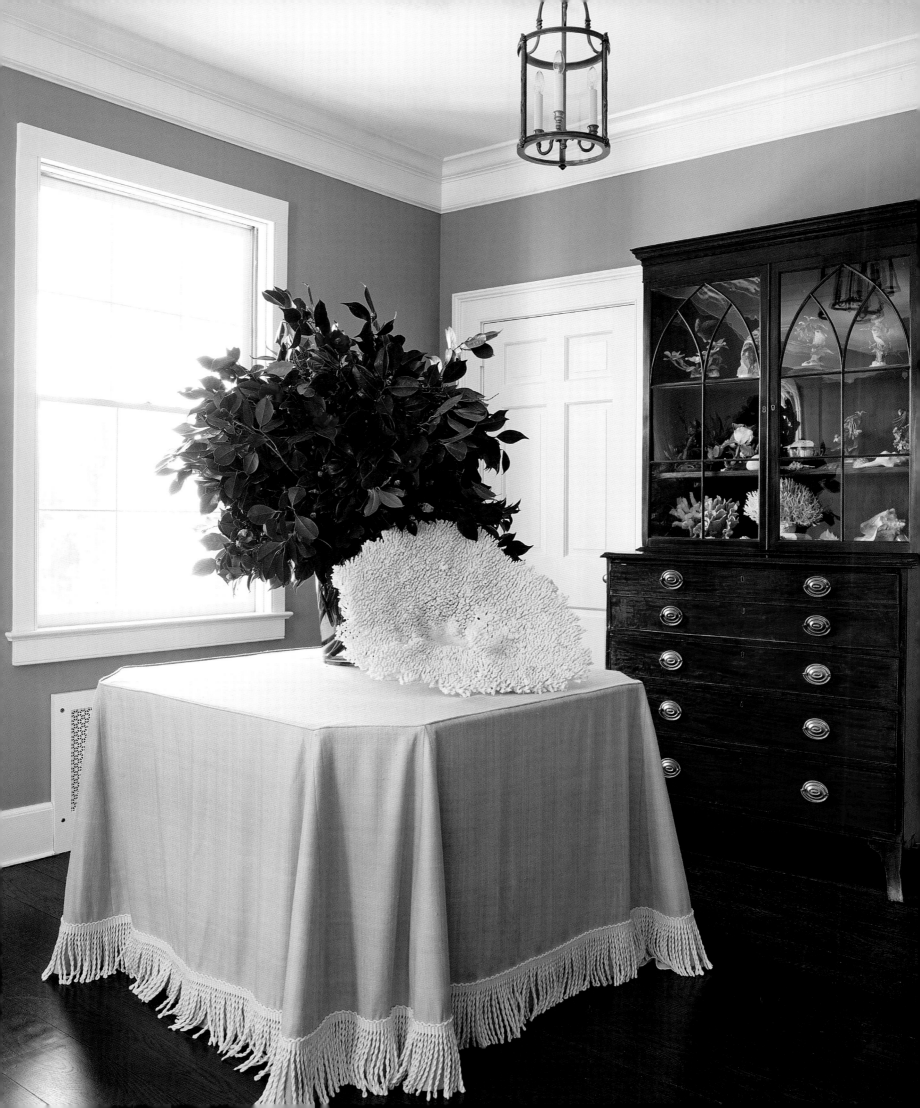

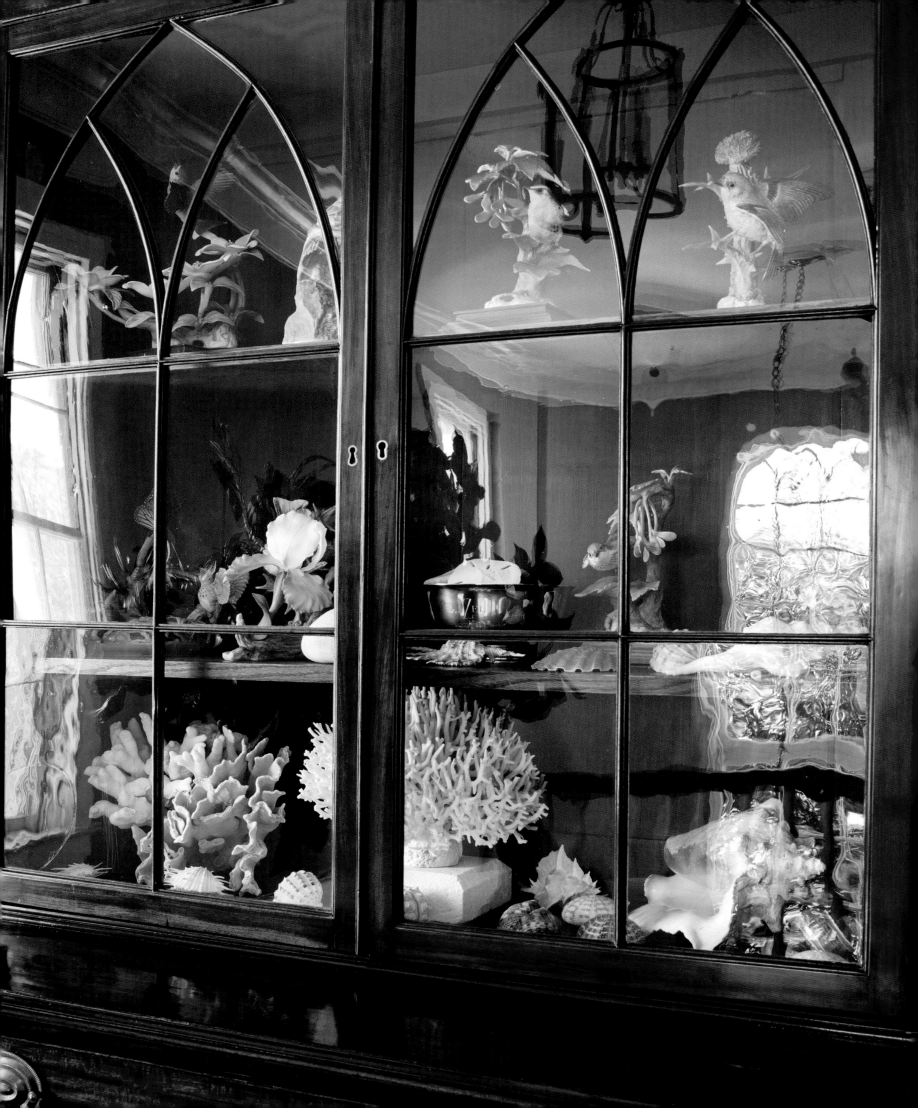

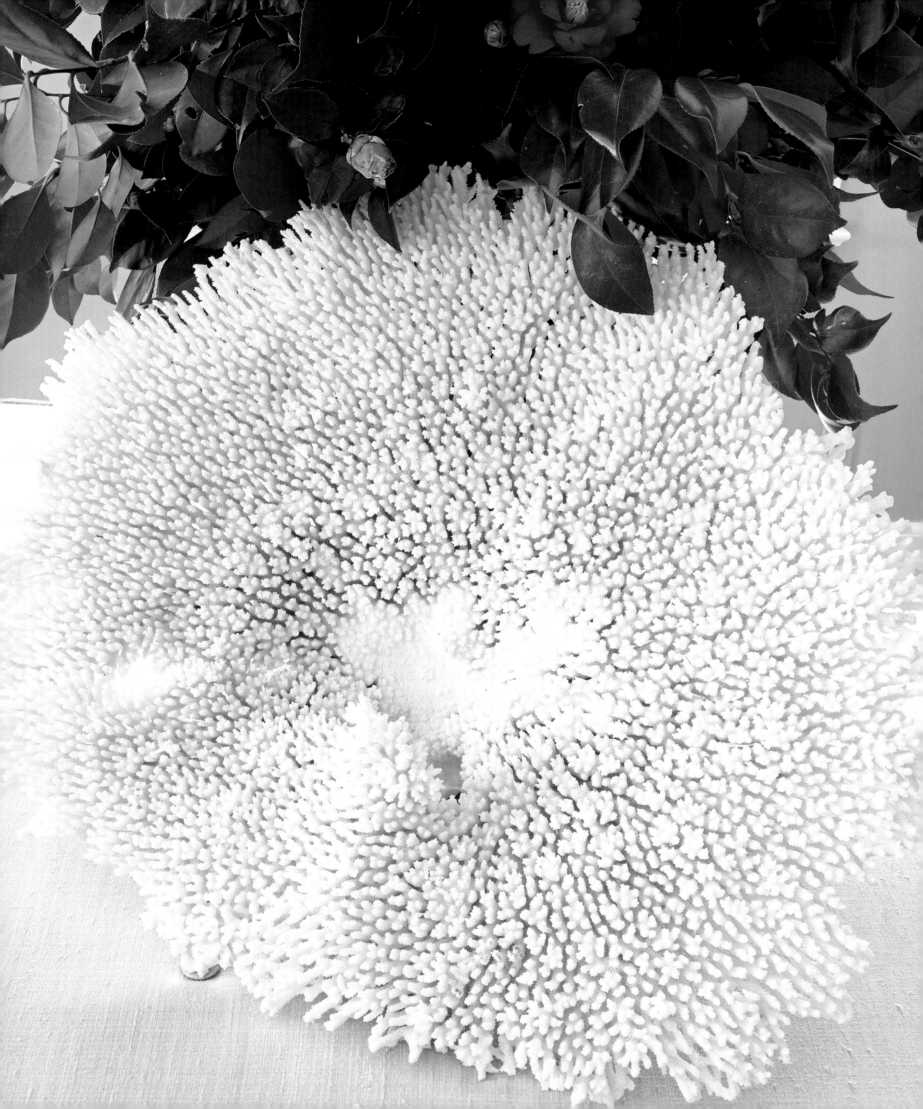

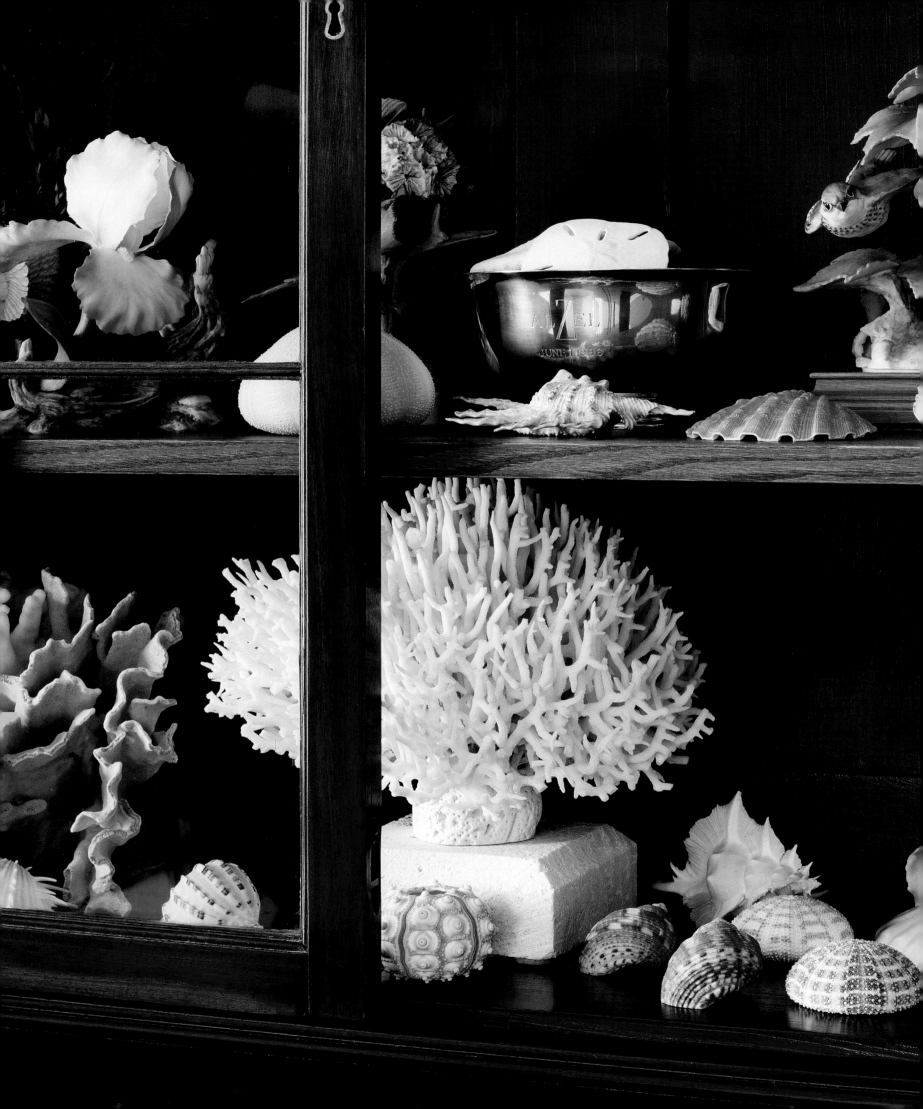

Now, behind that cabinet's glass doors, I've merged our collections. My shells are arrayed next to her Dodi birds. I don't think my husband or my boys will ever love a Dodi bird, but that's all right. My family knows how much they mean to me.

RELAX

When this was Estée's sitting room, the walls and the sofa were covered in a flowery, feminine, blue-and-white batik. After all those years in the sun, the fabric was shredding and it had to come down. I was glad. I wanted to simplify the room and make it a little more beachy. It's upstairs by the guest rooms, and everyone comes here to relax and talk or watch TV. (There are no TVs in the bedrooms. Out here in the country, I think there's something wonderfully old-fashioned about bedrooms that are just for sleeping and reading.)

I kept the big, comfortable sofas and chairs Estée had, but updated them with a more geometric batik, made by John Robshaw. Blue and white again, in honor of Estée and because it seems perfect for the beach. When I first spotted the coffee table in a local shop, it was a bit battered and the yellow paint was scuffed. But I was attracted to the strong shape. White lacquer can do wonders for almost anything.

The photograph of a breaking wave is by Clifford Ross, and the other wall-sized photograph is by Tina Barney. The sheer scale is compelling. It draws you in. And it gave me an idea: to take a photograph and have it blown way up, to give as a gift to a friend. I've done it many times and people love it.

Continuing the beach motif, I set out shells and large chunks of coral. Some of them came from Evolution, a favorite store in SoHo that's another great source for shells. I can never have enough of them!

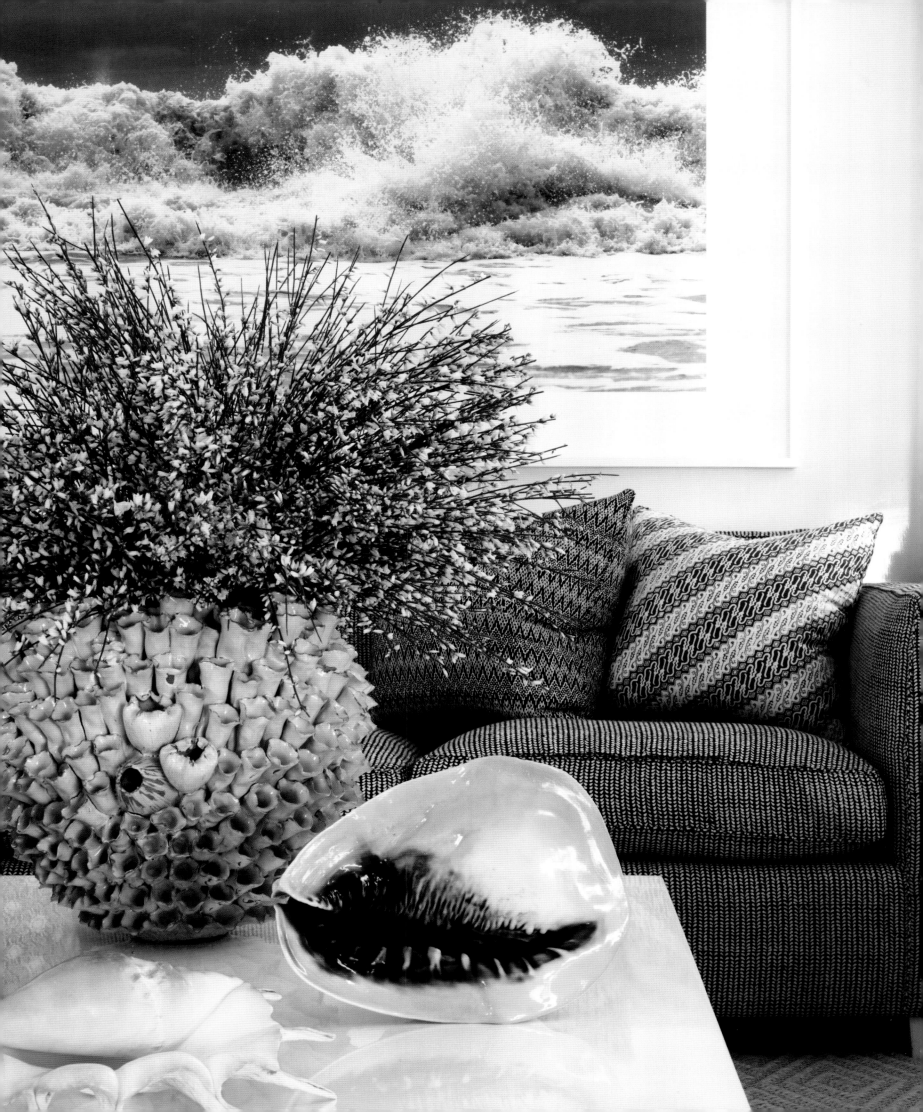

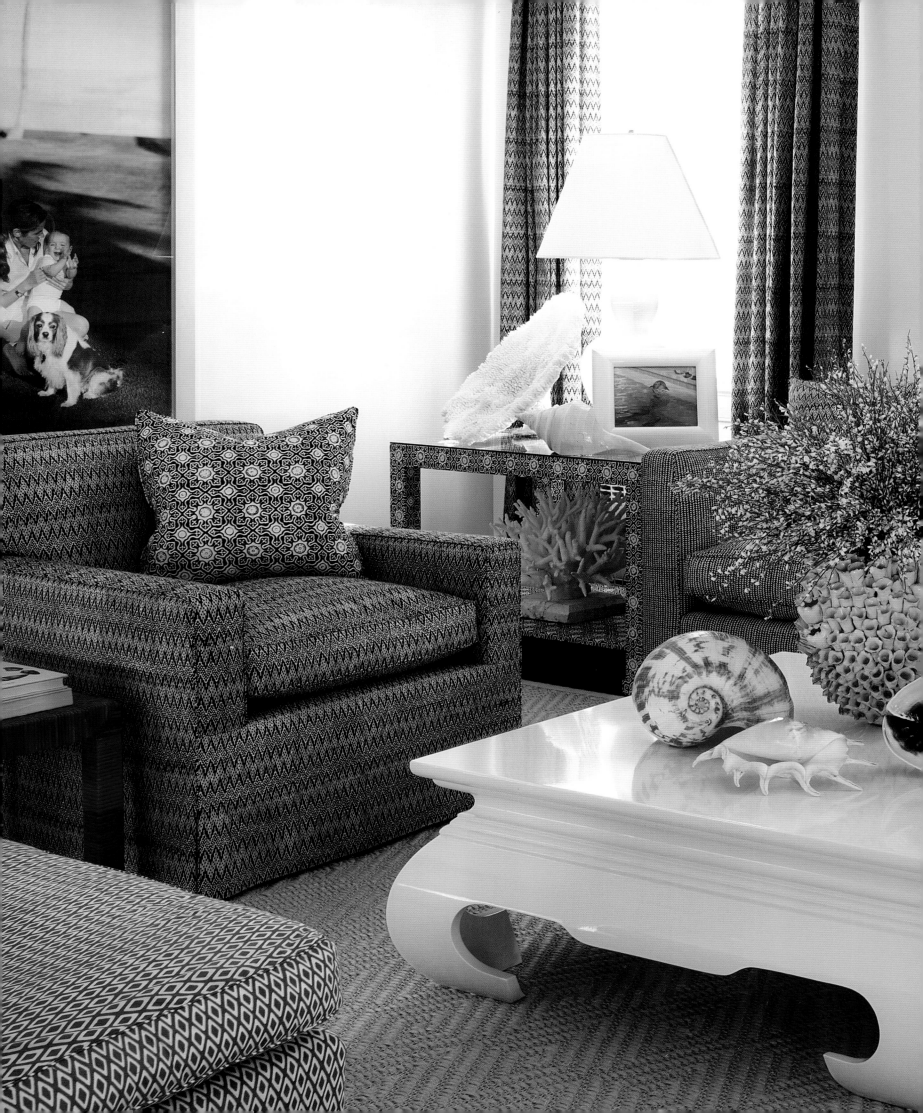

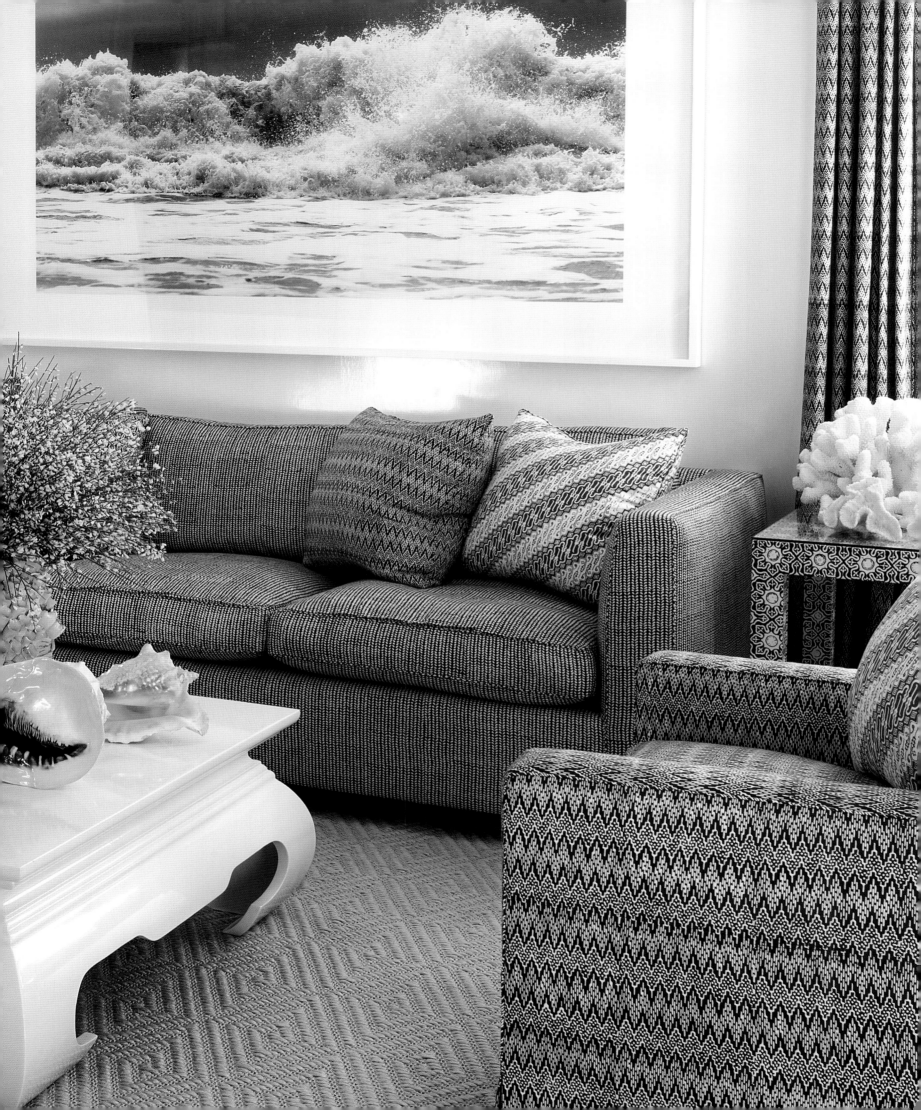

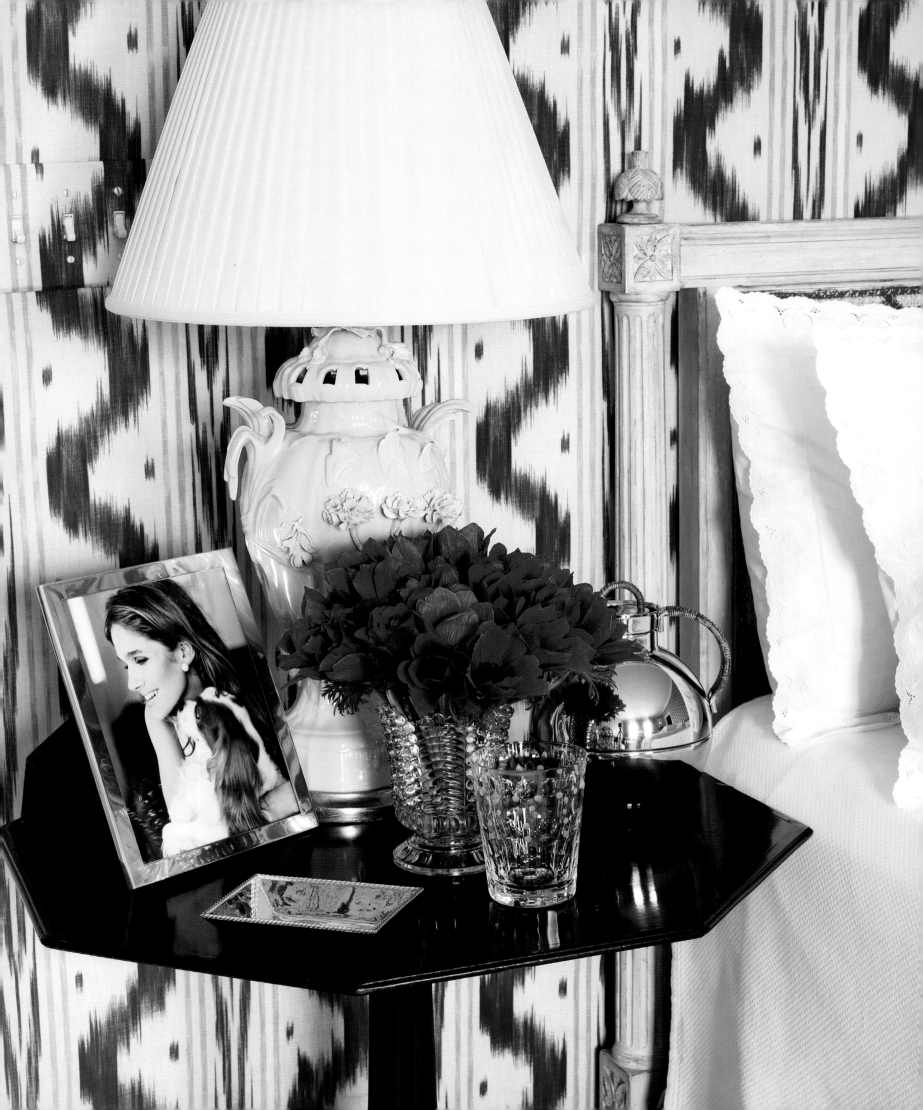

ESTÉE'S BEDROOM

Estée's devotion to blue and white was clear in everything she touched, from the design of a jar of face cream right down to the Porthault linens on her bed. That crazy zigzagging ikat fabric from Pierre Frey was her choice, and she used it every-where—on the walls, the curtains, the bed skirts, and the upholstery. She preferred twin beds—both of the original bedrooms had them—and these are French, made of white-painted wood.

On the bedside table she would always have a pad of paper with matching pen, a vase of flowers, family photographs, and a white porcelain lamp—the more ornate, the better. (I have to admit I've grown quite fond of those lamps.) A chalk drawing of my sister and me when we were eight and ten, wearing matching dresses, hangs on the wall right where she always had it.

But my favorite thing in the room is Estée's Louis XVI–style dressing table. When Eric and I first came here to stay and I opened the drawers, her hairbrushes and combs, her lipsticks and sunglasses were still there—as if she had never left. On top of the table was an array of perfumes. She felt every woman should have a ward-robe of fragrances—one floral, one spicy, one sporty, one black-tie formal. A silver tray held a selection of compacts—golden, enameled, sometimes set with semipre-cious stones. She was a genius at packaging and she knew how alluring a pretty compact could be. Some, shaped like Fabergé eggs, held solid perfume.

Now the dressing table displays a mix of her things and mine. I've taken a cue from her and designed simple, elegant gold compacts for my new cosmetics line. Then I went one step further, adding pretty accessories to keep on a bedside table, a vanity, or a desk—seashells dipped in gold, a chunky quartz dish to hold jewelry or soap, a paperweight shaped like a sea urchin. They're a little treat for the eye and they make a room feel more personal.

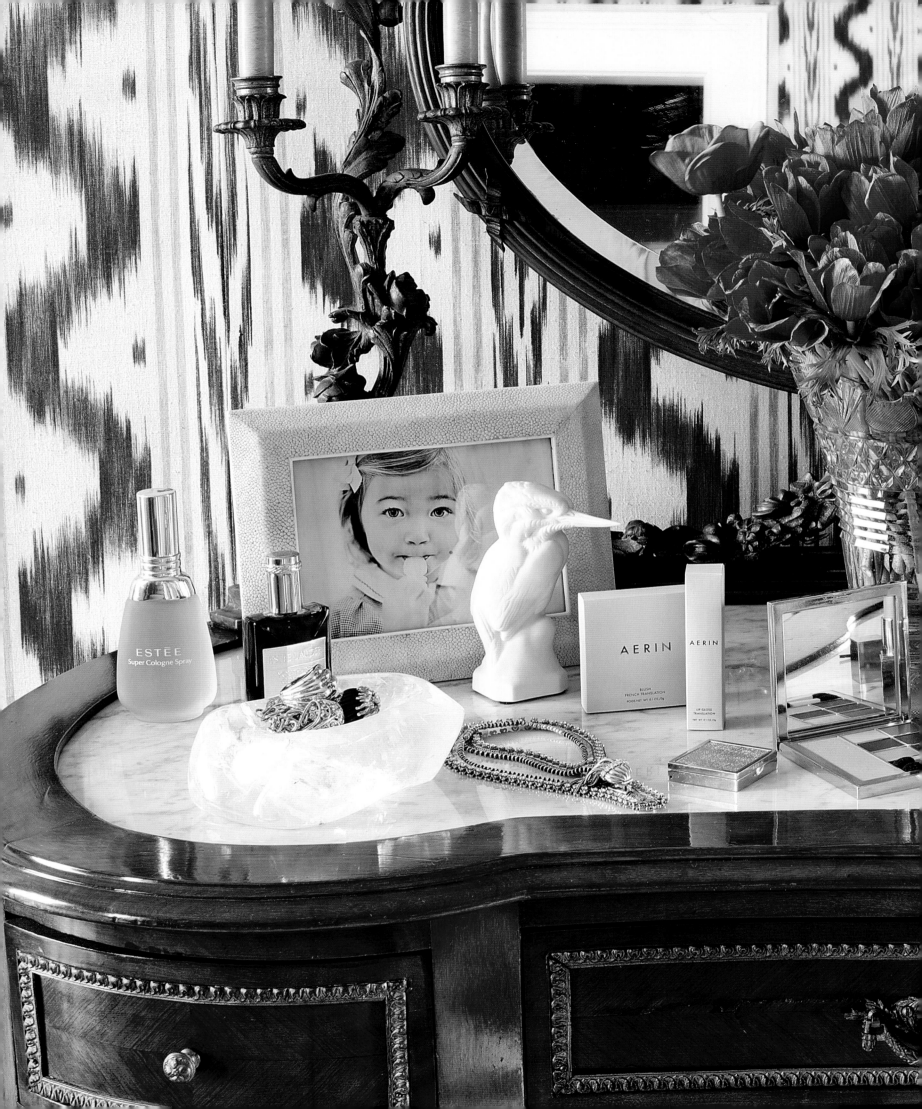

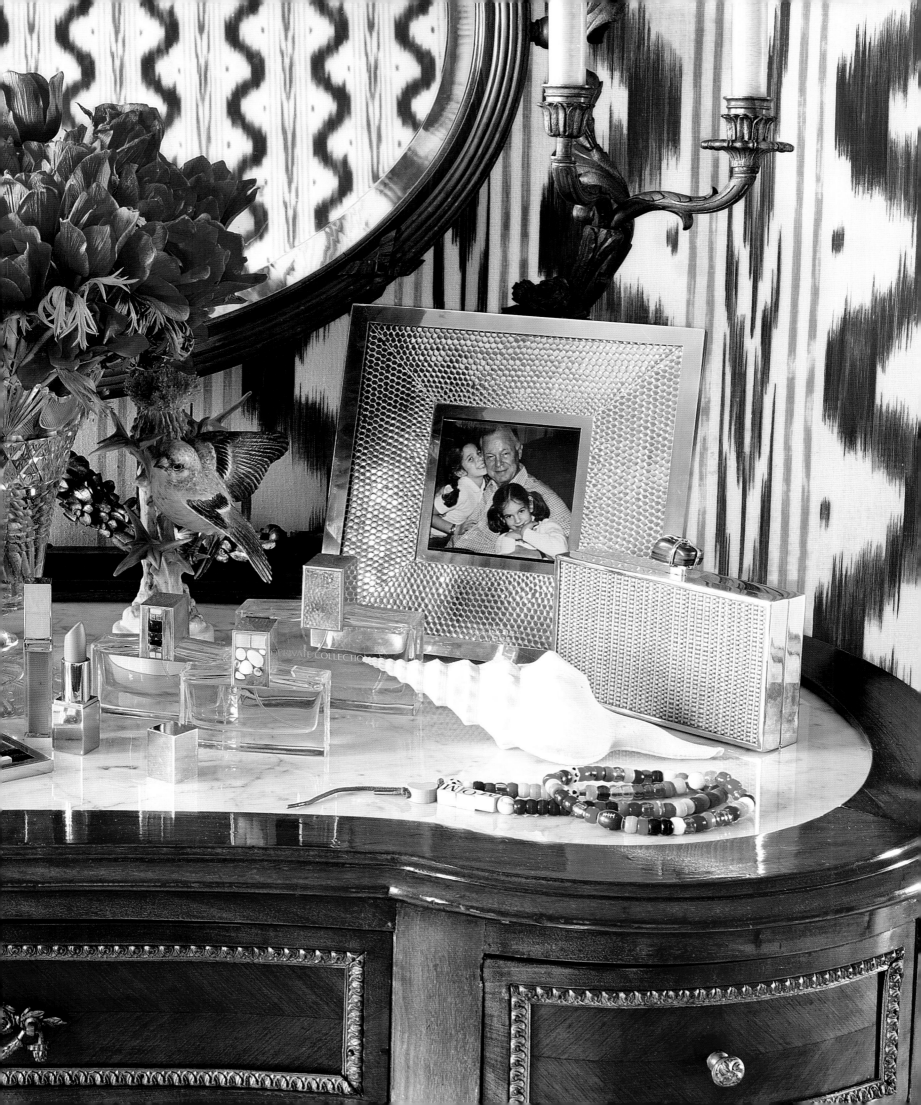

Estée's bedroom
is basically just
as she left it. I could
never take it apart.

MASTER BEDROOM

All the pattern in the master bedroom is a real departure for me. In the city, we sleep in a room that's pale gray. But out here, I took my design direction from Estée and indulged another side of my personality. Flowery prints on chairs, walls, and curtains are part of my history. Without them, I feel as if something's missing.

This particular print, by Michael Devine for AM Collections, captivated me. It's a little French, a little Early American, and it reminds me of leaves. When I walk into the room, I feel as if I'm up in the trees. The brown on beige is warm and inviting. It's not too masculine or too feminine; anyone would feel comfortable here.

One of the nicest gifts you can give yourself is beautiful bed linens. I had a wonderful time choosing the details—brown piping and the scalloped trim—on these linens from E. Braun. There's a duvet folded at the foot of the bed because I like to sleep under a down comforter, no matter what the season. They're light, and yet so cozy.

I followed my grandmother's formula once again for the bedside tables—fresh flowers, a notepad, and a white porcelain lamp. (These lamps are amazing. They're even more out-there than Estée's.) I thought two tufted chairs would be inviting in front of the fireplace. They're midcentury pieces by Edward Wormley that I recovered in white fabric to freshen them up a bit. White cushions also make two of Estée's chairs, which I brought up from the dining room and set on either side of a chest of drawers, look more youthful.

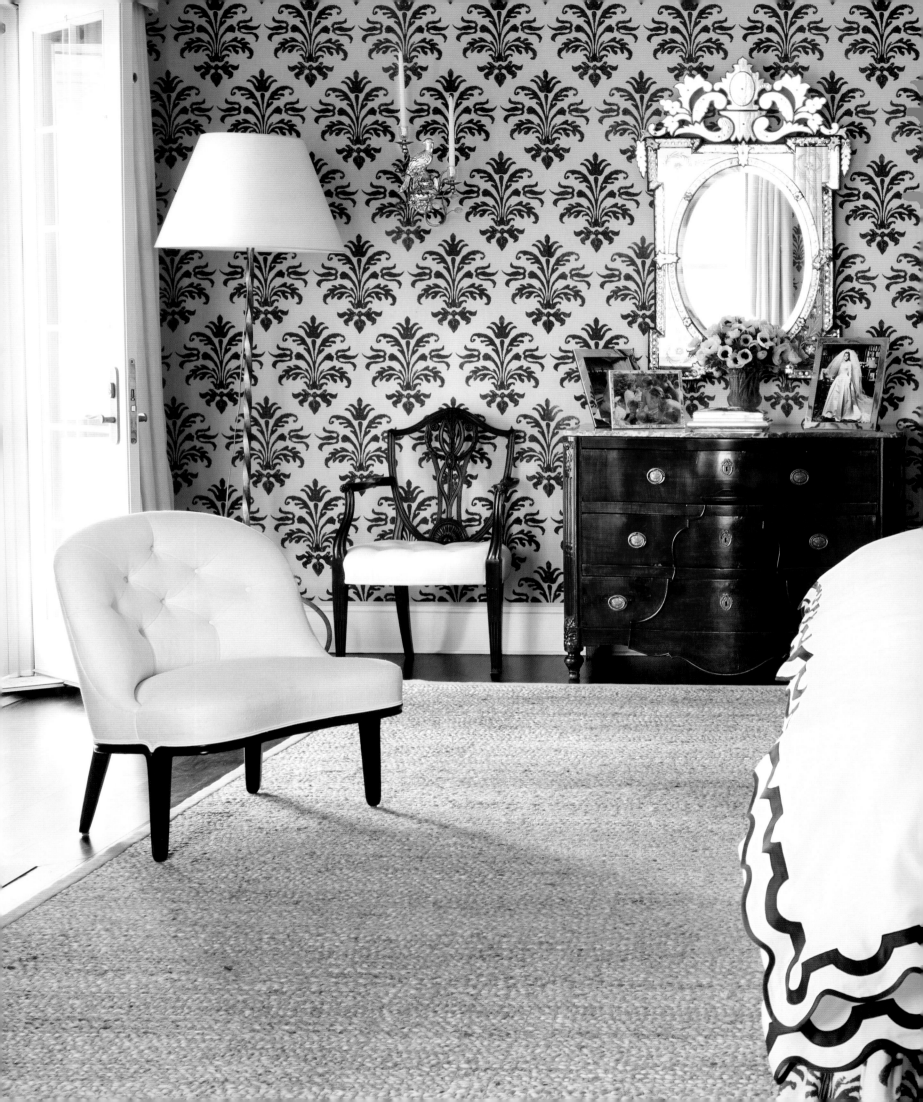

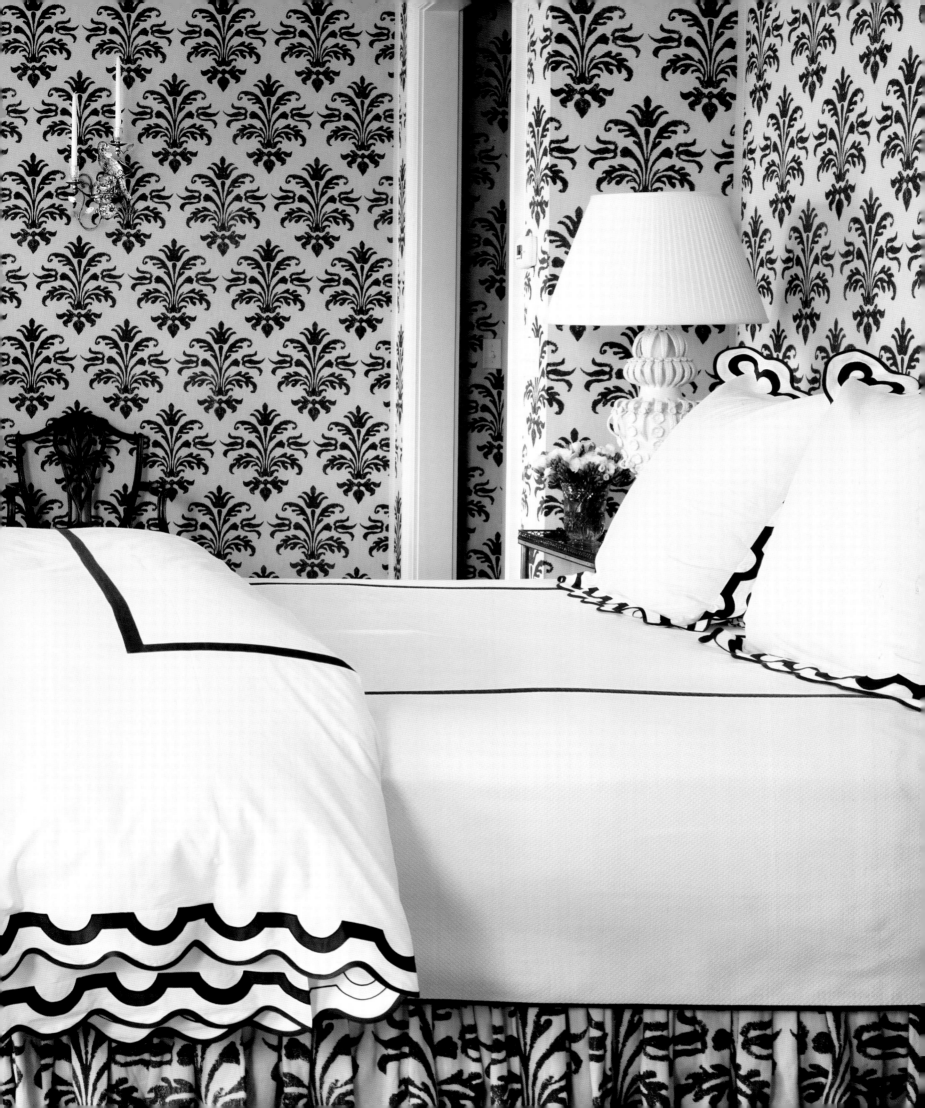

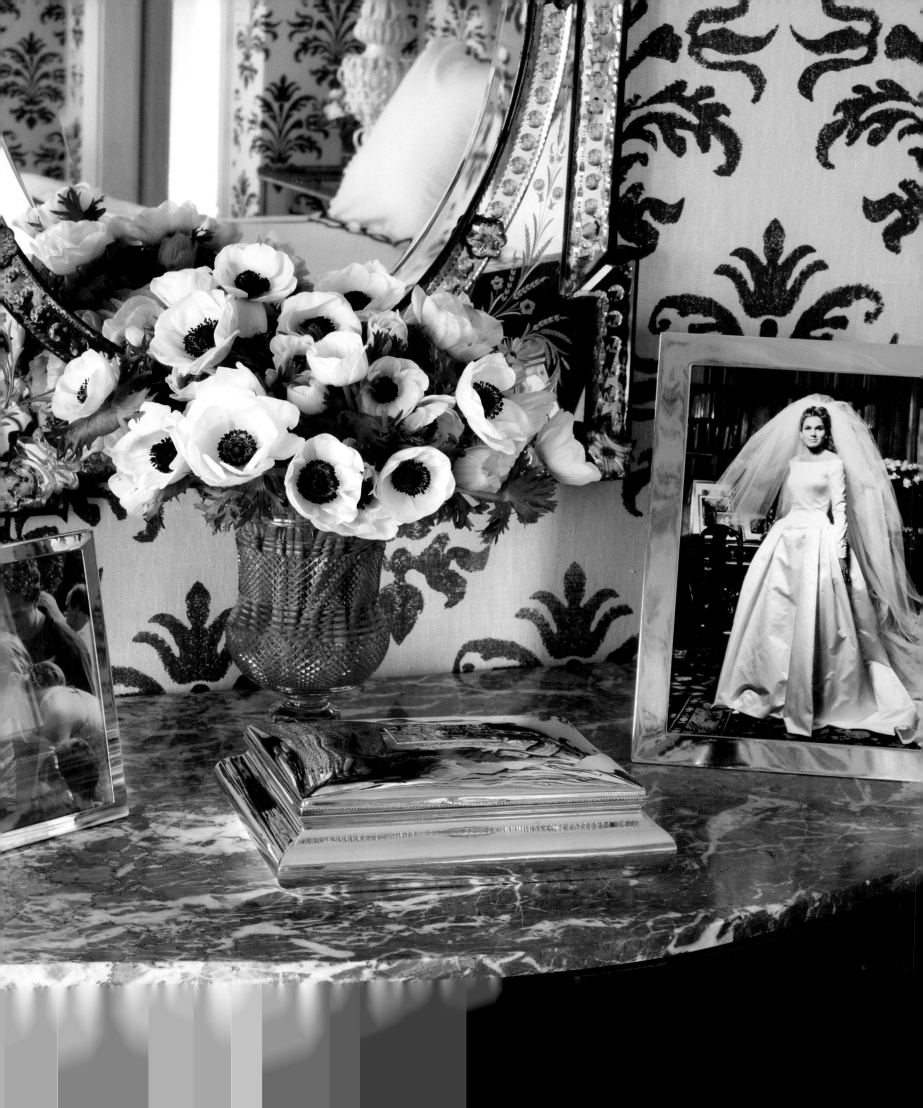

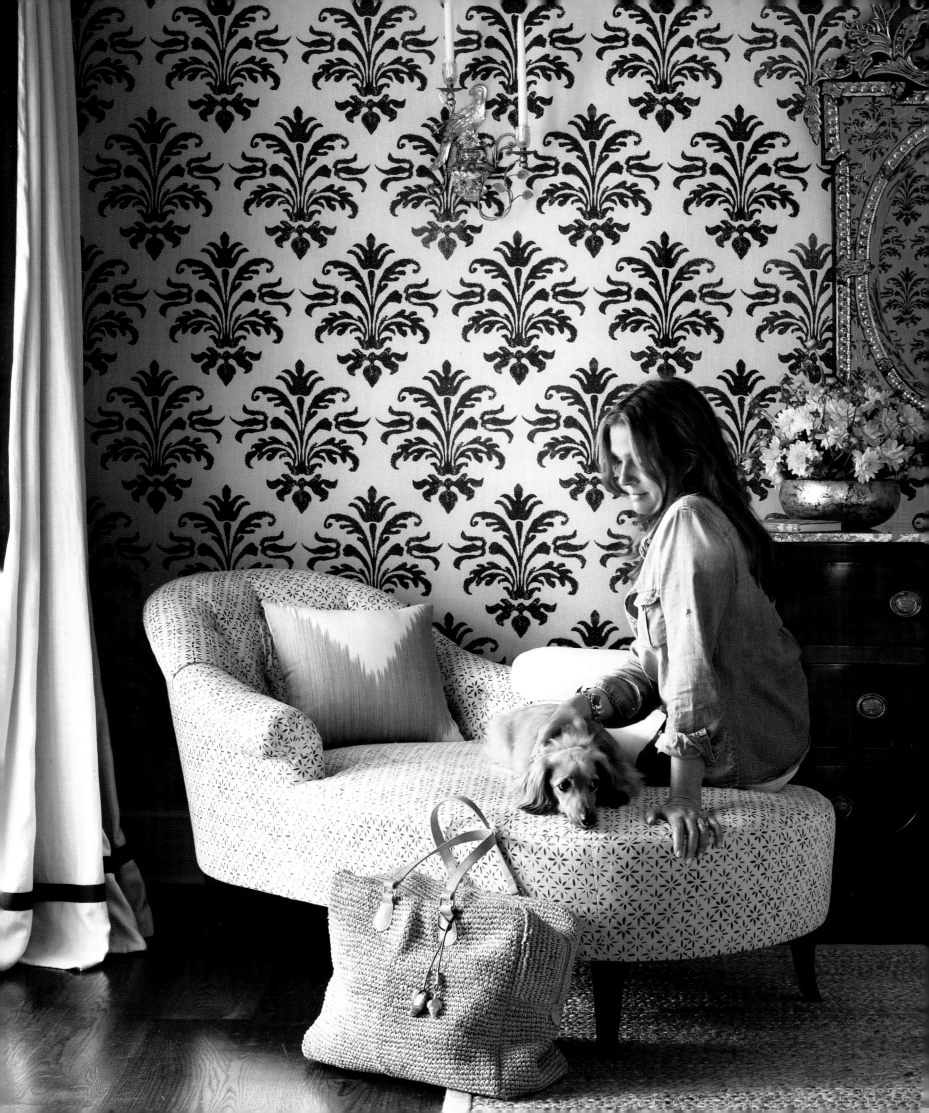

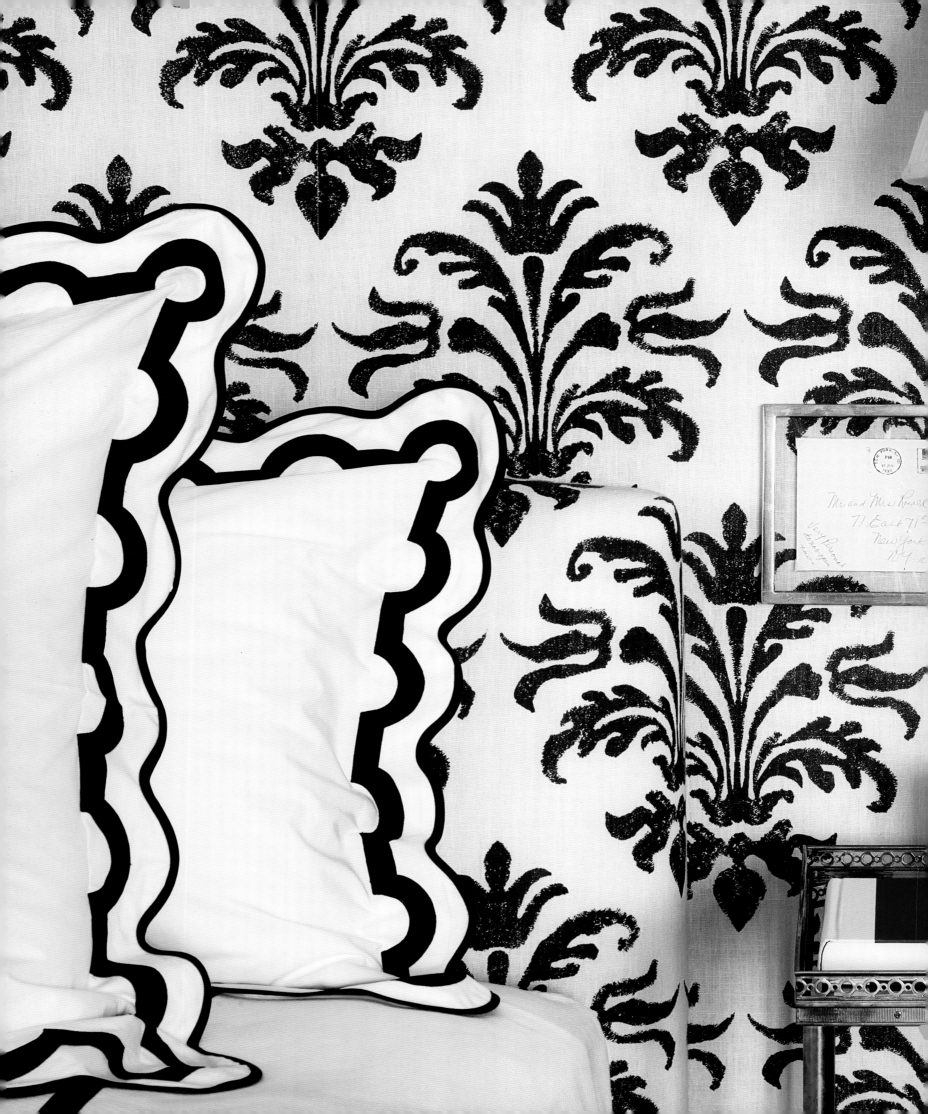

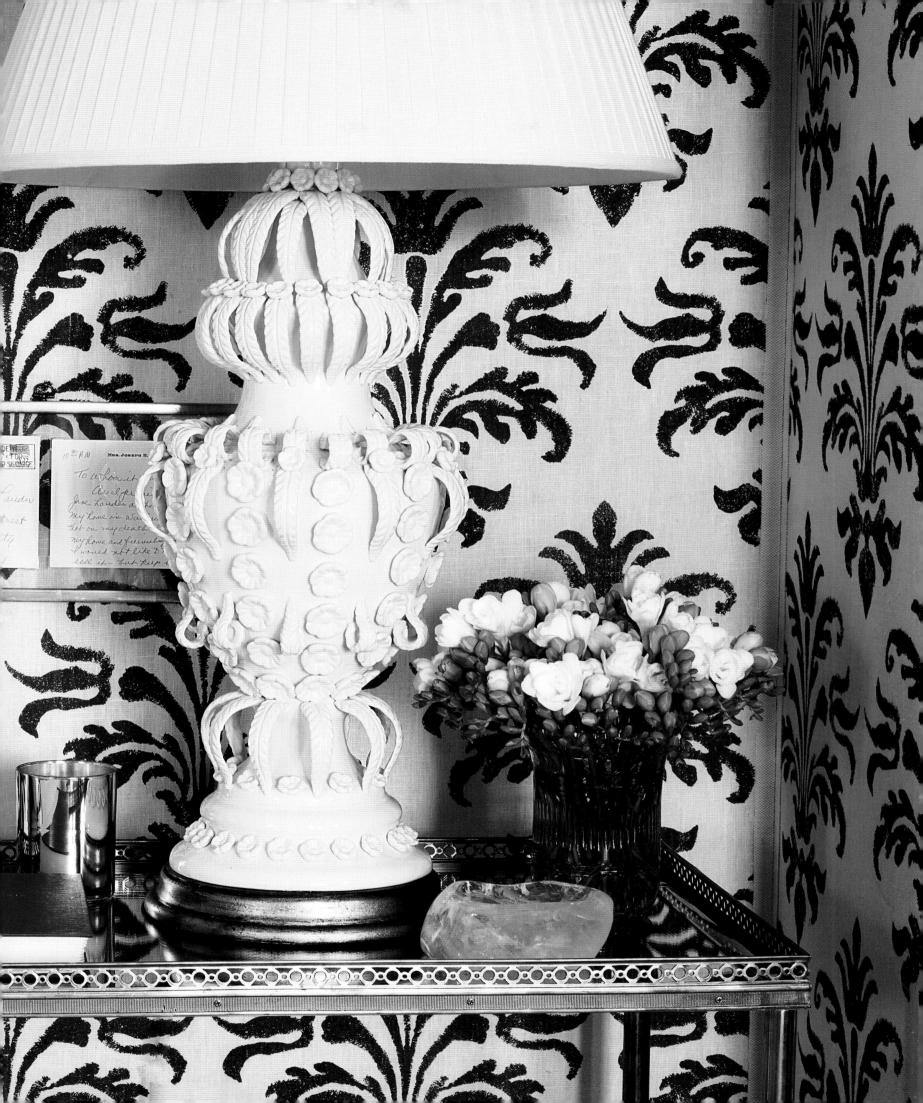

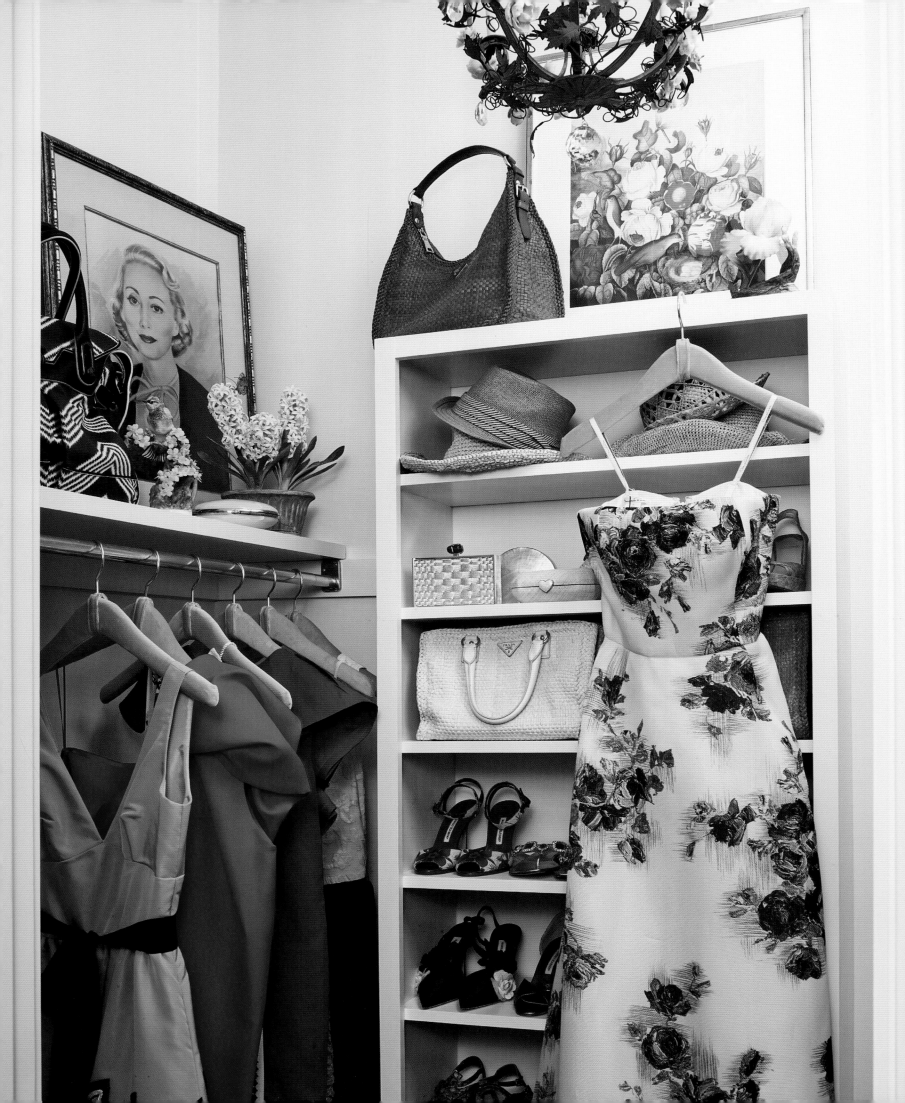

CLOSETS CAN
BE BEAUTIFUL, TOO

A drawing of Estée, which I brought down from the attic, sits on the shelf. I'll always put a few personal objects in a closet. To see a picture or a great wallpaper when you open the door is more interesting than just seeing clothes.

Open shelves make it easy to know exactly what you have. I dress very simply out here all year round—jeans and a shirt, or shorts and a tank top are my usual uniform. But I have clothes in my closet for every contingency, because I'd rather not carry garment bags back and forth from the city. There are simple summer shifts for a cocktail party and long, floaty dresses for more formal affairs.

The main idea is to keep it easy. If I need a quick cover-up, I'll throw on a man's shirt over my bathing suit. In winter, I move on to flannel shirts, big cozy sweaters, and down vests, with jeans in all sorts of colors. (White, pink, and green for summer. Black, chocolate, and aubergine for fall.)

In New York, I have to dress more seriously for work. In the country, it's all about comfort and familiarity. And of course I took the opportunity to hang another great vintage chandelier.

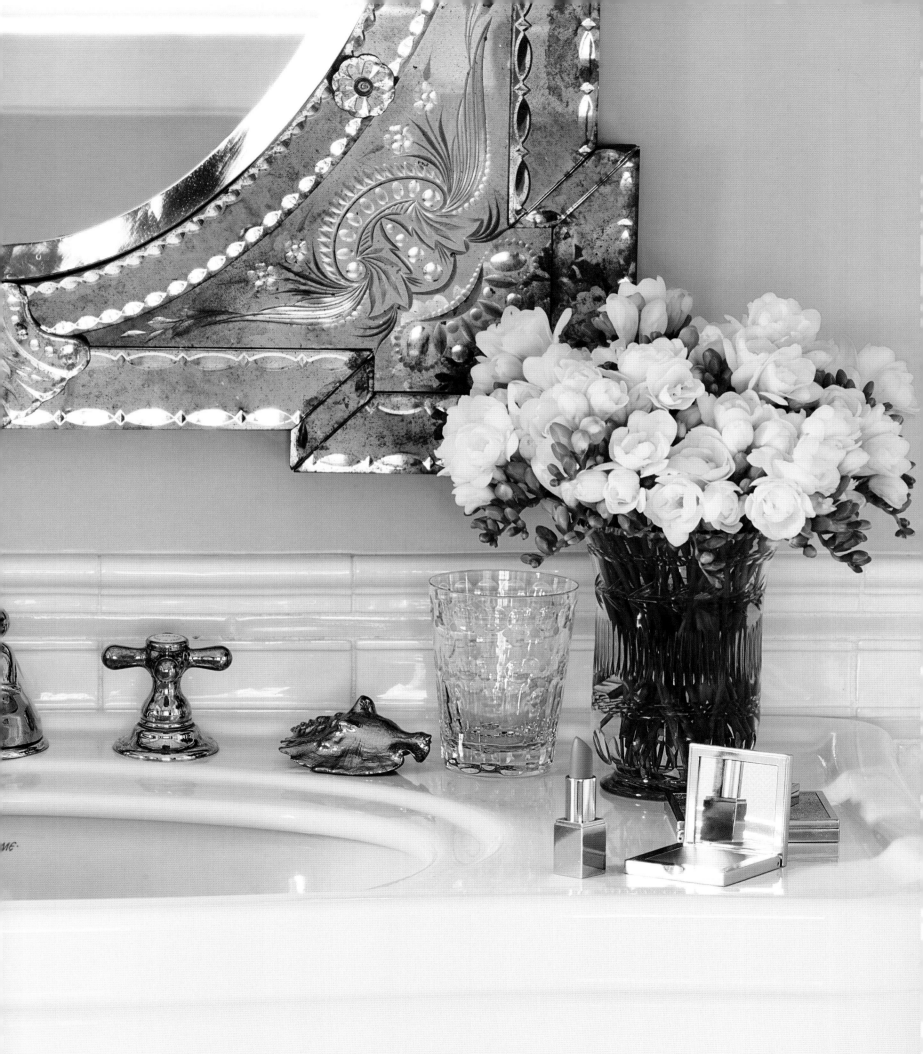

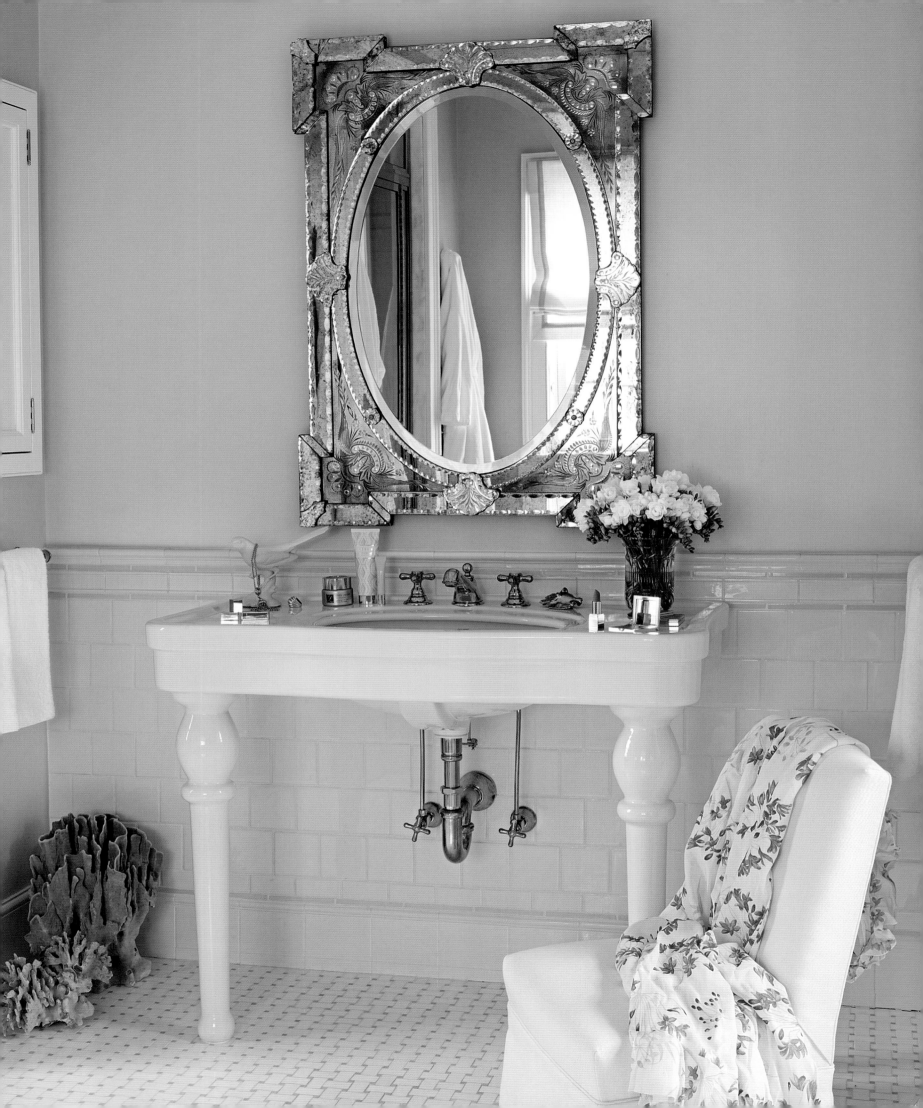

If there is enough space in a bathroom, one of the most luxurious things you can do is bring in a chair. It will feel more like a room and offers a comfortable place to sit and take off your things.

BE MY GUEST

This is the room I slept in as a child, when Jane and I came to stay overnight. Back then it had twin beds and a funny old toile on the walls, with Indians and Pilgrims. I was not fond of that pattern even then.

When I decided to redo it, I thought, Here's my chance to express my inner Estée. I could finally have the bedroom of my dreams, the kind where the walls and the curtains and the headboard are all covered in the same flowery print. The kind that would be way too much for Eric every day.

But it would be great for guests. The pattern completely envelops them when they walk in. Immediately, the room feels warm and safe, like a cocoon. The Early American highboy has stood between the windows for as long as I can remember.

There's a photograph of my mother, when she was in her twenties, on the desktop, along with some pretty note cards. If you can manage to fit a desk into a guest room, it's a real convenience. It gives people a place to park their laptop. They can check their e-mail and do any work that can't wait in the privacy of their own room.

Inviting friends out for the weekend gives me a chance to spend real time with them, and I want to make the experience as warm and welcoming as I can. That usually means setting a tray in their bathroom and filling it with products—lotions, cosmetics, and a makeup bag so they can take it all home. I'll set out a pretty robe and some slippers, because no one bothers to bring his or her own just for a weekend. L.L.Bean makes the coziest slippers, lined with shearling, and I keep a stash of them for guests.

I'll set fresh flowers on the bedside table, along with a few new books and magazines, chosen to suit their interests. If there are children coming, I like to leave a little present for them on the bed—a new box of LEGOs or a stuffed animal. I'll hang a beach bag in their closet to hold towels and sunscreen if we go to the beach. I try to think of anything else people might need, but the best way to know if a guest room really works is to sleep in it yourself one night. Then you'll quickly find out if anything's missing.

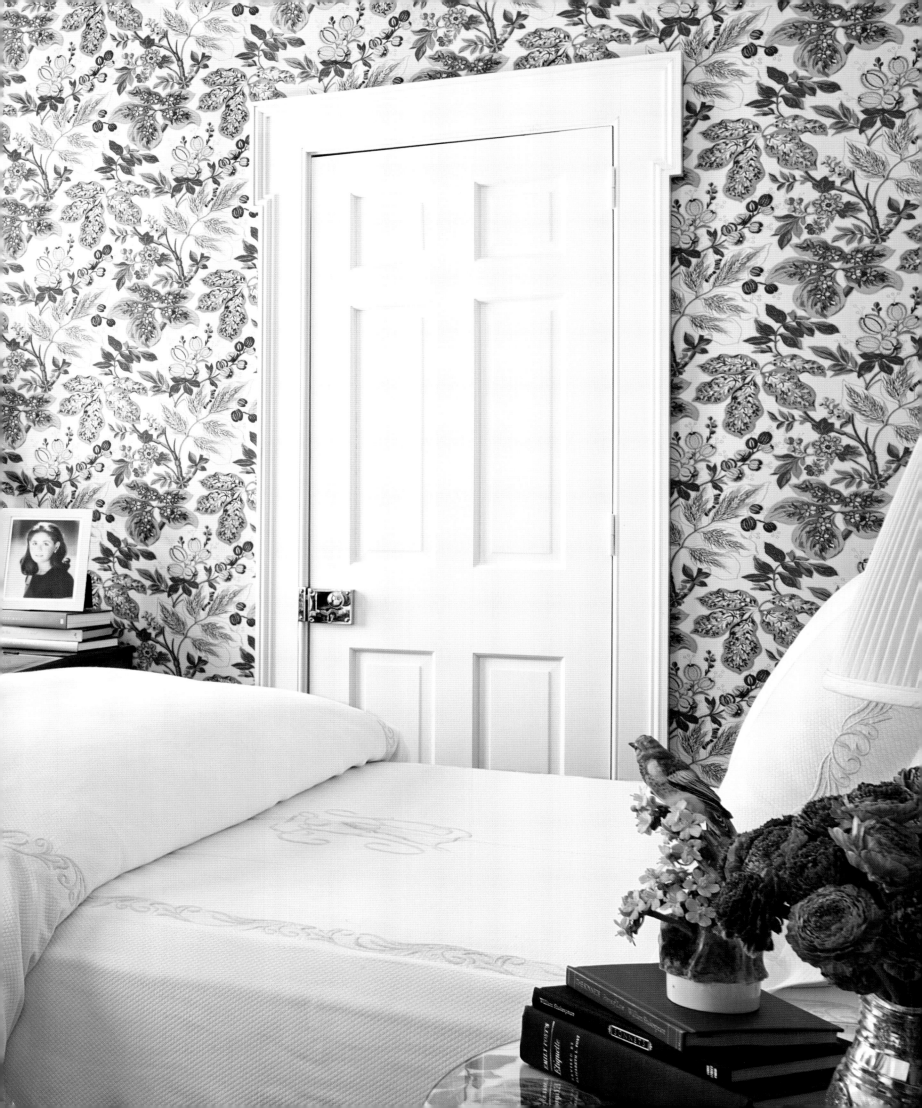

WHAT A GOOD
GUEST ROOM NEEDS

Extra blankets • An assortment of pillows
A luggage rack • Plenty of hangers • A robe and slippers
A scented candle • A carafe of water, with two glasses • Books
Notepads and a pen • A phone charger • Fresh flowers

IN THE GUEST BATH

Extra toothbrushes and toothpaste • Pretty soap
Shampoo and conditioner • Face soap • Cotton balls • Q-tips
Body lotion • Perfume • Shaving cream • A razor • Tweezers
Sunscreen • Nail polish remover • Advil

Estée kept her stationery in the desk in the corner, and inside the drawers I found all sorts of invitations and thank-you notes that she had saved. I understand that impulse. I've kept scraps of paper, little notes from my friends or my sons that have no monetary value. But they're priceless to me.

HIROSHI SUGIMOTO

Warhol by Galella *That's Great!*

ONARDO DA VINCI

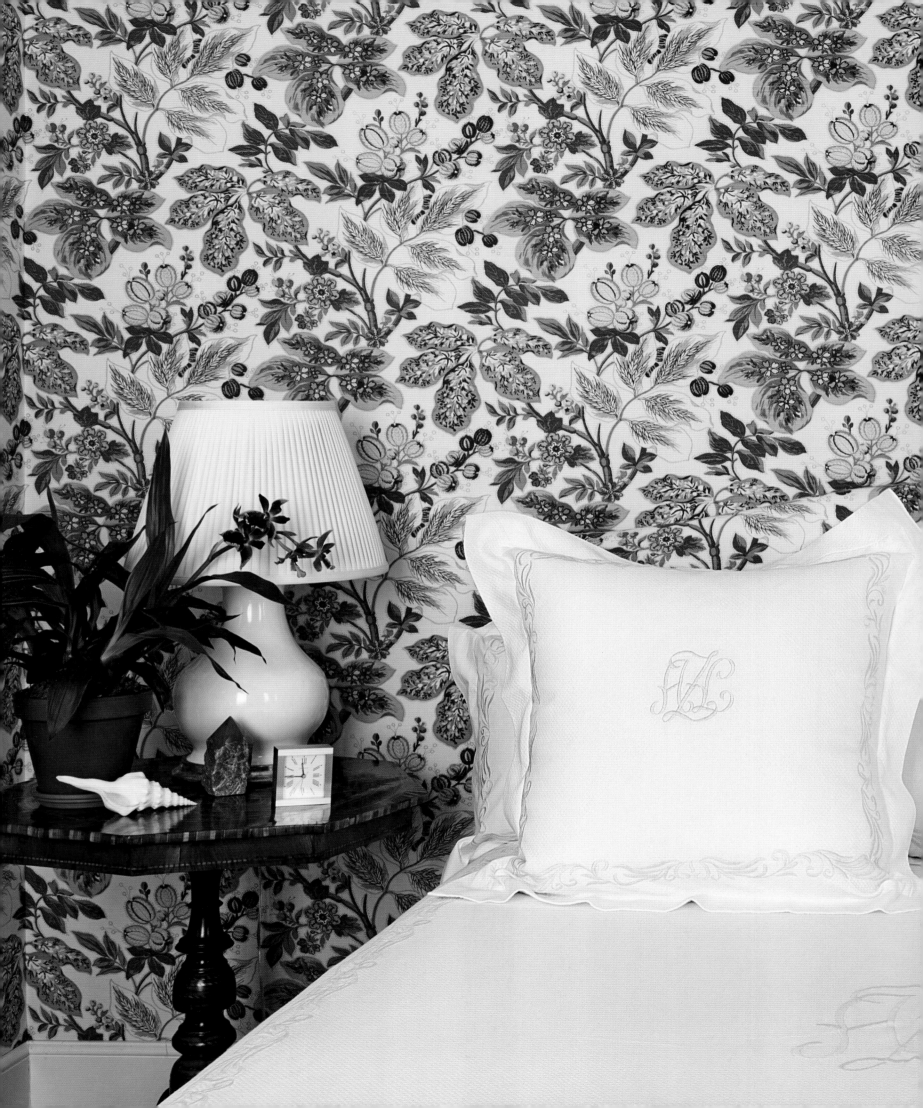

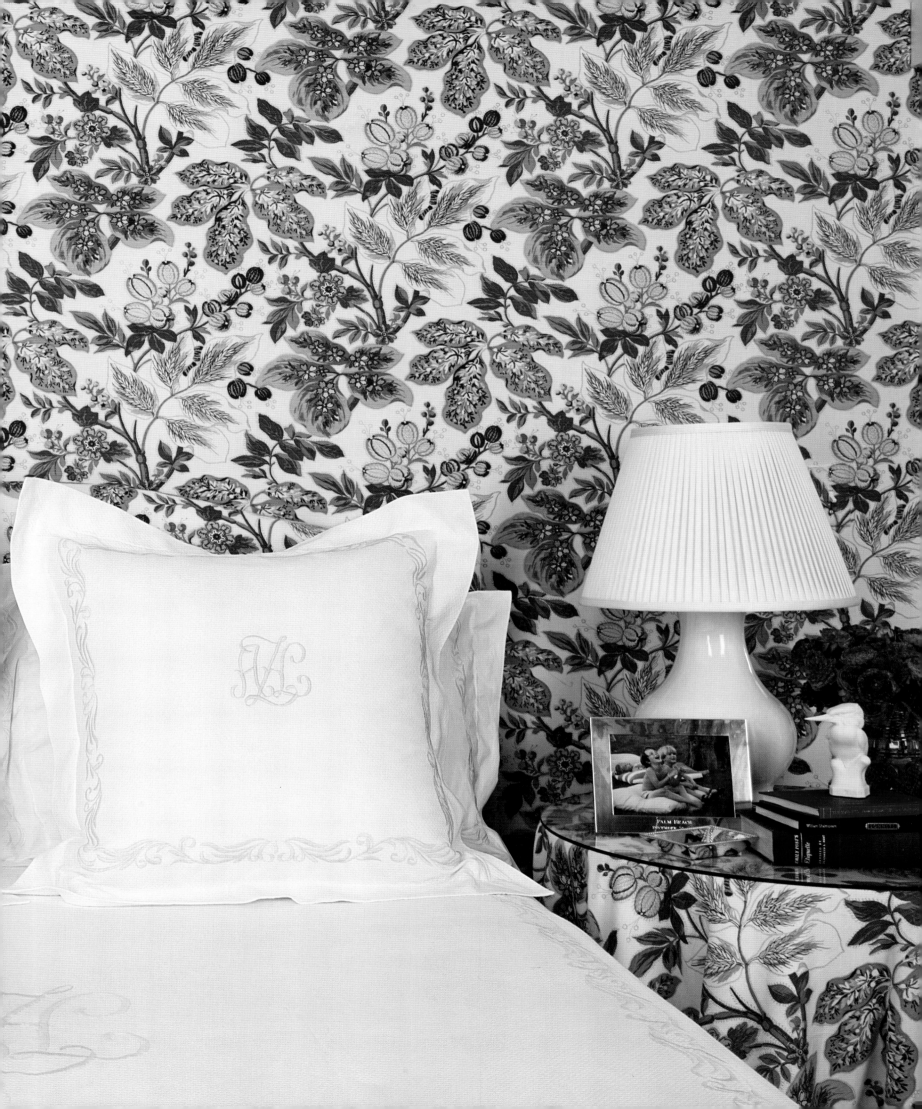

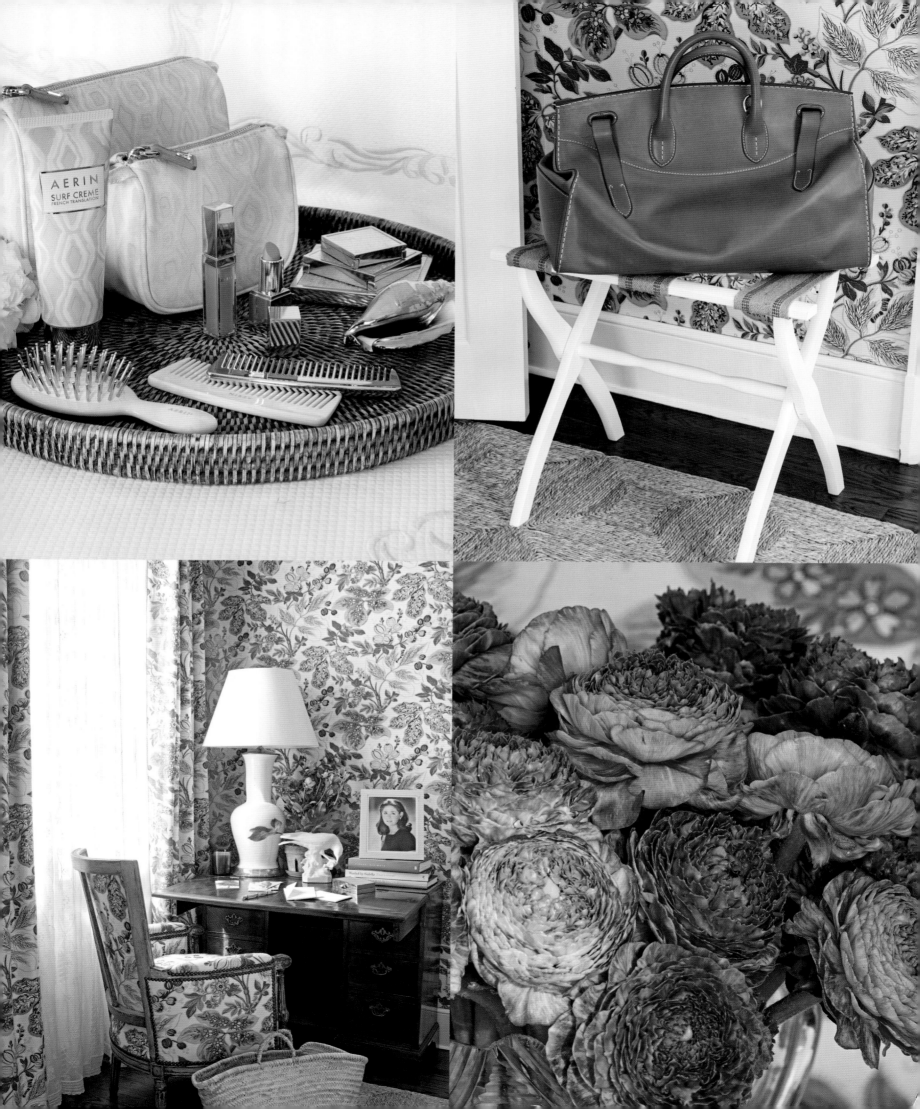

GREAT HOSTESS GIFTS

I like to be a good hostess. But it's also important to be a good guest.
Here are some ideas for gifts that might please your host:

- Pool toys
- European design magazines
- A new cookbook
- A croquet or badminton set
- A scented candle
- Freshly baked cookies
- Classic games—backgammon, Chinese checkers,
Chutes and Ladders, Candy Land
- *Vogue* magazines from the year your hostess was born
- Graeter's homemade ice cream, made since 1870 in Ohio.
A friend had some shipped to me after a visit—so clever.
- The top five books on the *New York Times* bestseller list

BE DIFFERENT

Just as in the city, my sons' bedrooms in the country are a blend of personality and pure fun. They're full of things that reflect their interests—tennis trophies, guitar picks, books about surfing. Jack's room is painted a beautiful blue, because he loves the ocean and the blue makes it feel like summer all year long. Will's room is done in green and white wallpaper that makes me think of tall grass and the jungle.

The art ranges from things the boys have made, like a LEGO truck, to pieces I've bought in art galleries, museum stores, or at auction—all of which are great sources for prints like that colorful zebra.

Two Brazilian brothers, Fernando and Humberto Campana, transformed a pile of stuffed animals into a chair. It was my mother's gift to me one year, on my birthday. She knew all of us would enjoy it. It's every child's fantasy.

I'm not sure the boys initially shared my love for monograms. But now I think they like it. It makes something as plain and simple as a pillowcase very special and personal. It's theirs and theirs alone.

If I didn't do what I'm doing, I think I would have enjoyed being a nursery school teacher. I love being surrounded by children. It's so much fun to watch my sons and all their friends grow up.

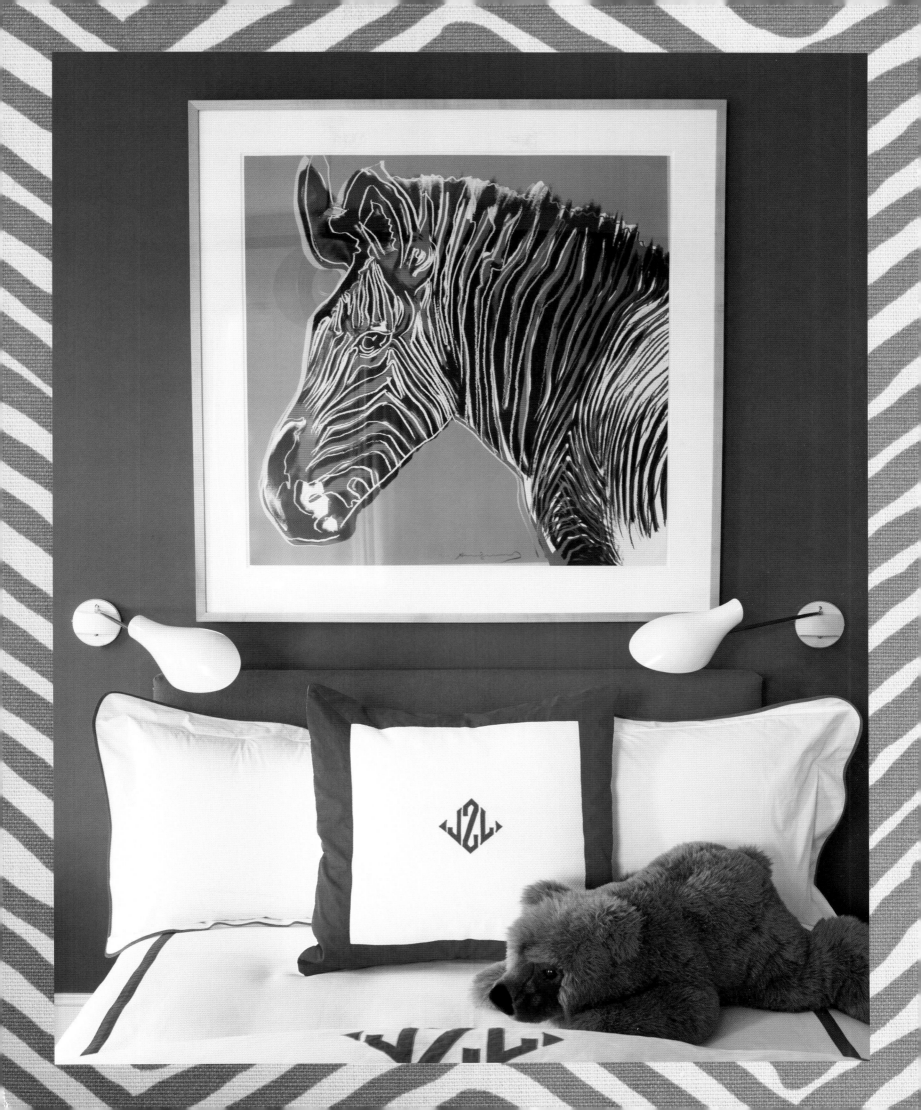

That surfboard in royal blue is a work of art all on its own. It's as eye-catching as any sculpture. I love the idea of color and surprise in a child's room. Where else could you hang a big blue whale?

SPLASH

There's a famous Slim Aarons photograph of Babe Paley in Jamaica, leaning on a pillar at her pool house. That simple, elegant structure, open on two sides, was the inspiration for our pool house. I love the idea of indoor-outdoor space, and this is one big room that's sheltered from the sun, yet the breezes can blow right through. We use it as a quiet space, an entertaining space, and a play space for the children on a rainy day.

The white cushions on the wicker furniture are made of Sunbrella indoor-outdoor fabric. We can sit down in our wet bathing suits without a qualm, and if something spills, it just wipes off.

With white walls, a white floor, and a white ceiling, this place feels pure and calm. The most vibrant touch comes from the throw pillows, in vintage floral fabric that I recolored for Lee Jofa to make it feel fresh and modern. One pattern is all flowers and birds, which Estée would have loved.

Sometimes I'll bring in one long table for a party and we'll serve dinner in here. Or I may move all the furniture out and use the pool house and terrace for a dinner dance. It's the most romantic setting. The only light comes from the glow of the candles, the coral chandelier, and the stars outside. Perfect.

There's one more house on the property—a tree house that we built for Jack's third birthday. (It's only five feet off the ground, because I'm a mom and I'm cautious.) The boys have used it as the site of many elaborate fantasies—a hideout, a bunker, a pioneer cabin. They love to spend the night up there with their friends—and sneak back to the house at midnight to raid the refrigerator for ice cream and Popsicles.

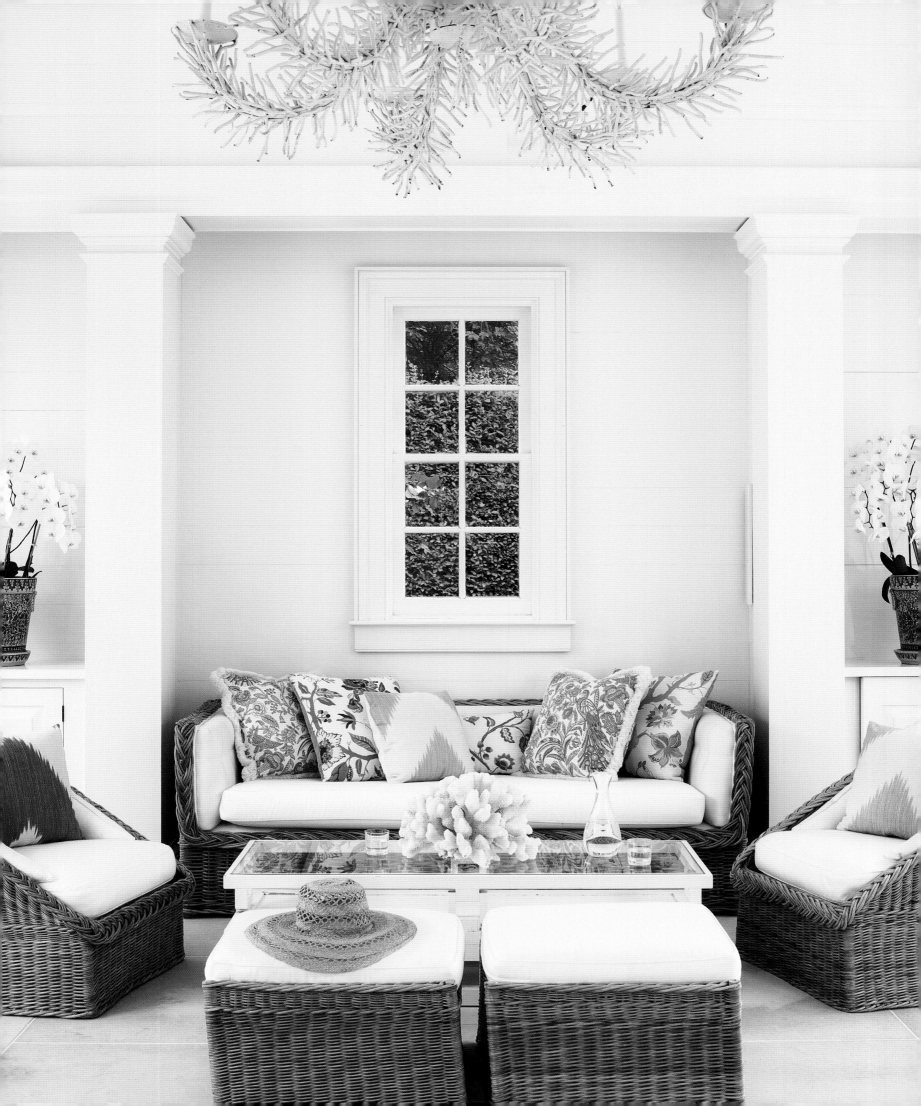

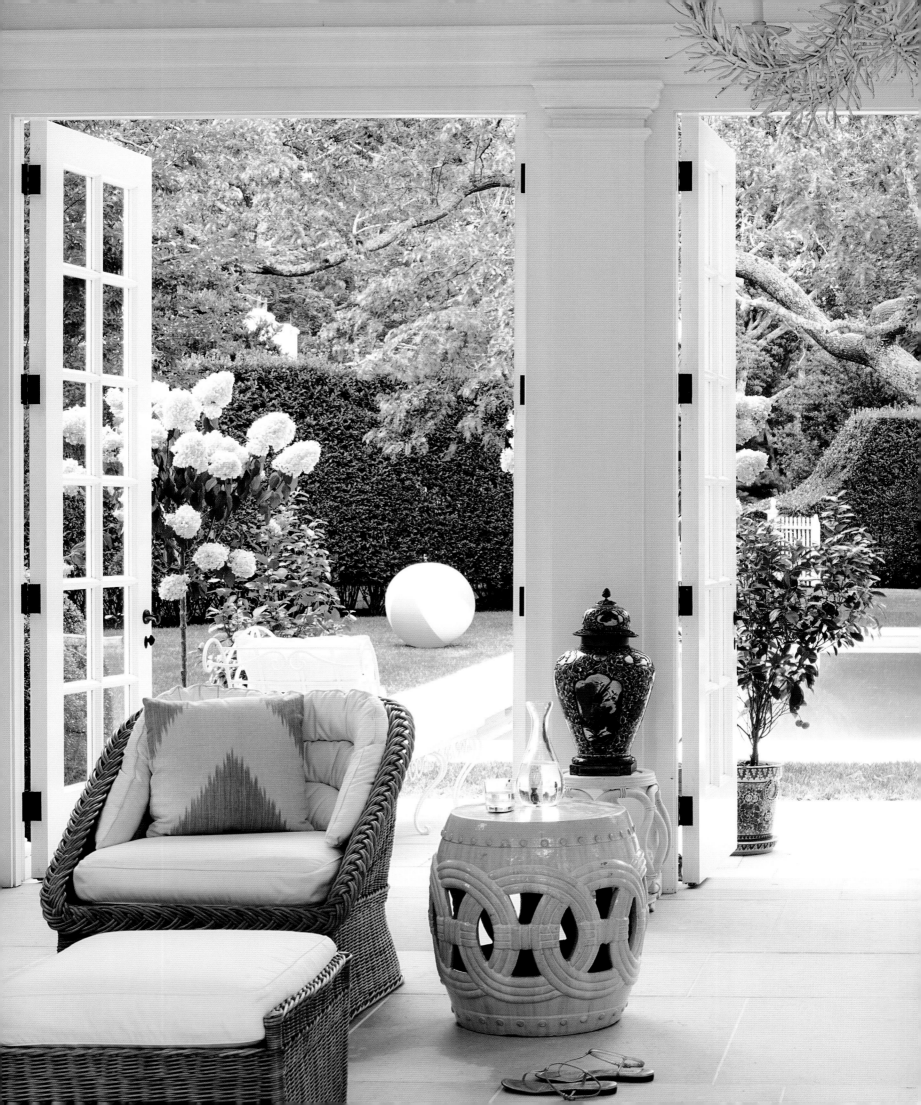

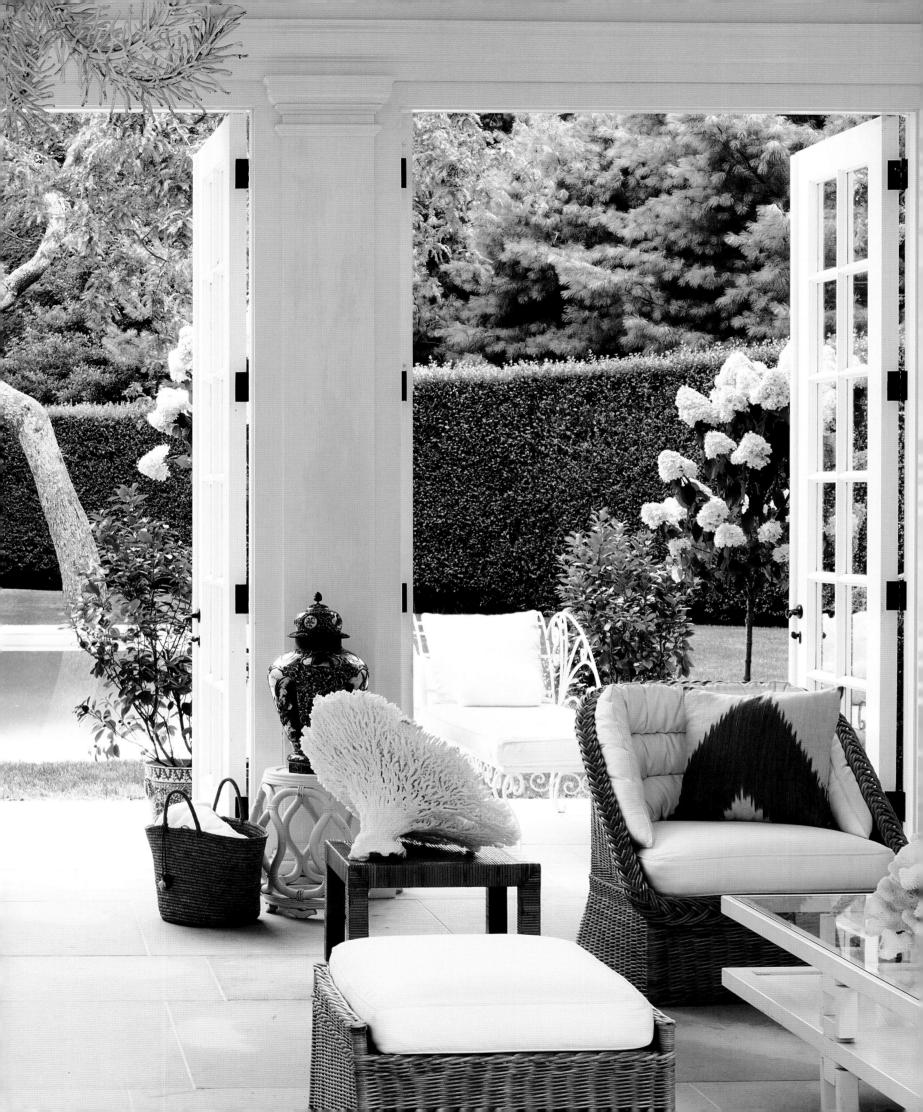

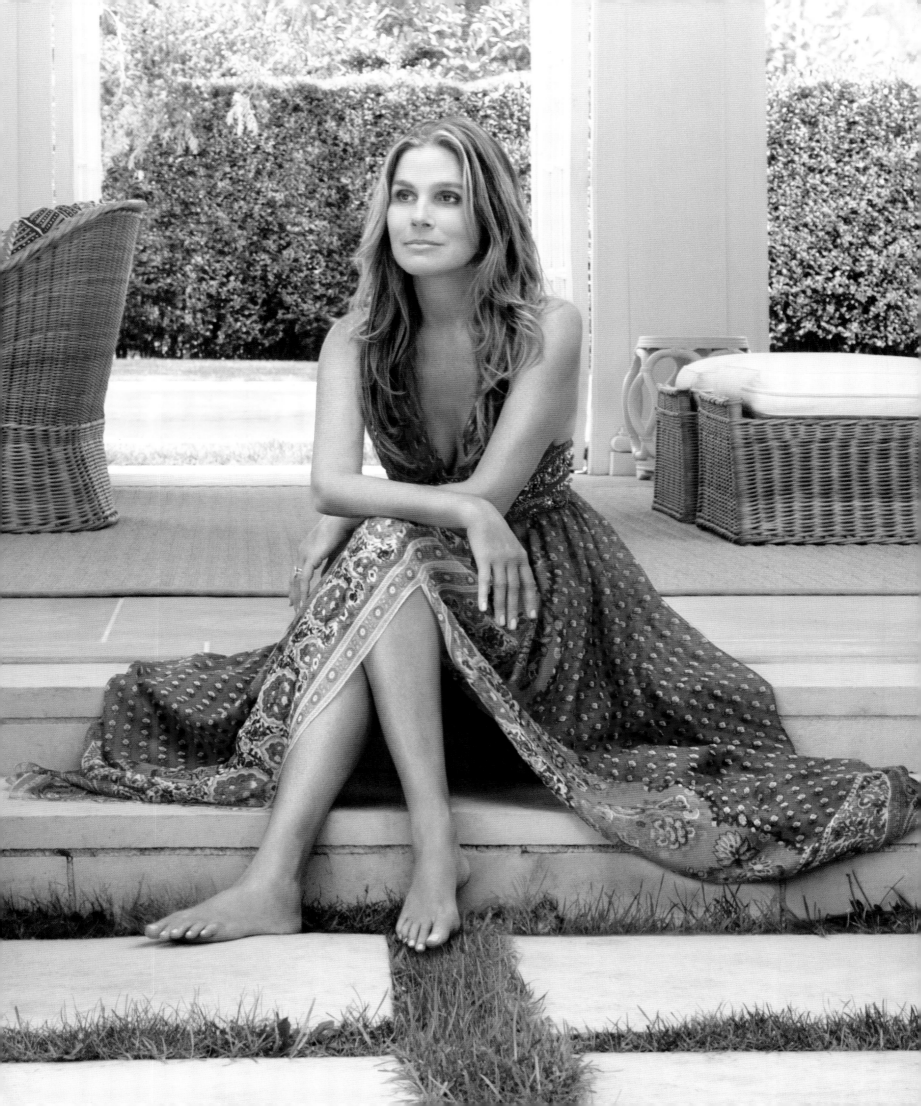

Pure white canvas on a rattan sofa says summer to me. Then just pile on the colorful pillows. You can't go wrong.

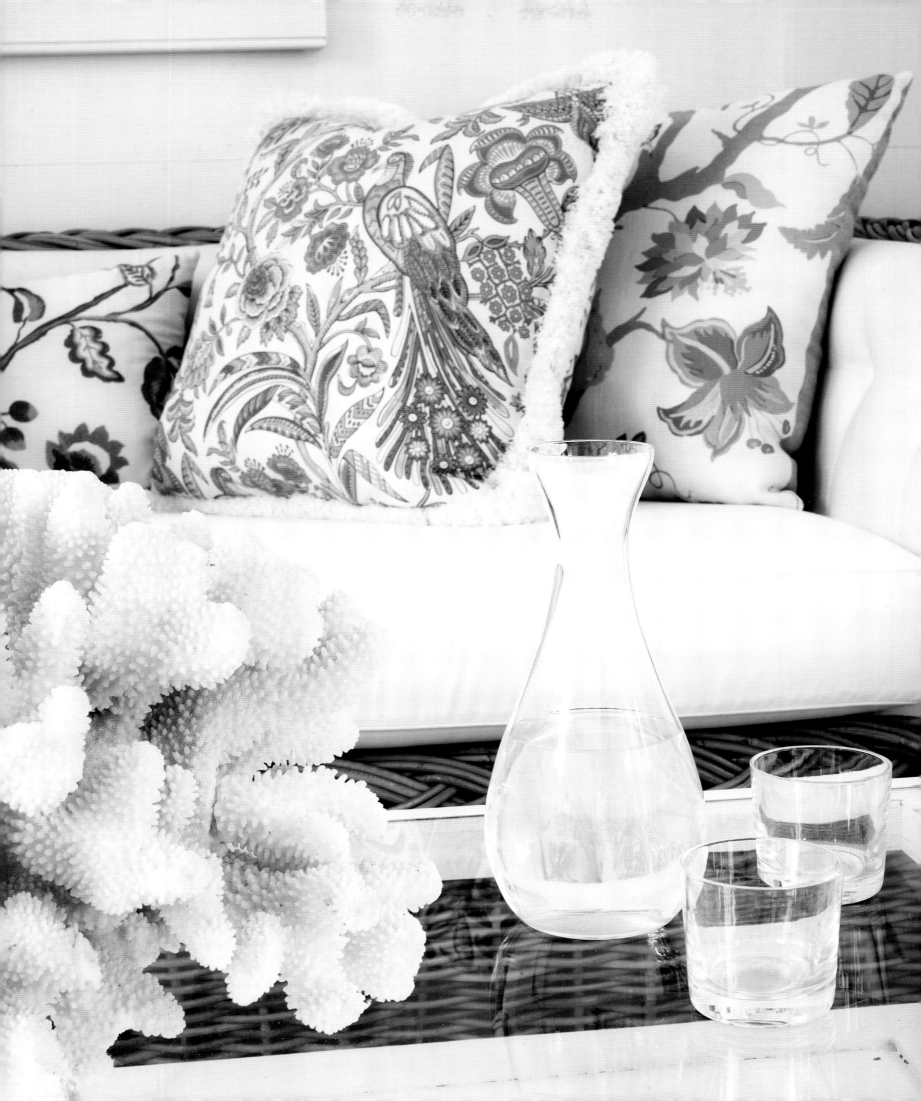

MAKING MEMORIES

My mother always gave these incredible birthday parties for my sister, Jane, who was born on the Fourth of July. She would invite whole families to our summer house on Wainscott Pond in Long Island, so it was a multigenerational affair. And of course my grandfather and grandmother would be there—Estée in some Ungaro outfit amidst the potato fields. My mom and dad had fallen in love with the light and the pond and those raw fields many years ago. They built a traditional shingle-style house and later bought an old barn and moved it onto the property.

So there would be Estée, in silk and high heels, and my mother in sandals and a denim skirt—very Bohemian. Mom would spread wonderful old American quilts out on the grass, and people would sit and picnic on fried chicken, potato salad, biscuits, and ham. It was the quintessential summer barbecue, topped off with ice cream and cake. Invariably, the birthday cake had a Barbie doll planted in the middle with the cake as her skirt, laden with frosting. All the tablecloths, plates, and napkins had a red-white-and-blue theme.

Jane and I would be dressed in matching white piqué sundresses, with red-and-white gingham ribbons in our hair. There would be toys and games for adults and kids, like potato-sack races and flashlight tag, when it got darker. I remember the geese flying overhead at dusk. And everyone would go home with a little shovel and tin pail full of candy.

I flash back to those Barbie cakes when I'm bringing out a Spider-Man cake for one of my sons. I owe my mother a lot; she taught me how to make any occasion special. It may just be a sleepover at our house for four ten-year-old boys, but I will still set the breakfast table with linen napkins and make sure there are flowers in the center. And there will be all sorts of cereals to choose from—even the kind that is full of sugar and that my boys are only allowed to have once a week. I want to make their lives fun and happy, because that's how I grew up.

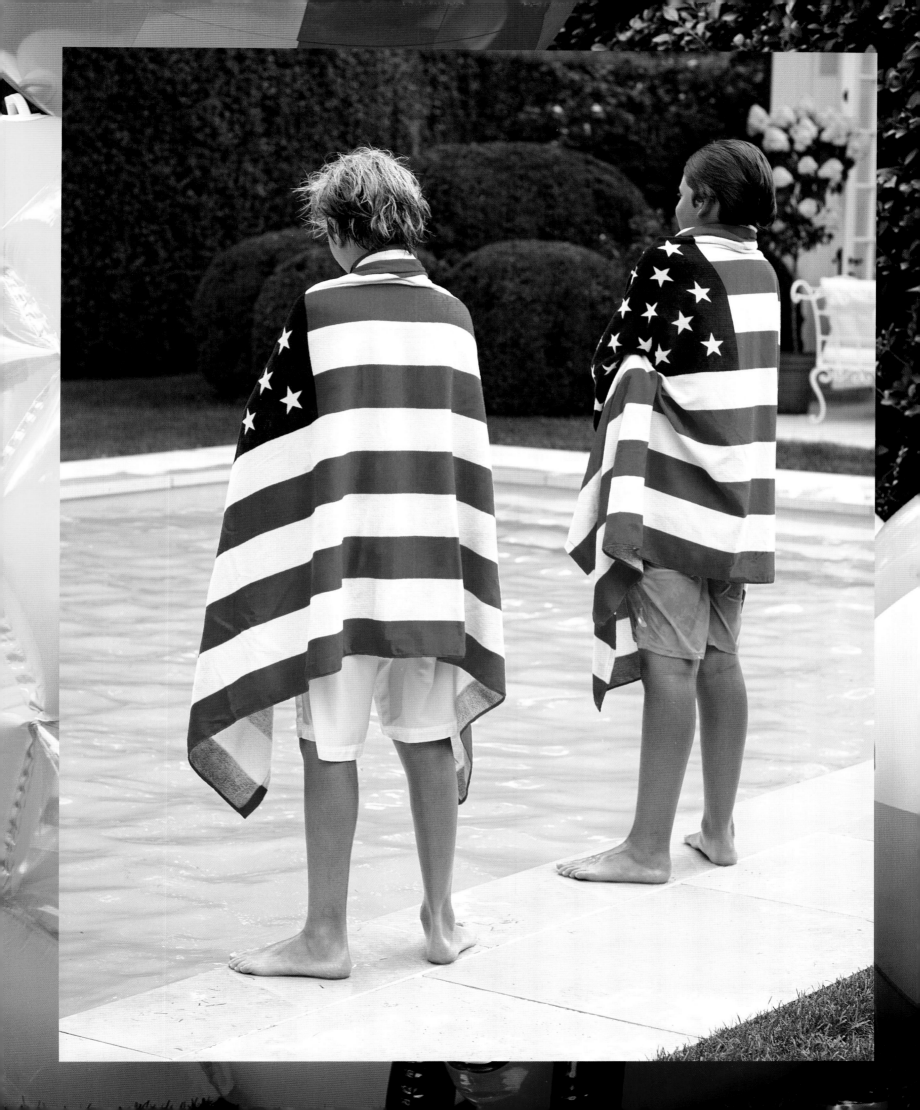

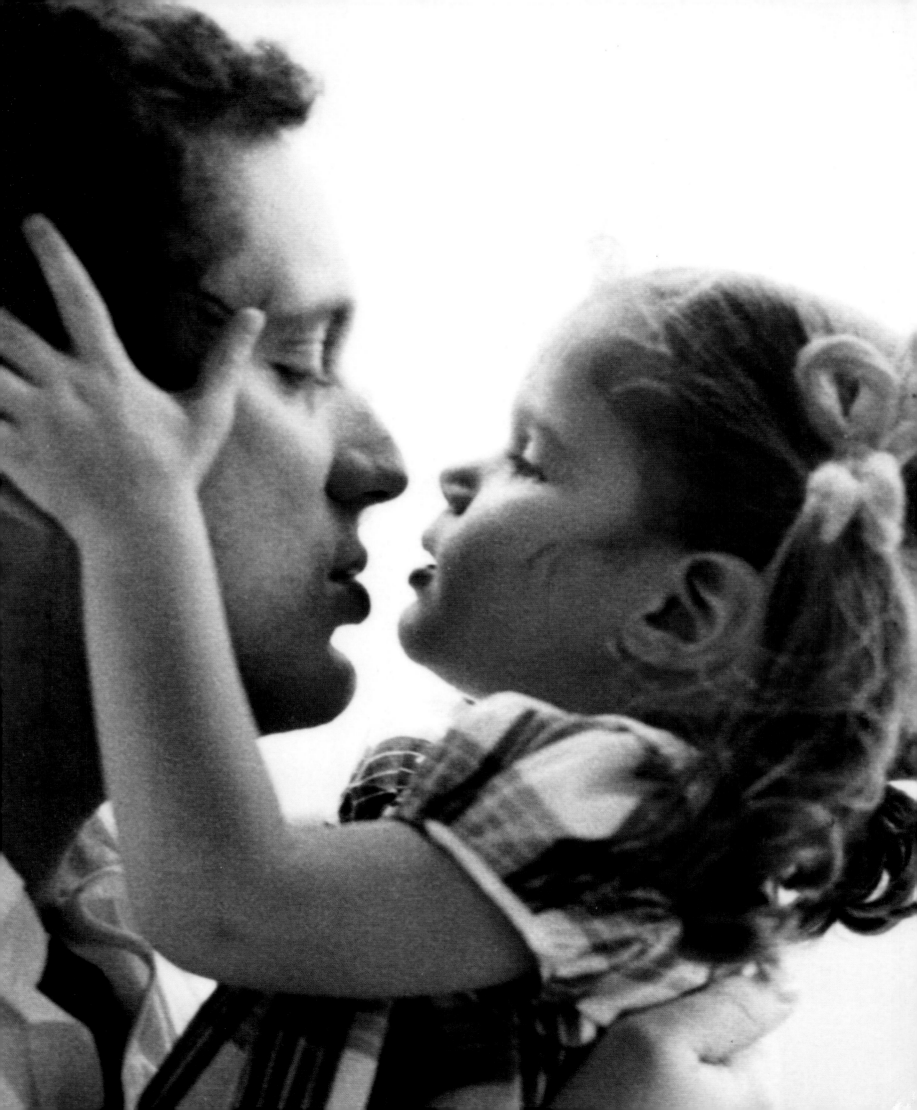

ACKNOWLEDGMENTS

I am grateful to the talented team that helped me bring this book to life: photographer Simon Upton, whose images grace these pages; Christine Pittel, who made my words more lyrical; Michael Reynolds, who styled these images; and Jill Cohen, who managed the project from the beginning.

And to my publisher, Potter Style, where Doris Cooper, Aliza Fogelson, and Jane Treuhaft devoted countless hours to every detail. Thanks to Doug Lloyd, whose design vision appears on these pages, and to my talented PR team at HL Group. To Paul Podlucky, who knows how to make hair and makeup naturally gorgeous, and to the countless others behind the scenes.

And to my fabulous team at AERIN.

PHOTOGRAPHY CREDITS

All photographs by Simon Upton except: framed author photograph on jacket front by Victor Skrebneski; all family photographs courtesy of the author; pages 132 and 232–233 by Claiborne Swanson Frank; and page 142 by Eric Boman, *Vogue Living*, Condé Nast.

ADDITIONAL IMAGES

Page 25 (bottom left): framed photograph by Tina Barney; page 29: drawing by Alejo Vidal-Quadras; page 33: artwork by Cy Twombly; pages 37–39: Beauvais tapestry, first half of the eighteenth century; page 42: painting by Yves Klein; pages 44–45: painting by Lucio Fontana and sculpture by Alexander Calder; page 49: artwork by Piero Manzoni; page 50: artwork by Richard Serra; page 61: artwork by Lucio Fontana; page 65: artwork by Sol LeWitt; page 88: Hulk print by Michael Scoggins; page 91: print by Roy Lichtenstein; page 96: artwork by Robert Mangold; page 118: framed flower photograph by Paul Lange; page 125: watercolor by Jimmy Steinmeyer; page 167: watercolor by Happy Menocal; page 187: framed photograph by Clifford Ross; page 223: print by Andy Warhol; page 225: framed photograph by William Wegman; page 226 (bottom left): framed artwork by Ellsworth Kelly.